FUNGI

Collected in Shropshire and Other Neighbourhoods

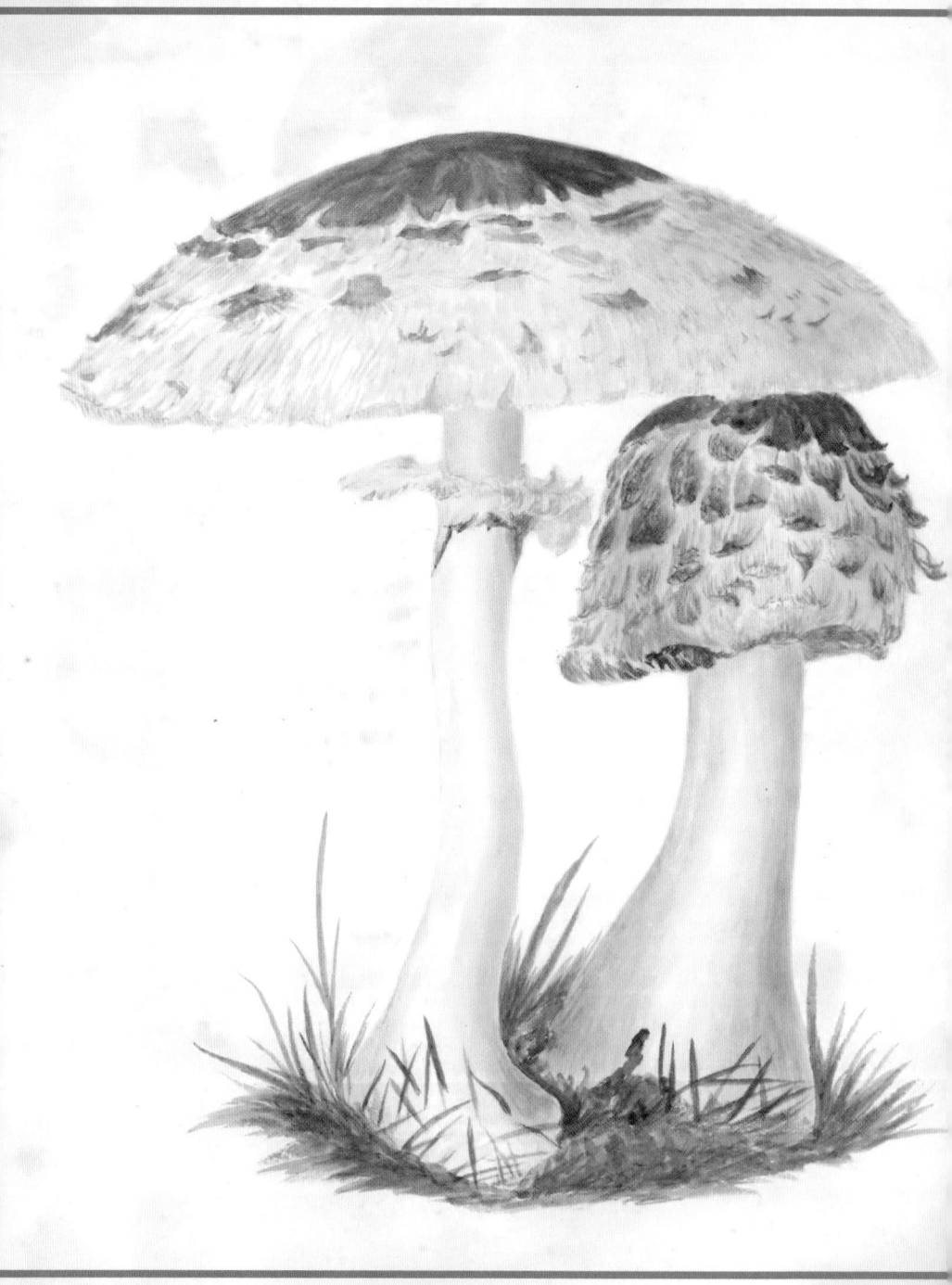

FUNGI

Collected in Shropshire and Other Neighbourhoods

A Victorian Woman's
Illustrated Field Notes

BY M. F. LEWIS

Foreword by Patricia
Ononiwu Kaishian, PhD

CHRONICLE BOOKS
SAN FRANCISCO

Library of Congress Cataloging-in-Publication Data

Names: Lewis, M. F. (Mycologist), author. | Kaishian, Patricia Ononiwu, author of foreword.
Title: Fungi collected in Shropshire and other neighbourhoods : a Victorian woman's illustrated field notes / by M.F. Lewis ; foreword by Patricia Ononiwu Kaishian, PhD.
Description: San Francisco : Chronicle Books, [2023] | Includes bibliographical references.
Identifiers: LCCN 2023016230 | ISBN 9781797227412 (hardcover)
Subjects: LCSH: Mushrooms--England--Shropshire--Pictorial works. | Botanical illustration--England--Shropshire--19th century. | Watercolor painting, British--19th century.
Classification: LCC QK607 .L495 2023 | DDC 579.509424/5--dc23/eng/20230517
LC record available at https://lccn.loc.gov/2023016230

Manufactured in China.

MIX
Paper | Supporting responsible forestry
FSC™ C136333

Design by Kayla Ferriera.
Typeset in Bulmer MT Pro.
Image on page 6 courtesy of fromoldbooks.org.

Disclaimer: This book is not a foraging guide and should not be used to determine the safety of consuming any fungi.

10 9 8 7 6 5 4 3 2 1

Chronicle Books LLC
680 Second Street
San Francisco, California 94107
www.chroniclebooks.com

CONTENTS

Foreword 7

Volume I 12

Volume II 56

Volume III 104

Notes 149

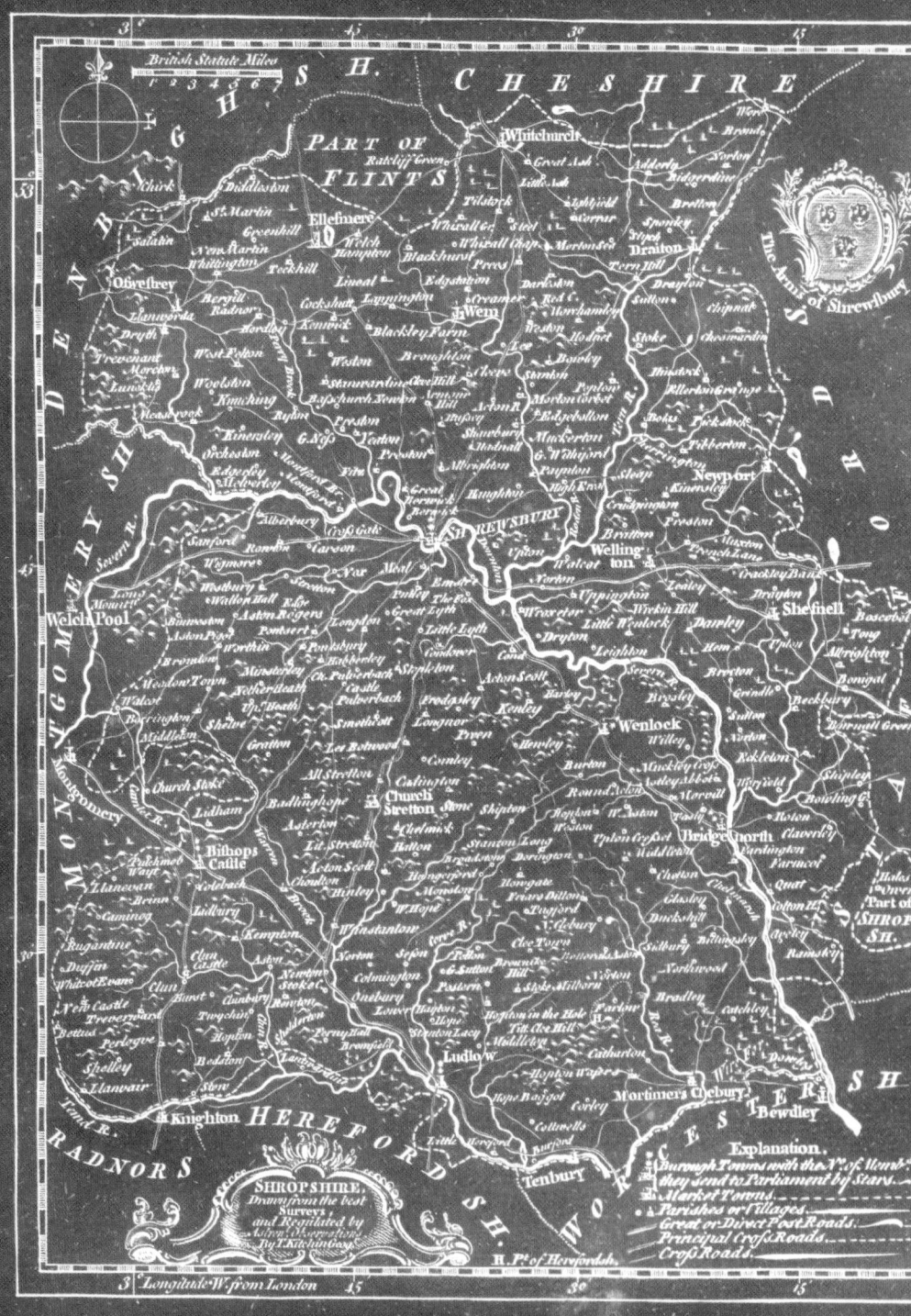

DENBIGH SH. CHESHIRE

British Statute Miles
1 2 3 4 5 6 7

PART OF FLINTS

The Arms of Shrewsbury

Whitchurch

Ellesmere

Oswestry

SHREWSBURY

Wellington

Welch Pool

Shefnall

Wenlock

Church Stretton

Bishops Castle

Bridgenorth

Ludlow

Mortimers Clebury

Bewdley

Knighton

HEREFORD SH.

RADNORS

Tenbury

WORCESTER SH.

MONTGOMERY SH.

SHROP SH.

R. Pt. of Hereford sh.

Explanation.
Burough Towns with the Nᵒ. of Membrs
they send to Parliament by Stars.
Market Towns
Parishes or Villages
Great or Direct Post Roads
Principal Cross Roads
Cross Roads

SHROPSHIRE
Drawn from the best
Surveys,
and Regulated by
Astron. Observations
By T. Kitchin &c.

Longitude W. from London

FOREWORD

By Patricia Ononiwu Kaishian, PhD

Fungi are complex beings. Innumerable fungal species, ranging in the millions, occupy nearly every type of habitat our planet has to offer—from desert air to rainforest soils to the guts of termites and humans. In each and every niche, they quietly carry out essential functions that underpin life as we know it. Some fungi form mushrooms—conspicuous, though often ephemeral, spore-bearing structures. Most fungi, however, live out their lives cryptically and microscopically, beyond the human gaze.

Though we are now in the midst of blooming appreciation for this kingdom of life, much of fungi biology remains obscure and unknown, even to mycologists. Despite fungi's undeniable ecological and medical significance, scientific research on them has lagged behind comparable pursuits in other areas of organismal biology, such as zoology and botany. Fungi have been termed *minority taxa,* defined as "taxa (groups of organisms) that consistently receive a disproportionately small amount of public and curatorial interest on a national or international scale relative to their species abundance and diversity" (Smith 2020).

This lag is largely due to a confluence of social forces that impeded research on these "lower taxa"—a Linnean term for groups of organisms deemed to be hierarchically beneath species that are better known, more conspicuously useful, more beautiful, or somehow more relatable to humans. To regard a group as "lower" is to invoke a pre-Darwinian and highly subjective understanding of organismal classification. Fungi were classified as "lower plants" for over two hundred years, from the eighteenth to the twentieth centuries. As such, they were not broadly considered worthy of formal exploration according to the so-called gentlemen's culture of science in Western Europe. Not only is the term "lower" inaccurate, but also fungi are decidedly not plants; in fact, fungi are more closely related to animals than they are to plants. The confusion shrouding this kingdom is a product of the indifference and even disdain toward fungi that was widespread in Western Europe and European American culture, and that lingers still today.

Professionalization of natural history research greatly expanded in the eighteenth, nineteenth, and twentieth centuries, times in which women were systematically kept undereducated and excluded from formal participation in the sciences. But fungi—commonly regarded by Western European "gentlemen" as inelegant, useless, gross, and deadly—were determined suitable study subjects for women. To explore fungi and other lower taxa (such as lichens, algae, and mosses) was not considered a serious concern to the male institutions of higher learning (Maroske and May 2018; Smith 2020). Some men, such as John Lindley (1799–1865), the first professor of botany at the University of London, distinguished between "polite botany," which included

fungi and which was for the "amusement" of women, and "botanical science," which was a serious discipline for men (Shteir 1996).

Historical mycology was therefore unique among other organismal fields for having more notable women contributors as well as women in positions of leadership in mycological societies. Accomplished women in the field included Catharina Dörrien, Marie-Anne Libert, Elise Caroline Bommer née Destrée, Mariette Hannon Rousseau, Mary Elizabeth Banning, Beatrix Potter, and Annie Lorrain Smith—all self-taught mycologists who contributed substantially to research in the years leading up to the twentieth century. Barred from formal institutions of science, women in fungal taxonomy were often seen as "isolated eccentrics," devoting the precious free time they had outside of domestic obligations to pursuing their true love: the science and natural history of misunderstood and maligned organisms (Maroske and May 2018). Mary Elizabeth Banning, a self-educated mycologist from rural America who spent decades studying fungi in Maryland, wrote, "Fungi are considered vegetable outcasts. Like beggars by the wayside dressed in gay attire, they ask for attention but claim none" (Burns 2022).

Scientists like to invoke a line spoken by Isaac Newton: "If I have seen further [than others], it is by standing on the shoulders of giants." Indeed, any decent scientist should well understand that no achievement in the field can be singularly attributed to one person. Nonetheless, the shoulders of many people—women and people of color in particular—have been stood upon without proper attribution or respect. As mycology gains global attention and thus attracts more

funding and more men, it is critical to acknowledge and celebrate the work of women and all of those who have been excluded on the basis of race, nationality, class, or expression from formal participation in science. Much of their work has been lost to history, though they are the people who shepherded the field of mycology when those in power were largely neglecting it.

Such was the fate of M. F. Lewis, a woman who dedicated decades of her life to the study of fungi across the verdant and rain-soaked habitats of England and Wales between 1860 and 1902. Her first name remains unknown, and her three volumes of gorgeous watercolor illustrations, titled *Fungi Collected in Shropshire and Other Neighbourhoods,* were forgotten for a century. Her sensitive, delicate, and scientifically accurate illustrations reveal a life of patient and meticulous observation. From depicting the large fruiting bodies of species such as *Cerioporus squamosus* ("dryad's saddle") to the more cryptic plant pathogenic rusts on rosebush and ash, Lewis's work demonstrates her dedication to the diverse world of fungal life. M. F. Lewis was clearly a scientist, despite likely being unpaid and underappreciated for her talents as such during her lifetime.

Here we highlight Lewis's collection as scientific and aesthetic work deserving of remembrance and celebration.

BIBLIOGRAPHY

Burns, Alanna. 2022. "The Secret History of Women and Mushrooms: A Centuries-Old Tale of Empowerment, Enlightenment, Education, and Magic." *BUST*, Spring. https://bust.com/eat-me/198770-a-comprehensive-history-of-mushrooms-used-by-women-as-food-activism-and-empowerment-4.html.

Maroske, Sara, and Tom W. May. 2018. "Naming Names: The First Women Taxonomists in Mycology." *Studies in Mycology* 89, no. 1 (March): 63–84. https://www.studiesinmycology.org/sim/Sim89/Naming-names--the-first-women-taxonomists-in-mycolog_2018_Studies-in-Mycolog.pdf.

Newton, Isaac. 1675. Sir Isaac Newton Letter to Robert Hooke. Simon Gratz Autograph Collection (#0250A), Historical Society of Pennsylvania. https://discover.hsp.org/Record/dc-9792, https://digitallibrary.hsp.org/index.php/Detail/objects/9792.

New York State Museum. N.d. "Mary Banning's Fungi of Maryland (1868–1888)." Natural History Illustration Collection, New York State Museum, New York State Education Department. http://www.nysm.nysed.gov/research-collections/collections/mary-bannings-fungi-maryland-1868-1888.

Shteir, Ann B. 1996. Cultivating Women, *Cultivating Science: Flora's Daughters and Botany in England, 1760 to 1860*. Baltimore, MD: Johns Hopkins University Press.

Smith, Nathan. 2020. "Minority Taxa, Marginalised Collections: A Focus on Fungi." *Journal of Natural Science Collections* 7: 49–58. https://www.natsca.org/sites/default/files/publications/JoNSC-Vol7-Smith_2020_0.pdf.

VOLUME
I

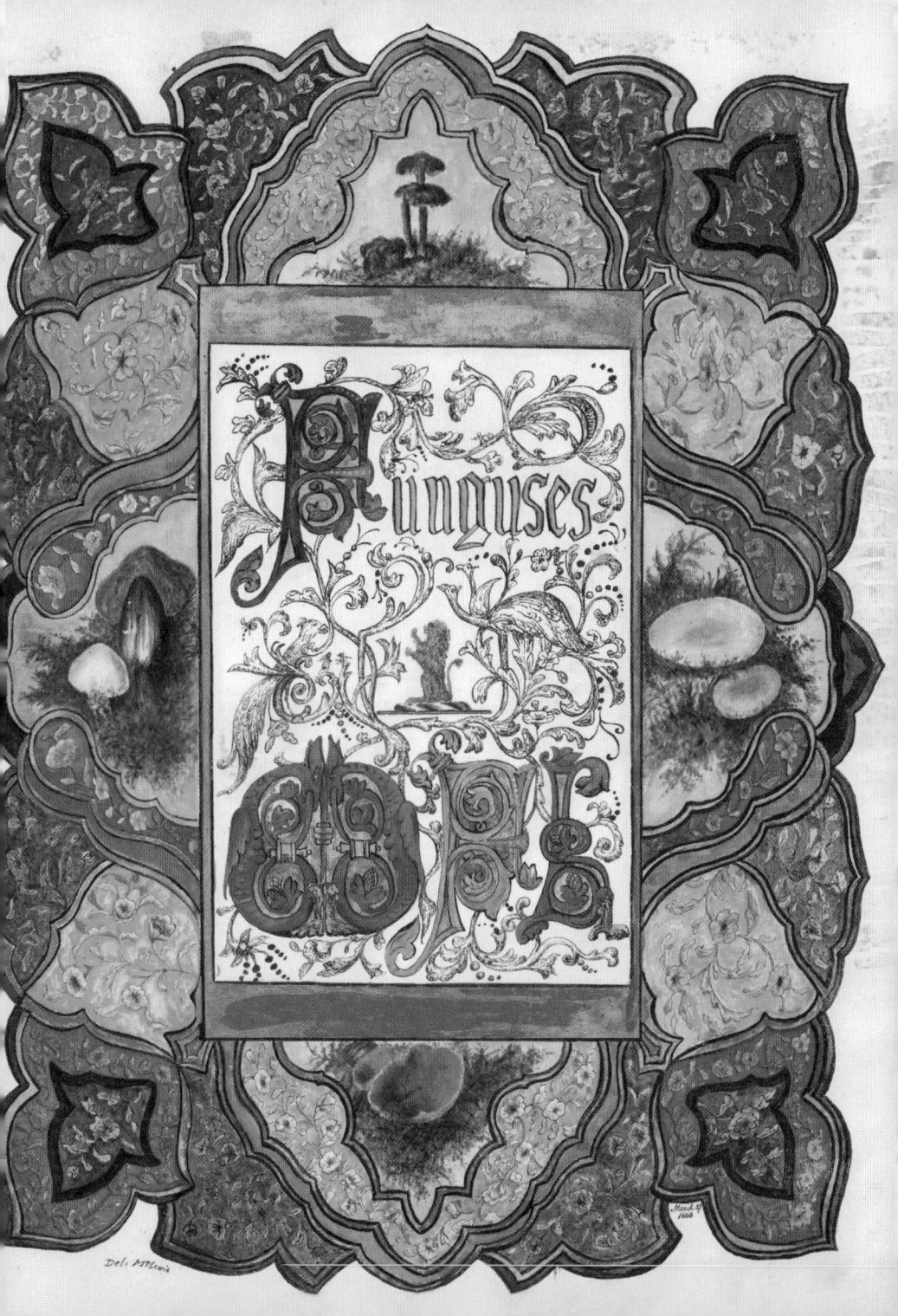

Funguses

Delt M⁵Lewis

March 9ᵗʰ
1866

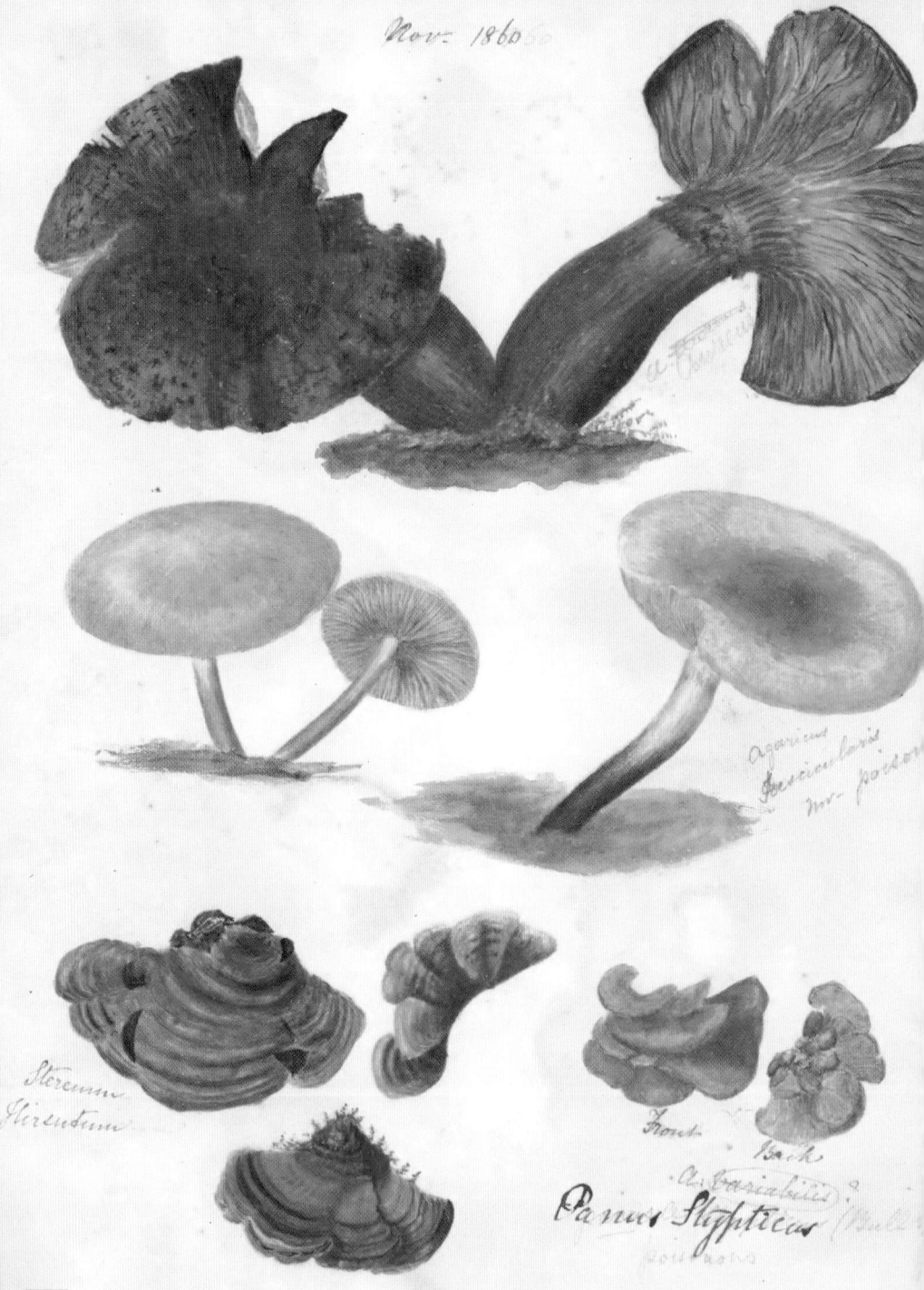

Nov: 1860

Agaricus fascicularis
nr. poison

Stereum
hirsutum

Front Back

A. variabilis ?
Panus Stypticus (Bull)
poisonous

14

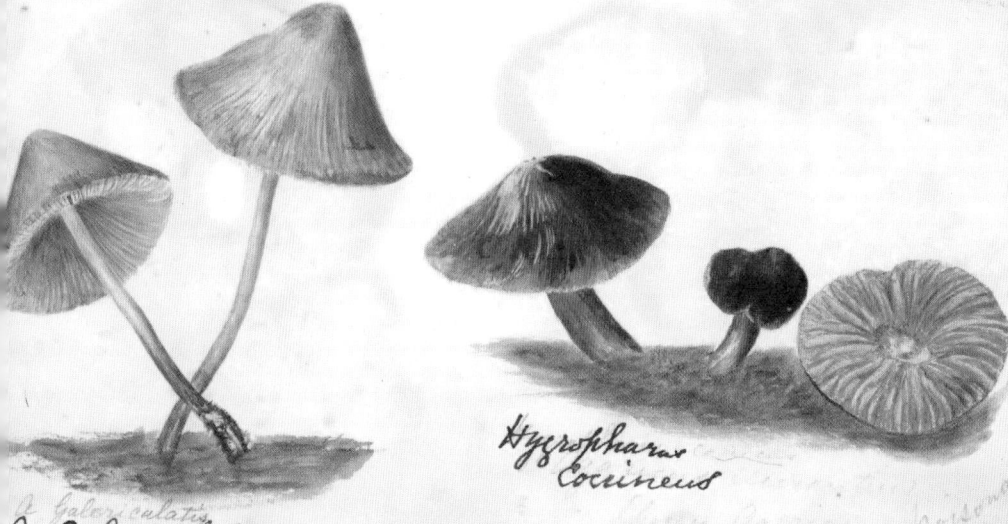

Oct 1860

a. Micaceus

A Peperatas

Pezize

A. humilis

Hygrophorus
Coccineus

A Galericulatus

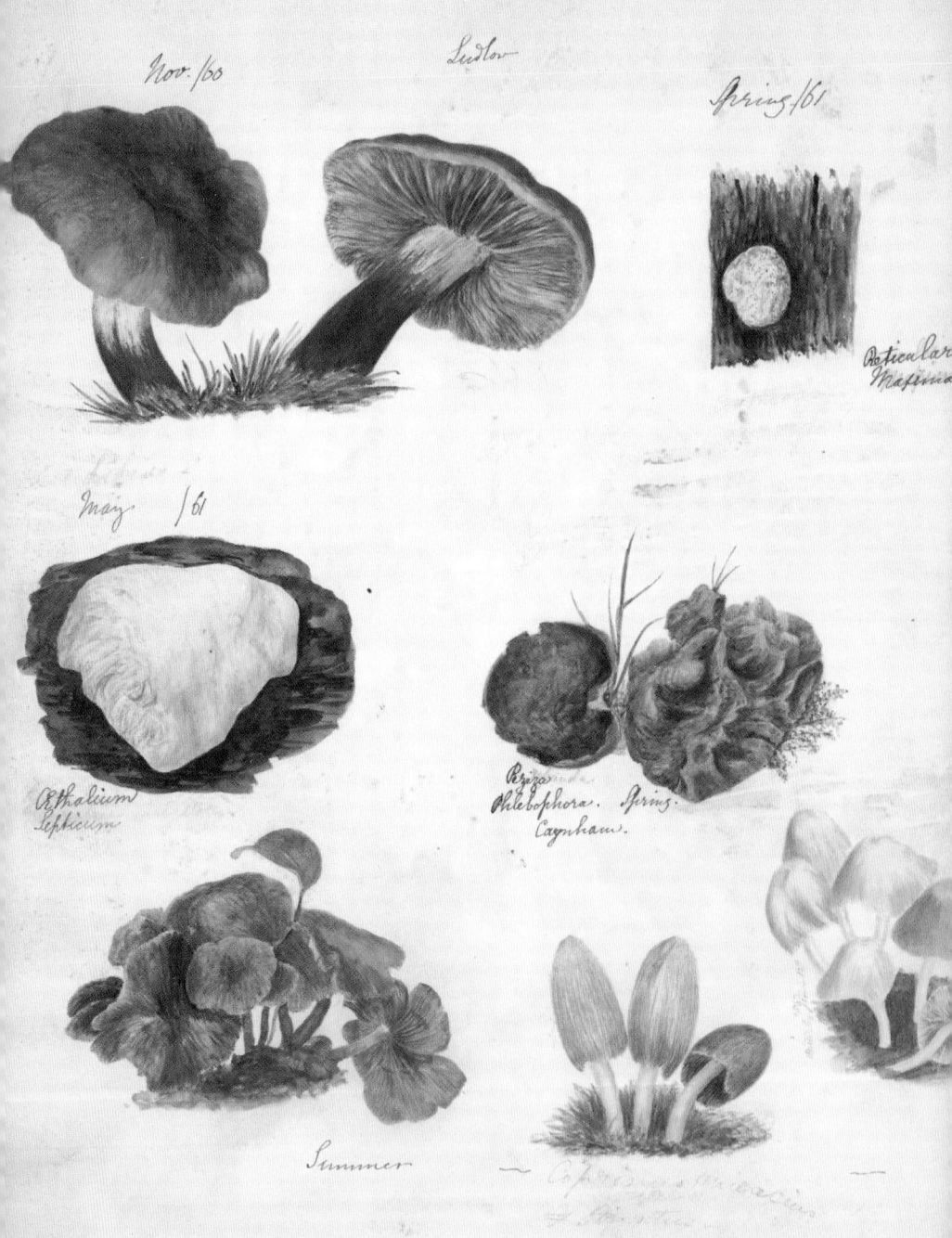

Nov. /60

Ludlow

Spring /61

Reticulare Maxima

May /61

Æthalium Septicum

Peziza Phlebophora. Spring. Caynham.

Summer

Coprinus micaceus Minstley

16

1861

arius
udus

Ludlow Wood

Odorus

Hygrophorus Virginius

1861

Hygrophorus Virginius

Conicus.

17

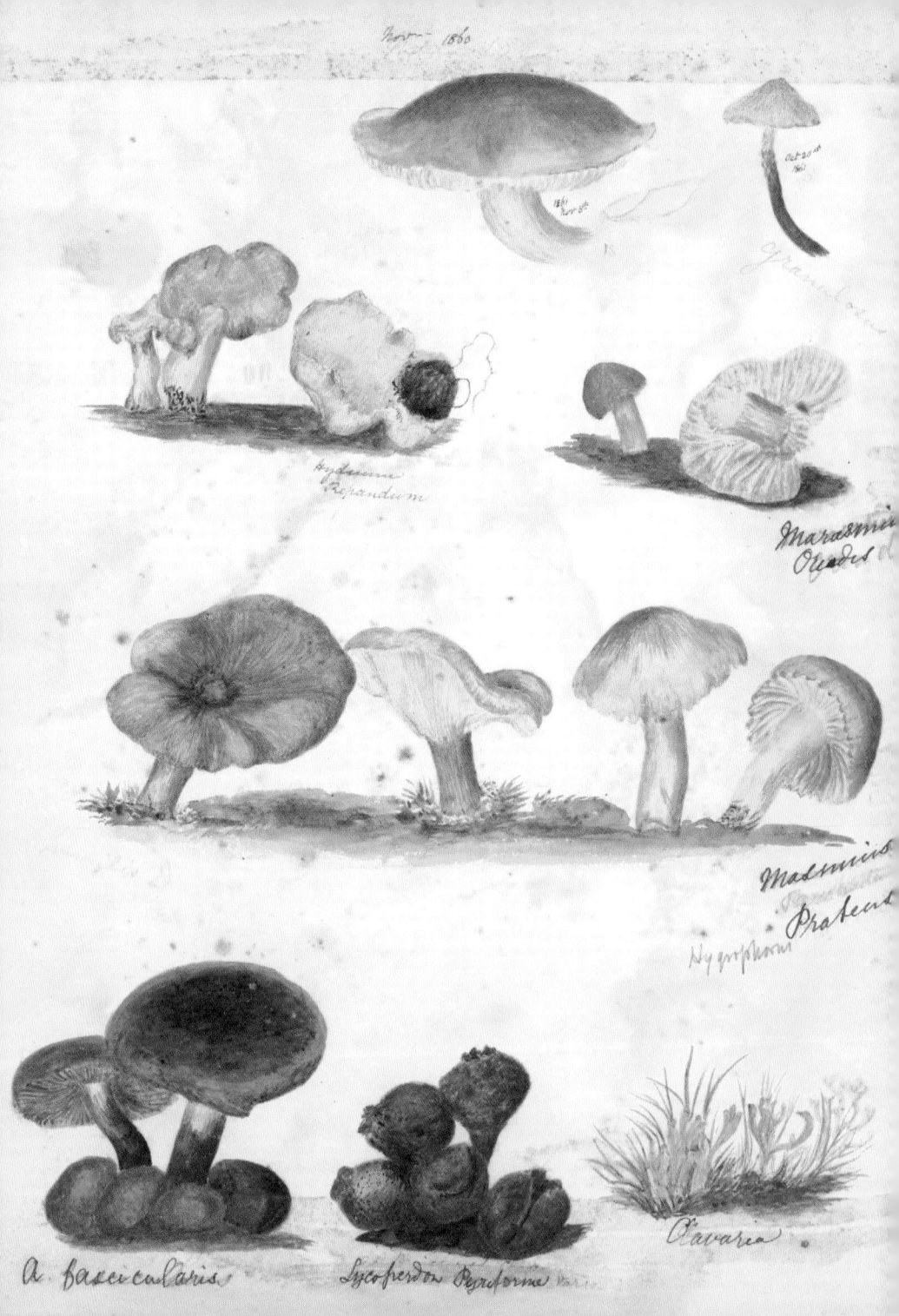

Novr 1860

Octr 10 1861

1861 Novr 4th

Grandoides

Hydnum Repandum

Marasmius Oreades

Marasmius Pratens

Hygrophorus

A. fascicularis

Lycoperdon Pyriforme

Clavaria

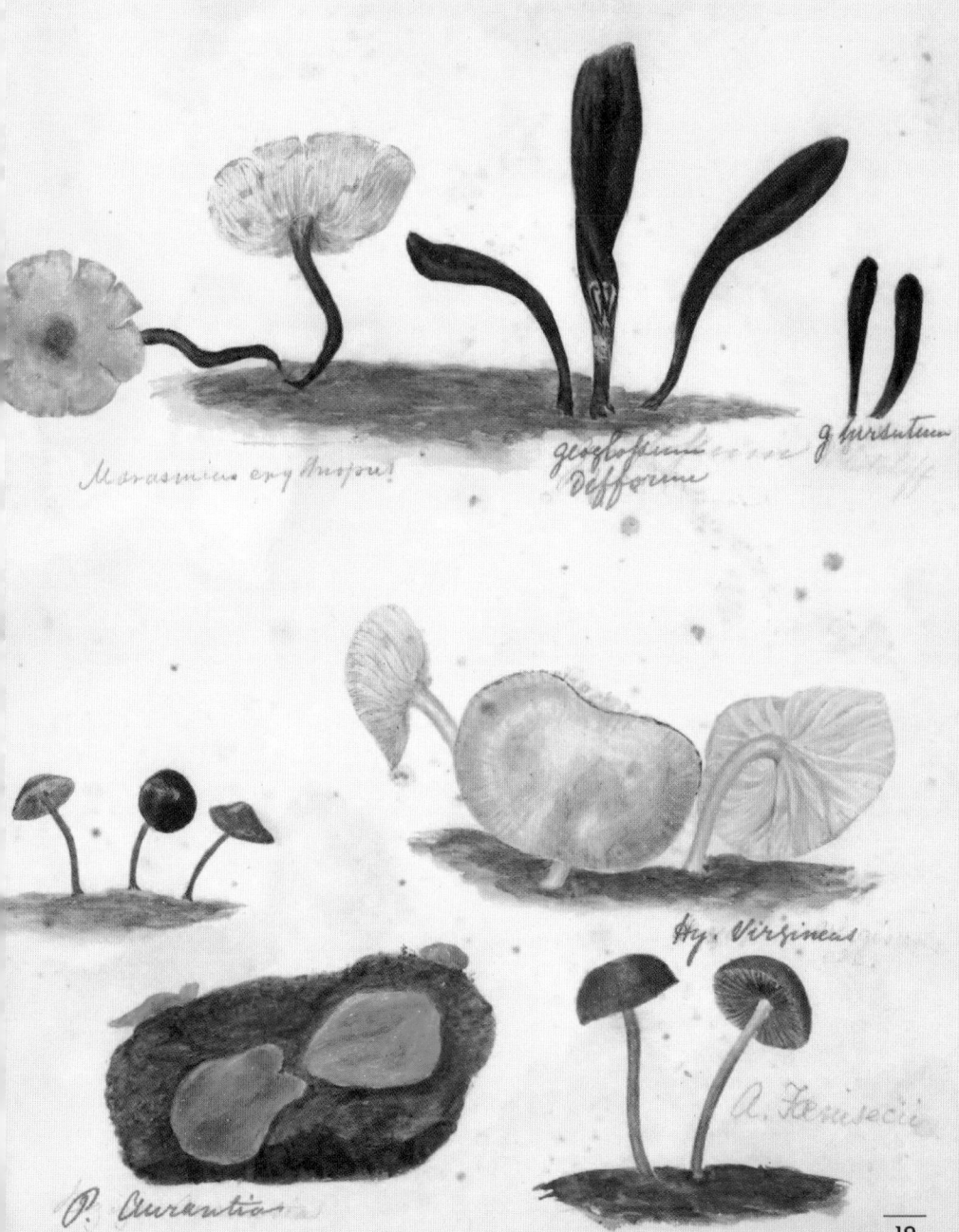

Lud Low 1860

Marasmius erythropus

geoglossum difforme

g. hirsutum

Hy. Virgineus

P. Aurantia

A. Fenisecii

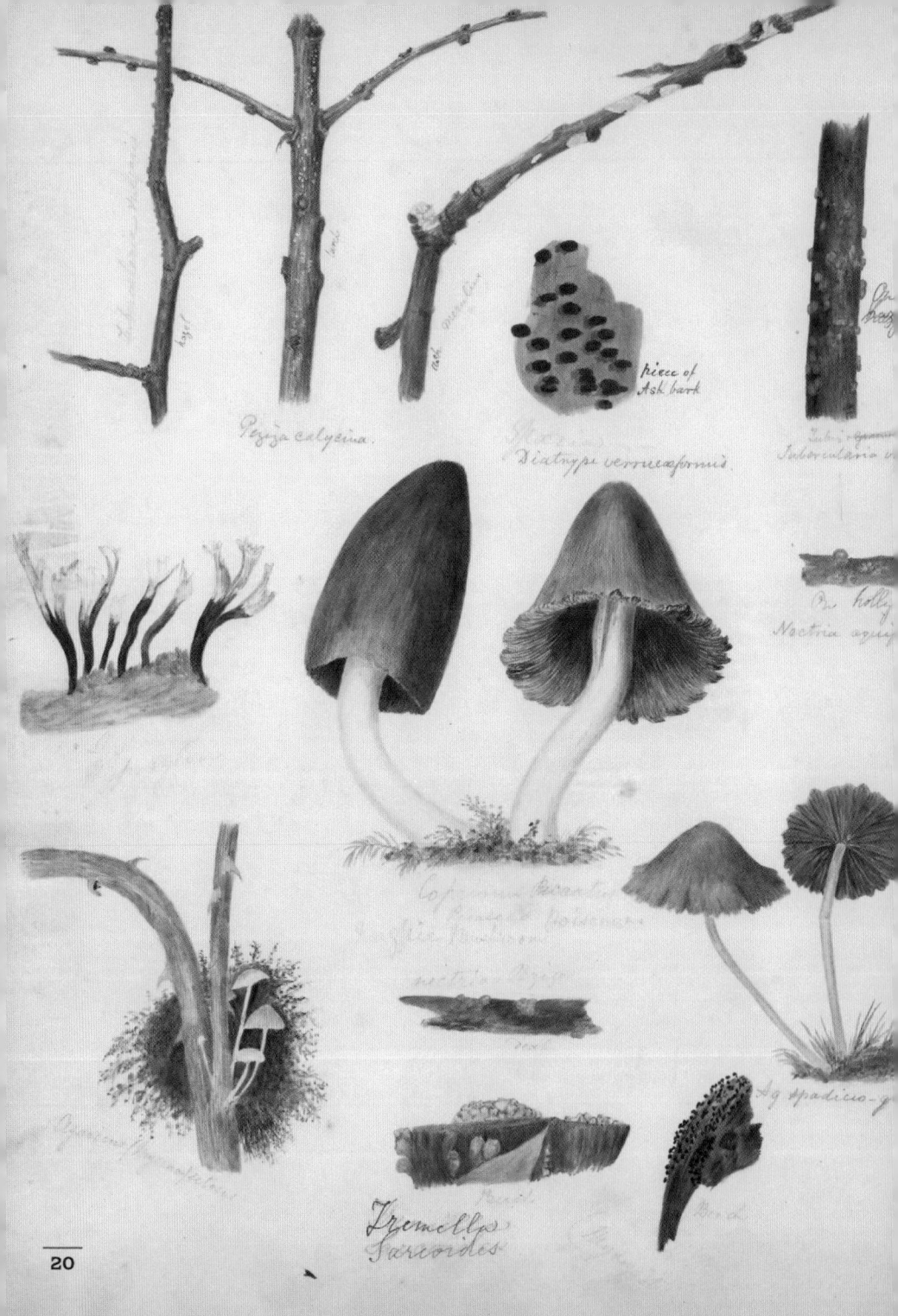

Peziza calycina.

piece of
Ash bark

Diatrype verruæformis.

Nectria

Coprinus

Tremella
Sarcoides

20

Agaricus Viridis Agaricus odorus.

Cordiceps Militaris

Clavaria

Hygrophorus
Ceraceus

A Hygrophilus

Scleroderma vulgaris

A Cackleus

A lacerus

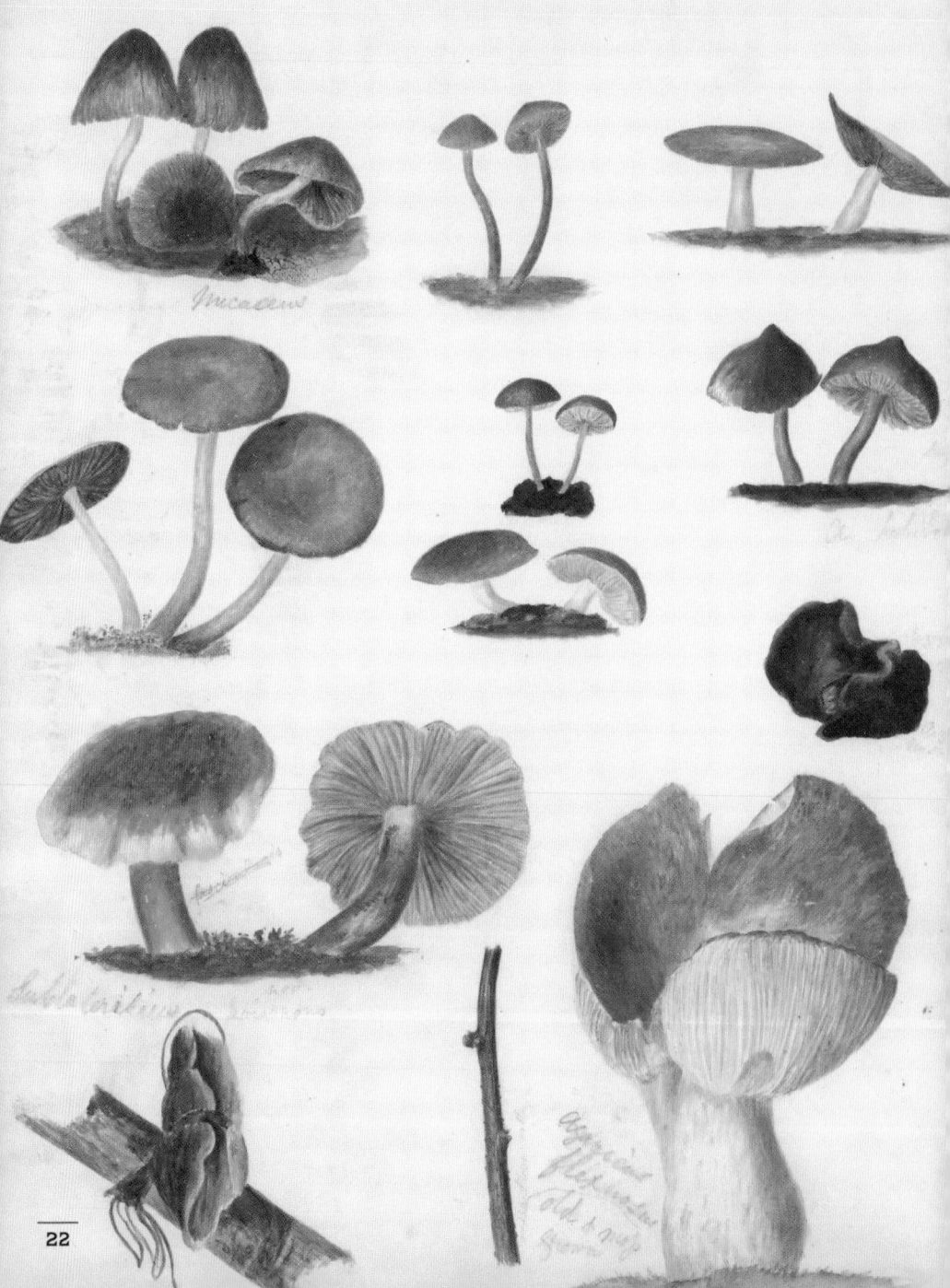

Glynfedr.
nr Crukhowell
All near Ludlow.
1860

7 of tubers

Ag: Lenticularis
Grammospodius

The largest
specimens of this was
10 inches across

Glynfedr

Jany 11th 1861. snow on the
ground.
Peziza coccinea

Peziza scutellina

23

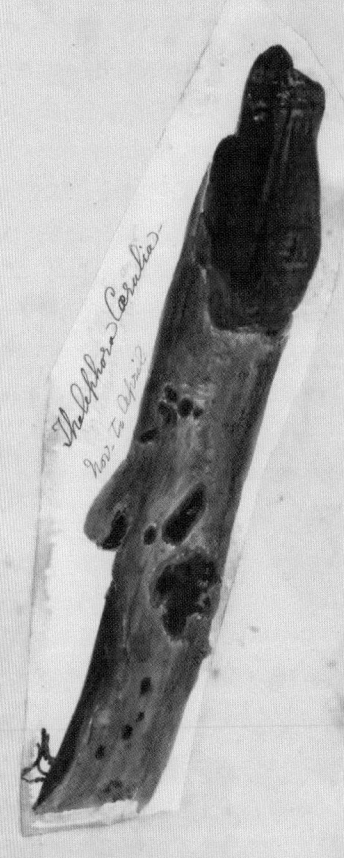

Thelephora Coralia
Nov. to April.

Marchantia polymorpha.

Peziza Tuberosa
April & May

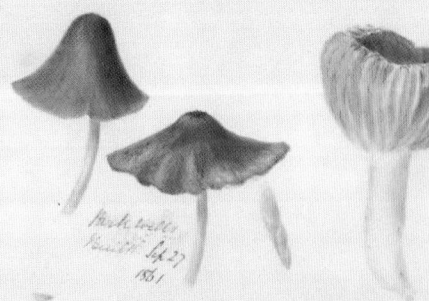

Bushwater
Bristth Sep 27
1861

Sept 27th
1861

Hygrophorus vinicus

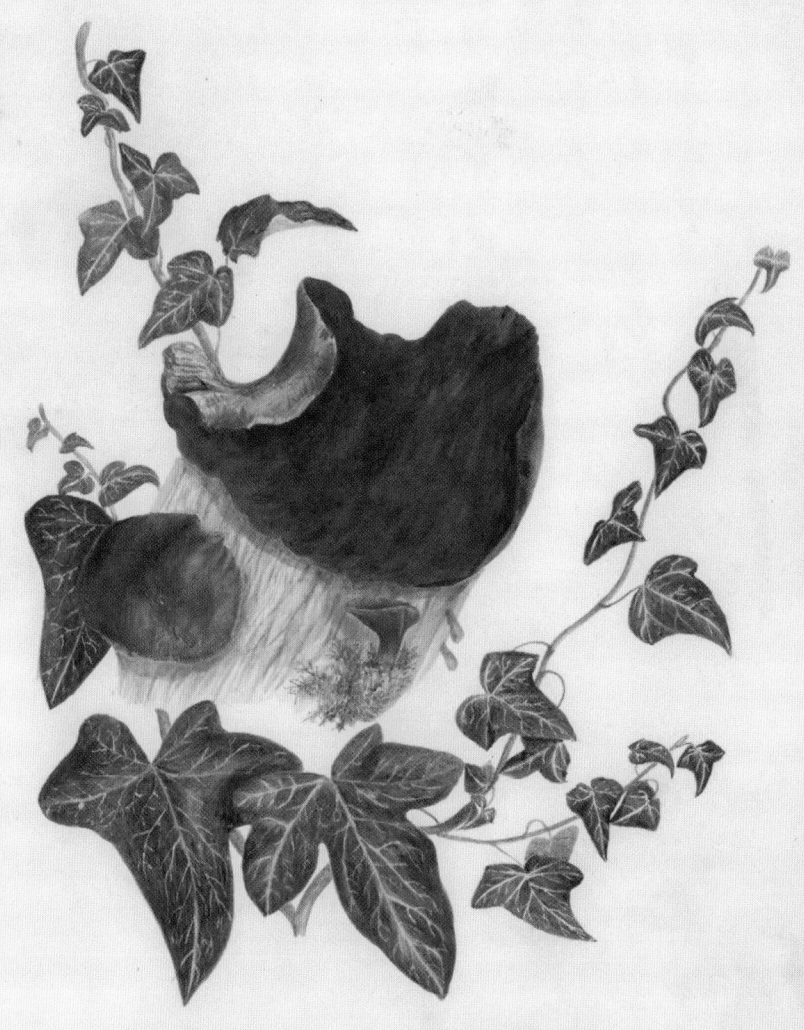

Hirneola Judæ Auricula

Jany 10th 1861
on an elder tree.

25

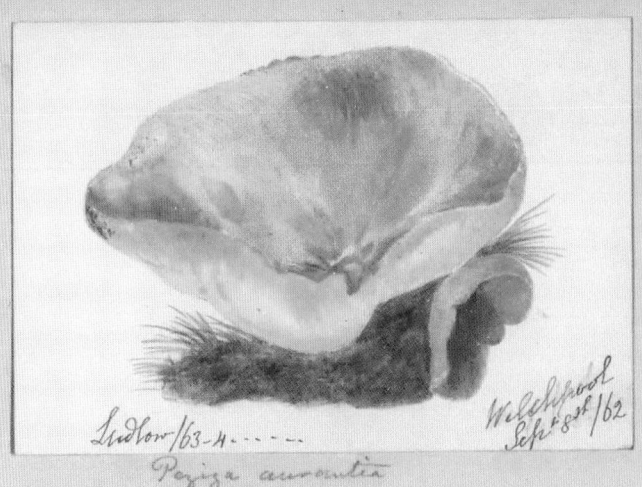

Ludlow /63-4.........

Welshpool
Sept 8th /62

Peziza aurantia

Maryknowle -/62 Sept to Nov-
on heaps of road
scrapings-

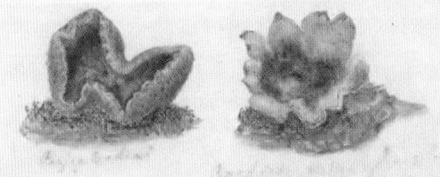

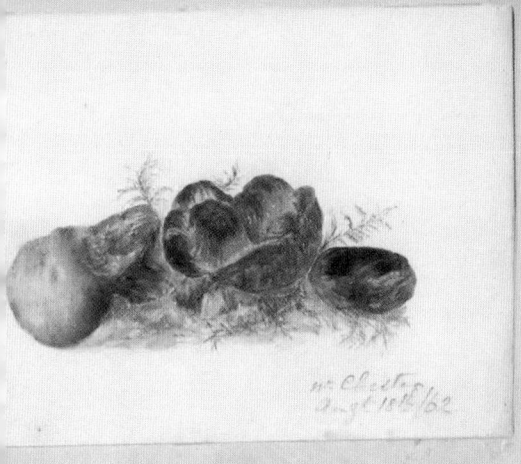

nr Chester
Augt 18th/62

Polyporus
Giganteus

Augt 5th 1861
Whitcliff Ludlow
also nr Builth

27

Russula-
depalens. Aug. 168

Cantharellus
Umbronatus
rare.

Aug. 13
Builth

Sept. 16th
Cladonia pyxidata.
a lichen.

Ludlow
April. Peziza
(Discina Repan
Peziza repanda.

Cladonia

A. Pratensis,
var. Ag of Agaricus Campestris

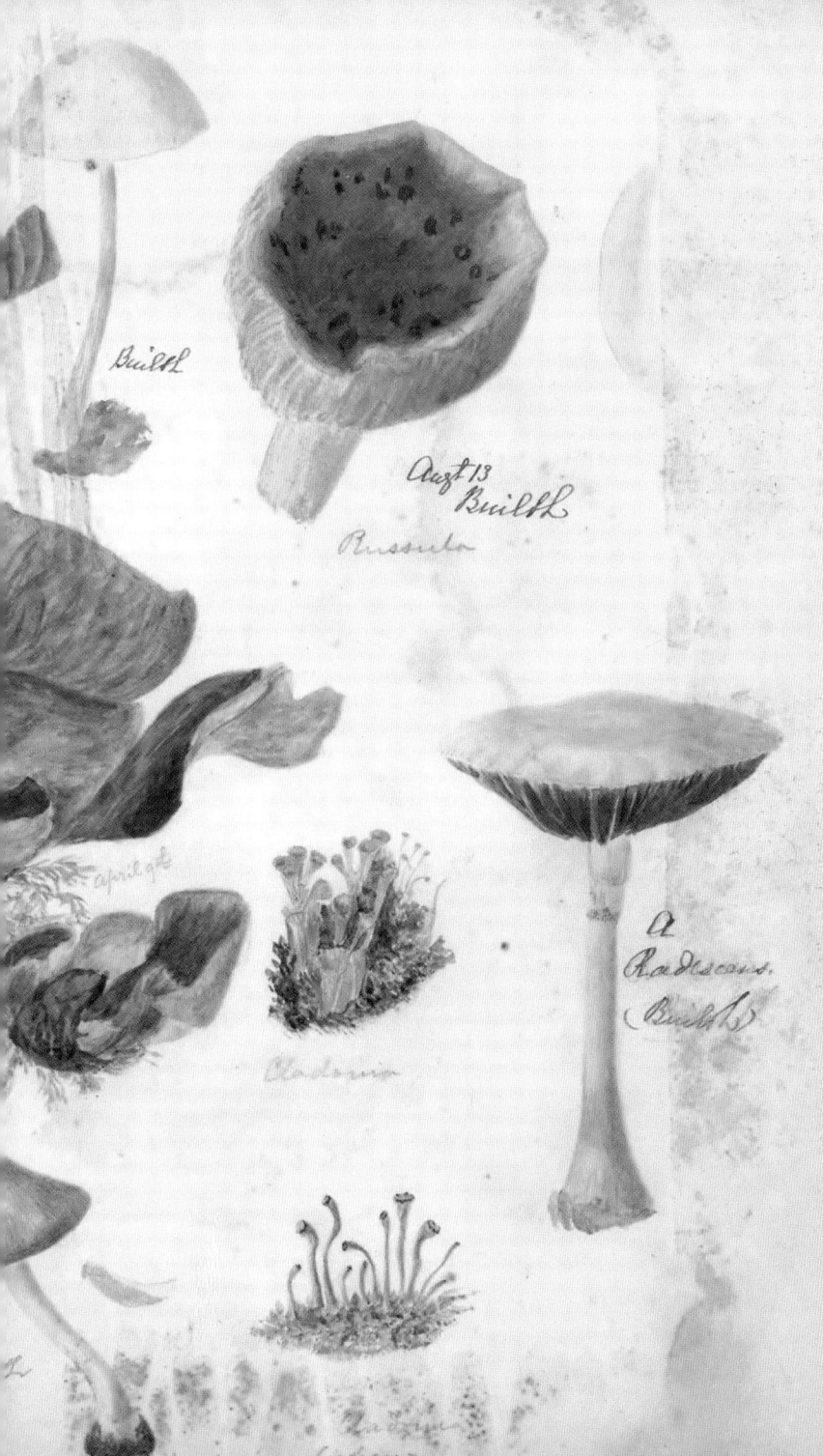

Builth

Aug 13
Builth

Russula

April 9th

Cladonia

a
Radiscans.
(Builth)

Ludlow
1862

a
Cepaestipes
(on tanbed
in hot house)

July 22

Russula. July 22

Cladonia

Boletus
Subtomentosus

Boletus Variegatus
variegatus
July 22

a
Cristata

July 22

a Liberianus Aug 15th

Agaricus tener.

30

1861 & 62

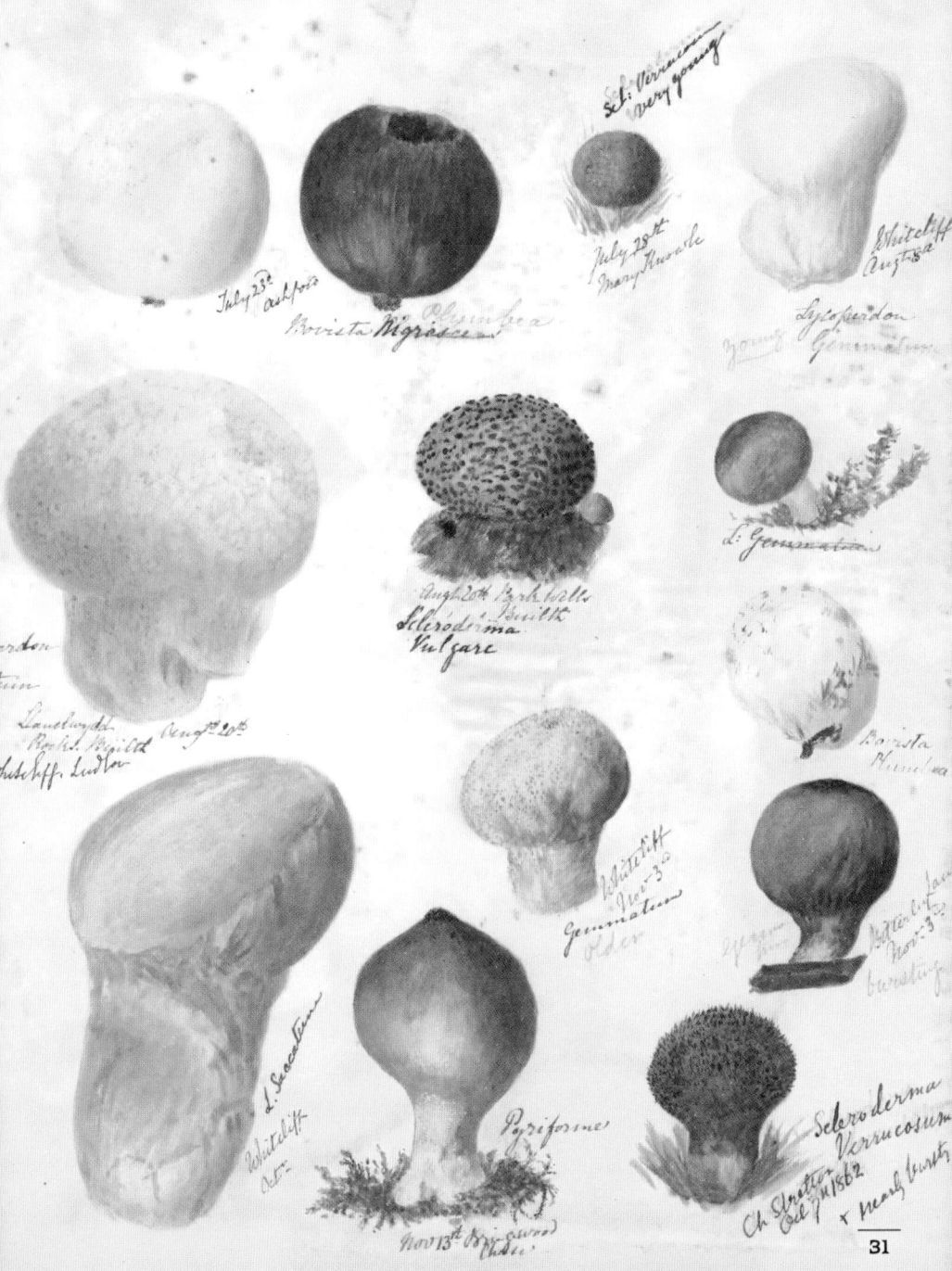

Scl: Verrucosum
very young

July 23d ashpois

Bovista Nigrescea Plumbea

July 28th
Maryknoale

Whitcliff
Augt 8a

Young Lycoperdon
Gemmatum

Augt 20th Park Wells
Builth
Scleroderma
Vulgare

L: Gemmatum

Gandwydd
Rephi Myillth Augt 20th
Whitcliff Ludlow

Bovista
Plumbea

Whitcliff
Nov 30
Gemmatum
Older

gemm
Watterdefaw
Nov 30
bursting

L Saccatum
Whitcliff
Oct

Pyriforme

Scleroderma
Verrucosum
Ch Stretton
Oct 7th 1862
x nearly burst

Nov 13th Bringewood
Chase

31

Helotium Citrina
Peziza cyathoides.

Peziza corea.
April 25th
From a tan bed in
Mr Hoffae's garden

Geaster Mammosus
May 1st 1866 Oribury

H. Pustxxx
Mary Knowl
Whytelef
July 8

A. Campanulatus
May 23rd

P. Pulxxxx
May 23

May 28th

P. Squamosus

1861

Buttington

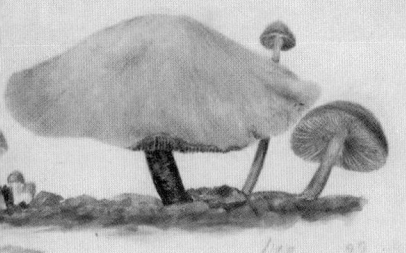

A Conopilus June 22

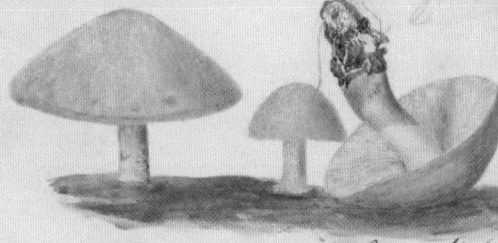

June 20th 1861

...togoneum
...tiacum June 26th

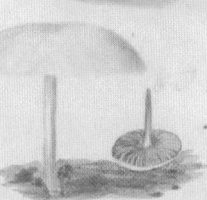

June 26th

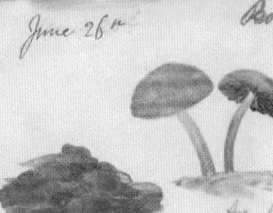

Bolitus Elegans

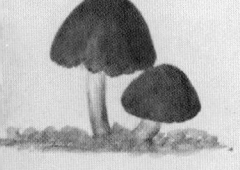

Buttington

Buttington

On cow dung
July 26
Peziza stercorea.

July 26

Ag foenisecii

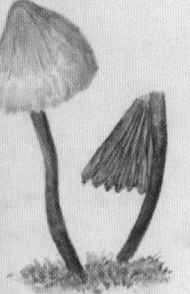

July 29

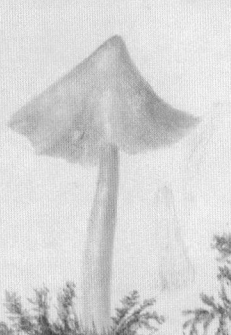

Hy Ceraceus
Meadow Ring

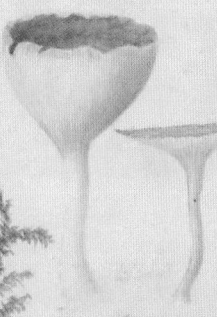

Agaricus July 29 Whitecliff
Infundibuliformis

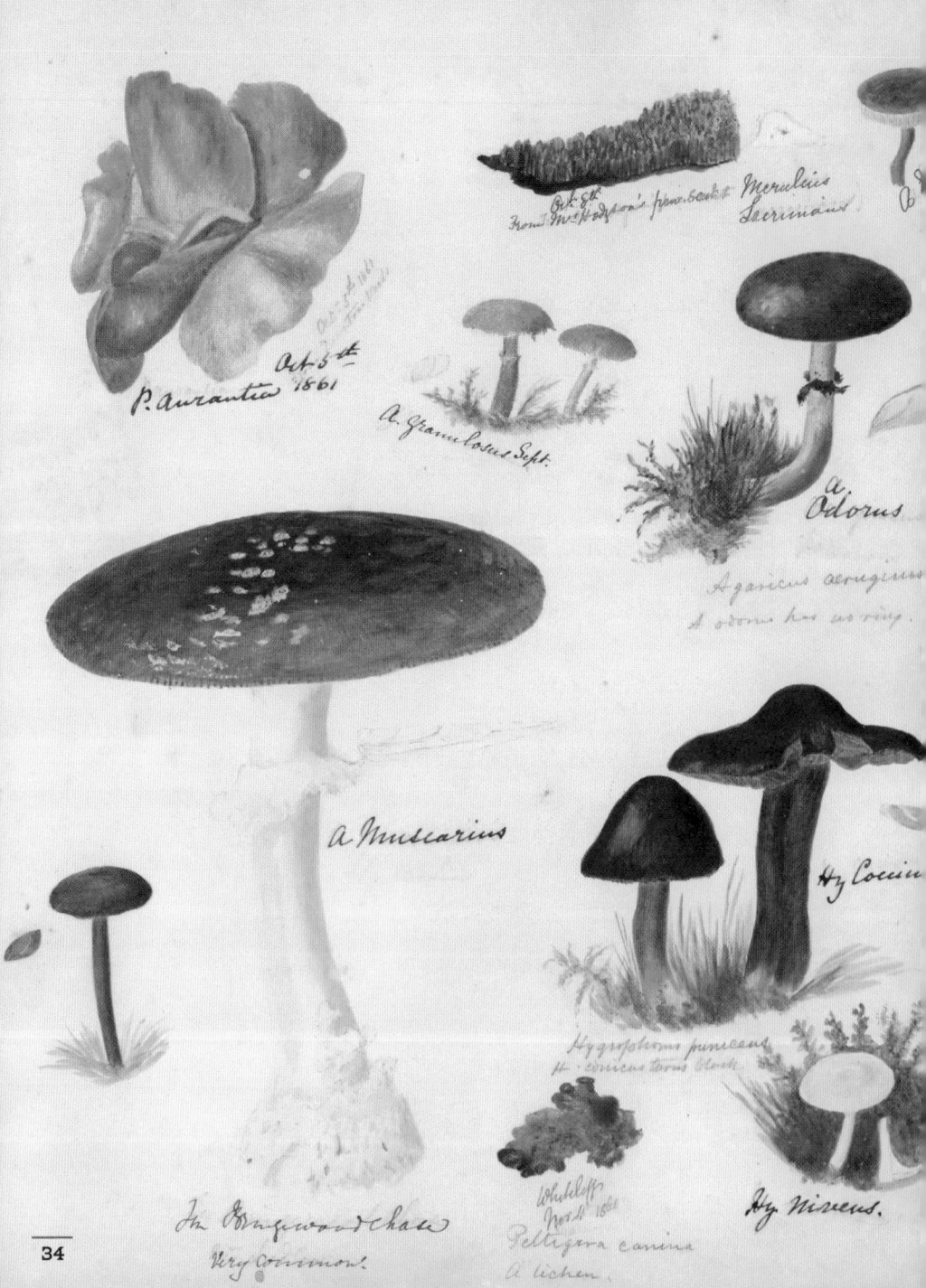

P. Aurantia
Oct 5th 1861

A. Granulosus Sept.

Oct 5th
From Mr Hodgson's pew seat.
Merulius
Lacrimans

A. Odorus
Agaricus aeruginus
A odorus has no ring.

A Muscarius

Hy Coccin

In Ringwood Chase
Very common.

Whiteliff
Nov 5th 1861
Peltigera canina
A lichen.

Hygrophorus puniceus
H. coniceus turns black

Hy Nivens.

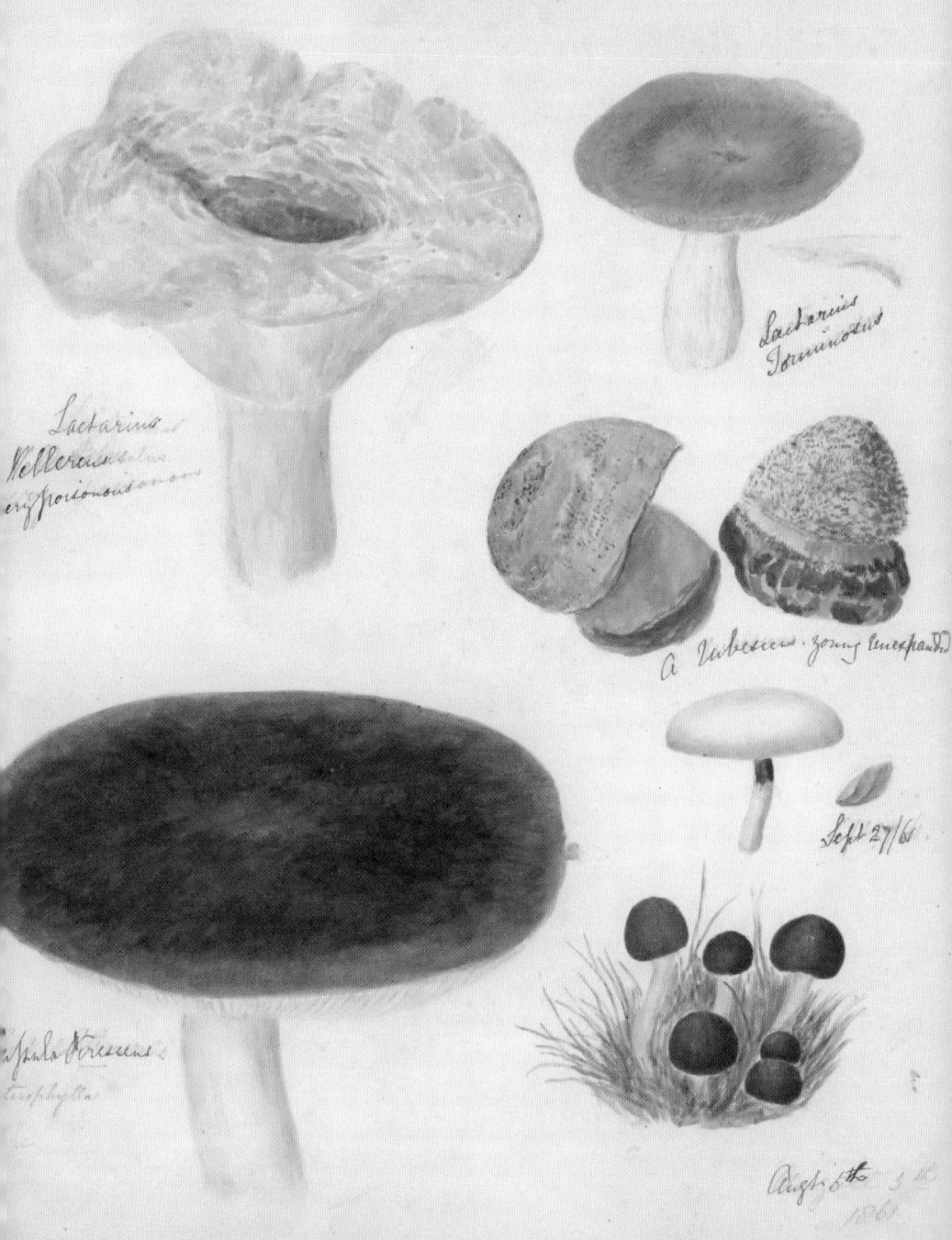

1861

Lactarius Vellereus eryptoroneurinoxii[?]

Lactarius Torminosus

A. rubescens. young unexpanded.

Sept. 27/61

Agaricus Georgenes terophylla

Augt 6th[?] 1861

1861

Polyporus hispidus
Owen Apple Tree July 3/61

Polyporus dryadeus
P. hispidus does not exude drops of
moisture

Cordiceps
Capitata

Coti Chioneurus

Ludlow
Augt 7th

Balch 15th Augt

Cantharellus
Cibarius

Boletus luridus Augt
poisonous
Bitter

Cortinarius Turbinatus
Augt 8th 56

Sep 25
1861

Whitcliff
Oct 9th 1861

Clavaria fusiform

P macropus.
Pego cupulais

A squarrosus

...fum Olivaceum

Cerancides Oct 9

Riparia Hypoxylon
Oct 15th

Inequalis

Cf.co formis

Oct 19

Cl:
Coralloides Oct 18

Coprinus?
fimetarius

...matus

A Nidorosus
Oct 19th /61

P
Alligatus Oct 14/61

Oct 18 Betterby

Oct 19

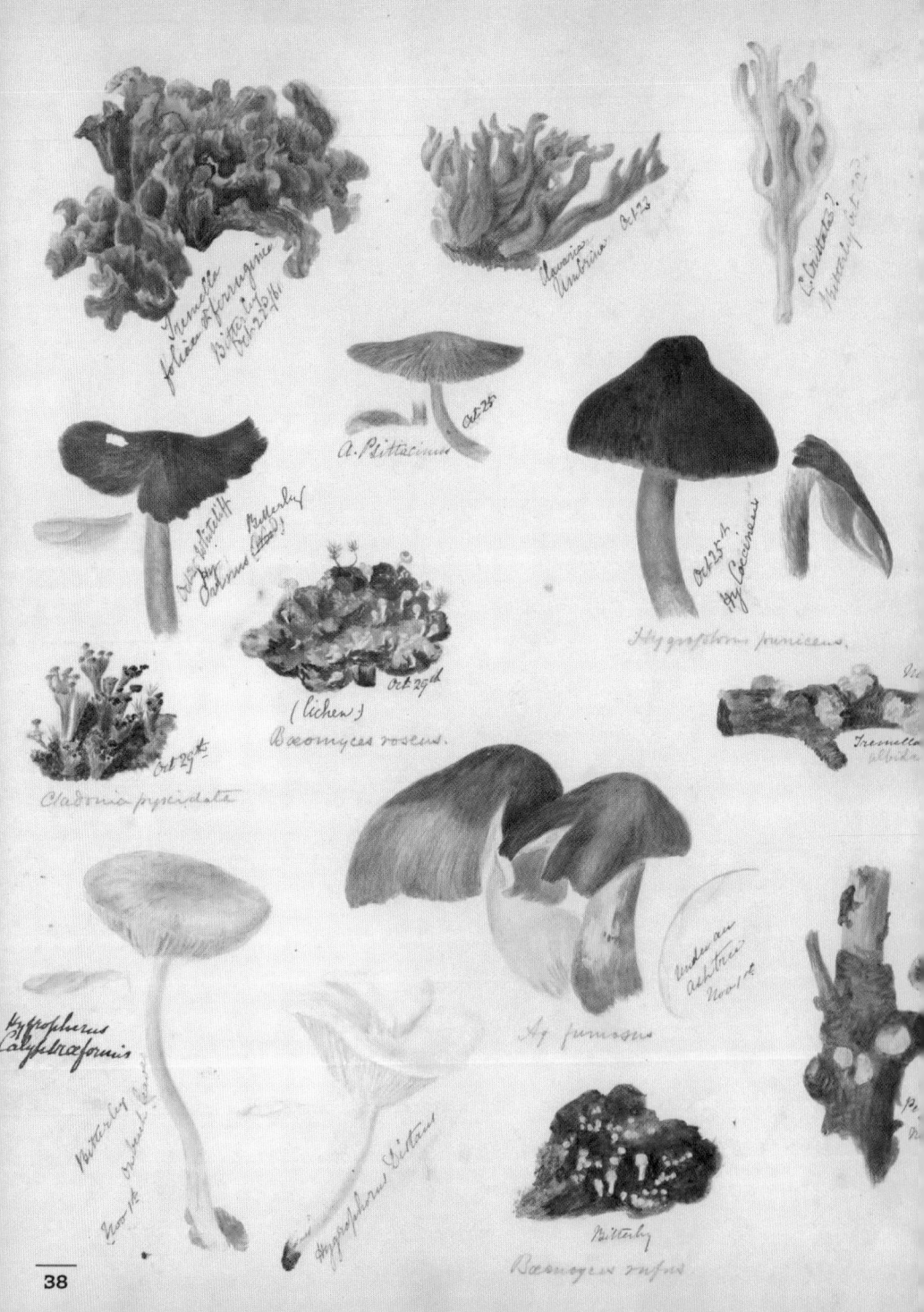

Tremella
foliacea & ferruginea
Bitter... Oct 21/61

Clavaria
Umbrina Oct 23

L. cristata?
Nursery Oct 23

A. Psittacinus Oct 25

Oct 25th
Ag Coccineus

Hygrophorus puniceus.

(lichen)
Bæomyces roseus. Oct 29th

Cladonia pyxidata Oct 29th

Tremella
albida

Hygrophorus
Calyptræformis

Ag fumosus

Hygrophorus Distans

Bæomyces rufus

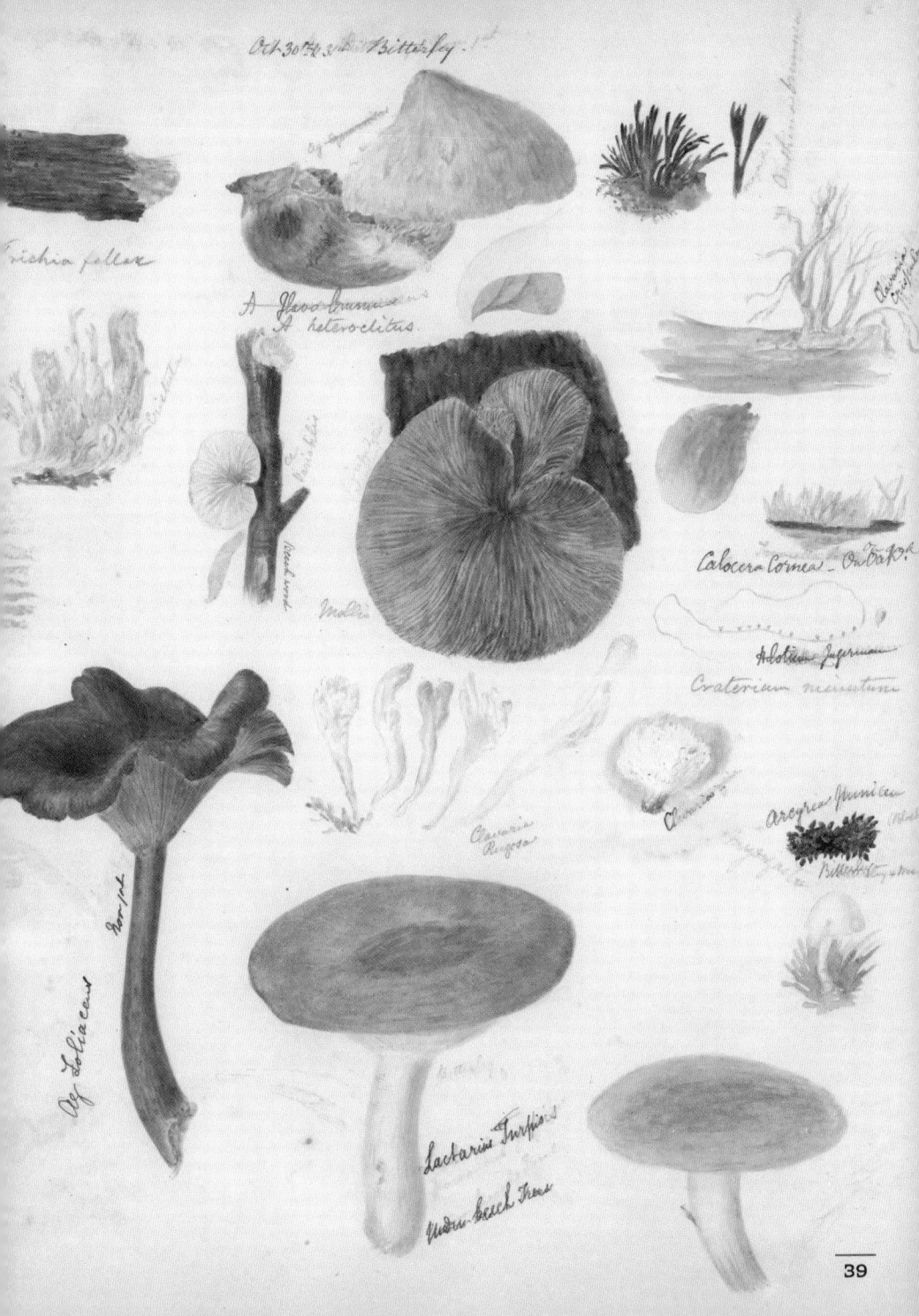

Oct 30 & 31. Bitterly.

Trichia fallax

A. flavo-brunnea
A. heteroclitus.

Calocera Cornea - On Oak

Craterium minutum

Clavaria
Rugosa

Arcyrea fusca

Ag Foliaceus

Lactarius Turpis
under Beech trees

39

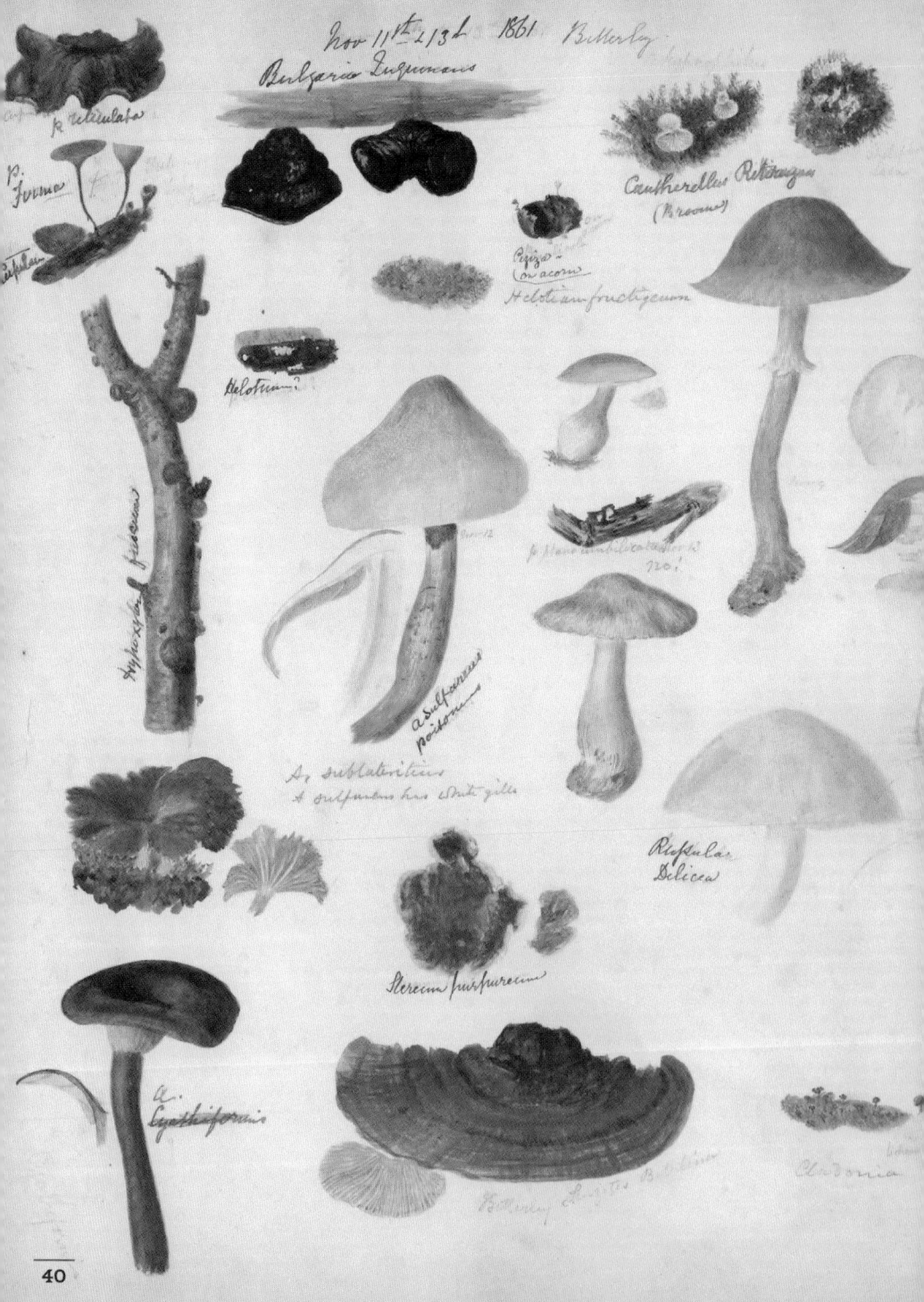

Nov 11th & 13th 1861 Butterley

Bulgaria Inquinans

P. reticulata

P.
Forma

Cutpulum

Cantherellus Retirugus
(Brown)

Pezie
on acorn
Helotium fructigenum

Helotium ?

Hypoxylon fuscum

A. sublateritius
A. sulfureus has white gills

a sulfureous
poisonous

Russula
Delicea

Stereum purpureum

A.
Cyathiformis

Butterley Daedgetes Betulina

Cladonia

40

1861
Bitterley Novr 1st & 2nd

Under horse chesnut

Agaricus ? glcaucocephalus ? Junior

Helvella Crispa

Under Beech Tree

Tomarius

Cortinarius

Cortinarius radicata

Cortinarius cinnamomeus

Conlry lane Novr 9th

On Beech leaves

[illegible]

amethystina

Bitterley Ludlow &c

Bringwood chase
Pezza humana

On oak tree
A galericulatus

On beech leaves

Nov 6th

Whitcliff. Under fir trees

Novr 6th

Novr 6th

41

Ludlow Woods.

Cyathus Striatus

St. Mollis

P. Cupularis

Helvella Lacuno
Nov 19

Russula Rosacea

P. Brumalea

Polyporus fumosus.

Cantharellus Infundibuliform

Bulgaria

Hydnum Farenaceum
Nov 23

A. Epipterygius

Leotia Lubrica
Nov 20

Tear like Lacrymans Bitterly Nov 20.

P. Nidulans

Underside
Nov 20 Bitterly

42

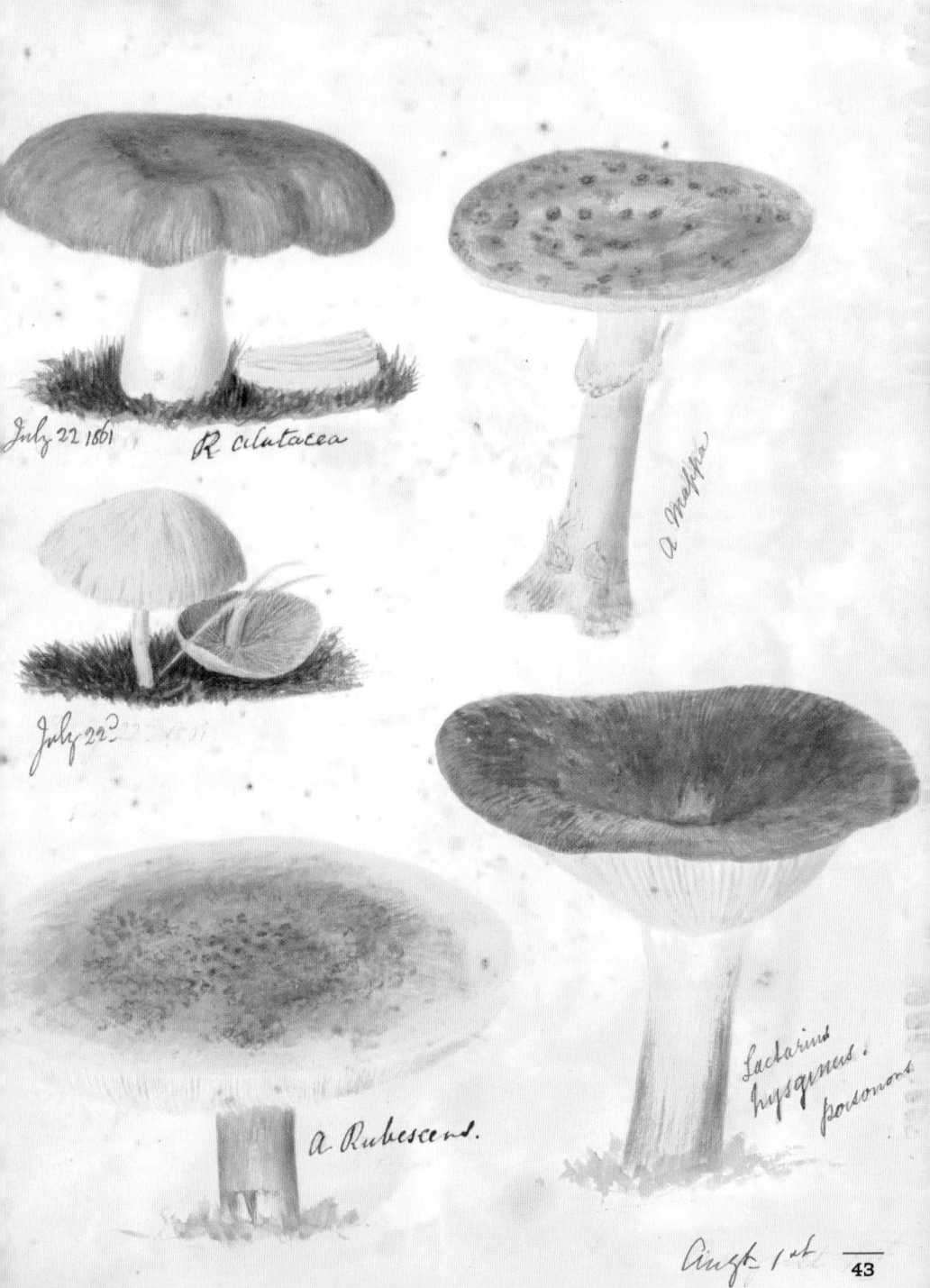

July 22 1661 R cilutacea

a mappa

July 22ª

a Rubescens.

Lactarius
hysginus:
poisonous

Augt 1st

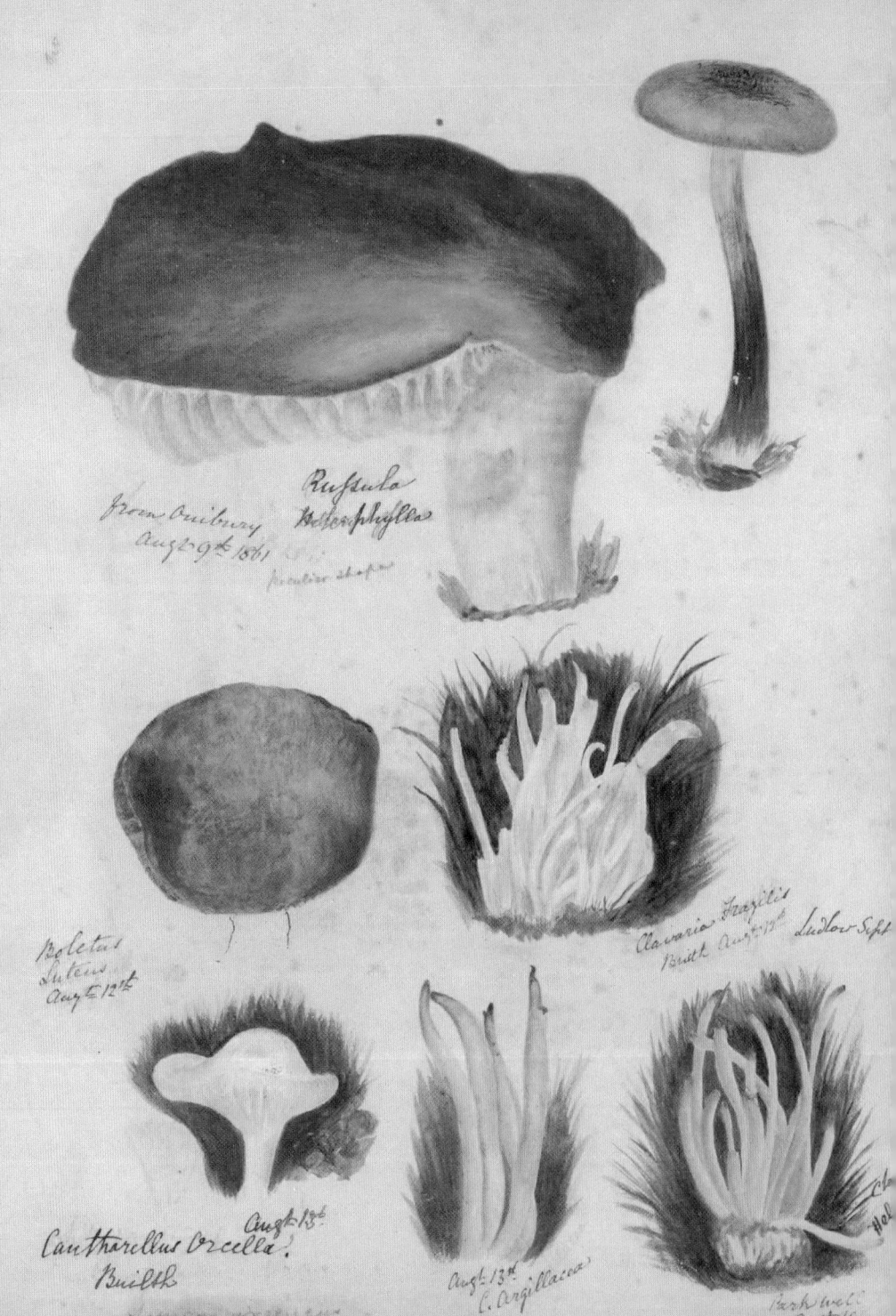

*Russula
Heterophylla*

From Bubury
Aug 9th 1861

Peculiar shape

*Boletus
Luteus*
Aug 12th

Clavaria Fragilis
Builth Aug 13th Ludlow Sept

Cantharellus Orcella?
Builth Aug 13th

Agaricus virgineus

Aug 13th
C. Argillacea

Park well
Aug 18

Boletus.

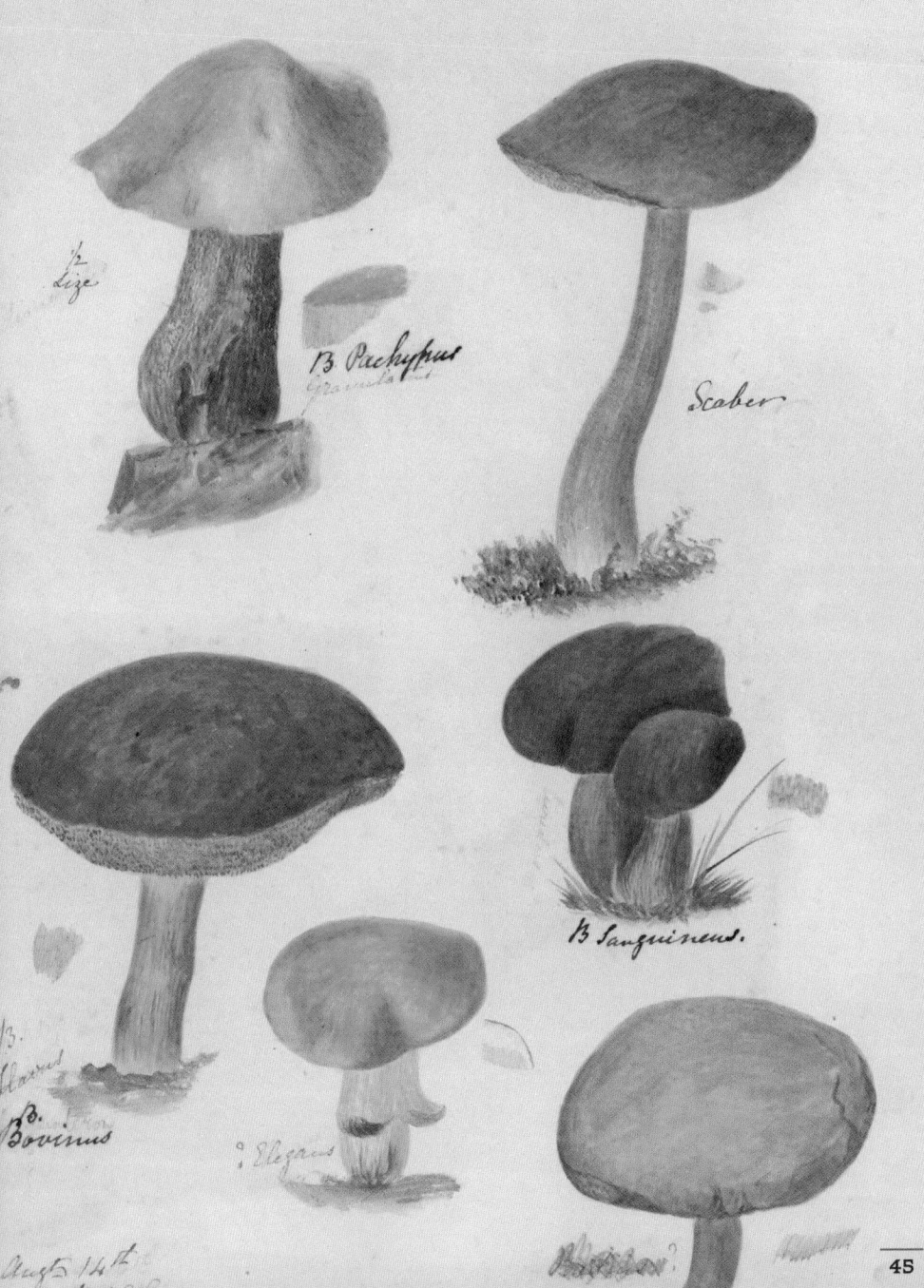

½
Size

B. Pachypus
(granulatus)

Scaber

B.
Flavus

B.
Bovinus

Elegans

B. Sanguineus.

Aug 14th
1861 Builth

45

A Phalloides
Aug^t 17 1861 Poisonous
Glamorgan.
 1867 Ludlow

Lactarius chrysorrheus
Aug 17
Glanell

Russula nigricans ?

A Braunatricle

inferorum Aug 20

Sep

Park wille
Aug 19

Ludlow
167
Agaricus
radicatus

Agaricus Cahillerii
Marasmius
rotula.

park wille
Aug 20

A Asper
Park wille
Aug 19
Ludlow
168

Hebeloma
Dulcamora ?

Cantharellus Orcellvid

Sept 2

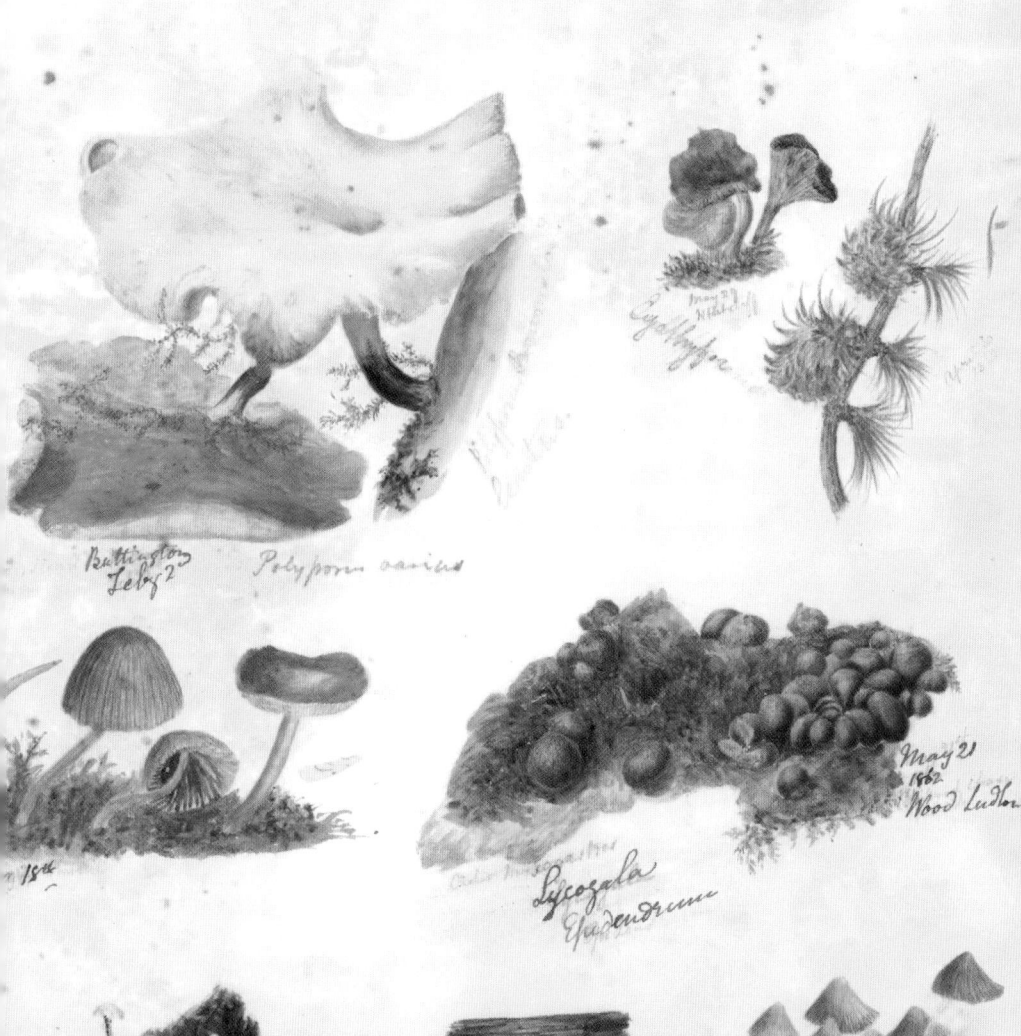

1862

Battington
Feby 2

Polyporus ovinus

May 21
1862
Wood Ludlow

Lycogala
Epidendrum

A Stylobates?
May 21/62

1862

47

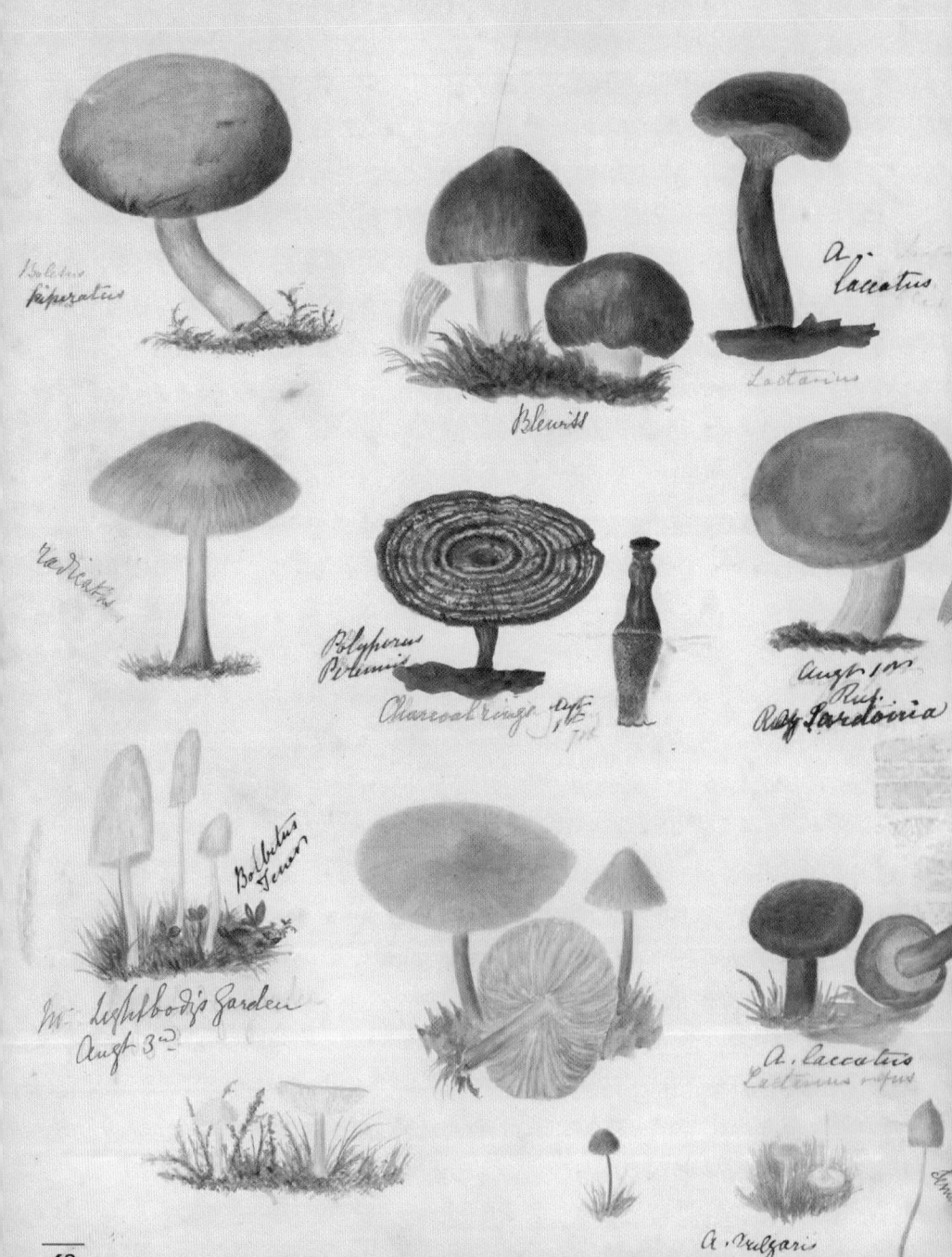

Boletus
Paspeatus

Blewitt

A.
laccatus

Lactarius

Radicatus

Polyporus
Perennis

Charcoal rings

Aug. 1st
Ruf.
Ray Sardonia

Bolbitus
Tenex

Mr Lightbody's Garden
Aug. 3rd

A. laccatus
Lactarius rufus

A. vulgaris

Hy semi

48

Boletus
1861

Built
Sept 3 *Larianus*
Chrysenteron
Ludlow/67

Scaber

Built
Sept 7

Chrysenteron

Sept 12
Archippus
Glandyge
Castaneus
– rare

B *laricinus?*

Whitcliff Oct
1871

Chrysenteron

Butterfly Larnph

Subpoletus

B. *striaepes?* Bringwood
Nov 81

Scaber
Yellow gray
variety

49

Boletus 1862

(Abbotsfield)
Augt 23

Sept 20

Sept 20
Bovinus
Ludlow

Subtomentosus
Ludlow

Dacrymyces
deliquescens

Versif

Sept 20
Edulis
B edulis has no ring
it is B luteus.

Stiopes —

50

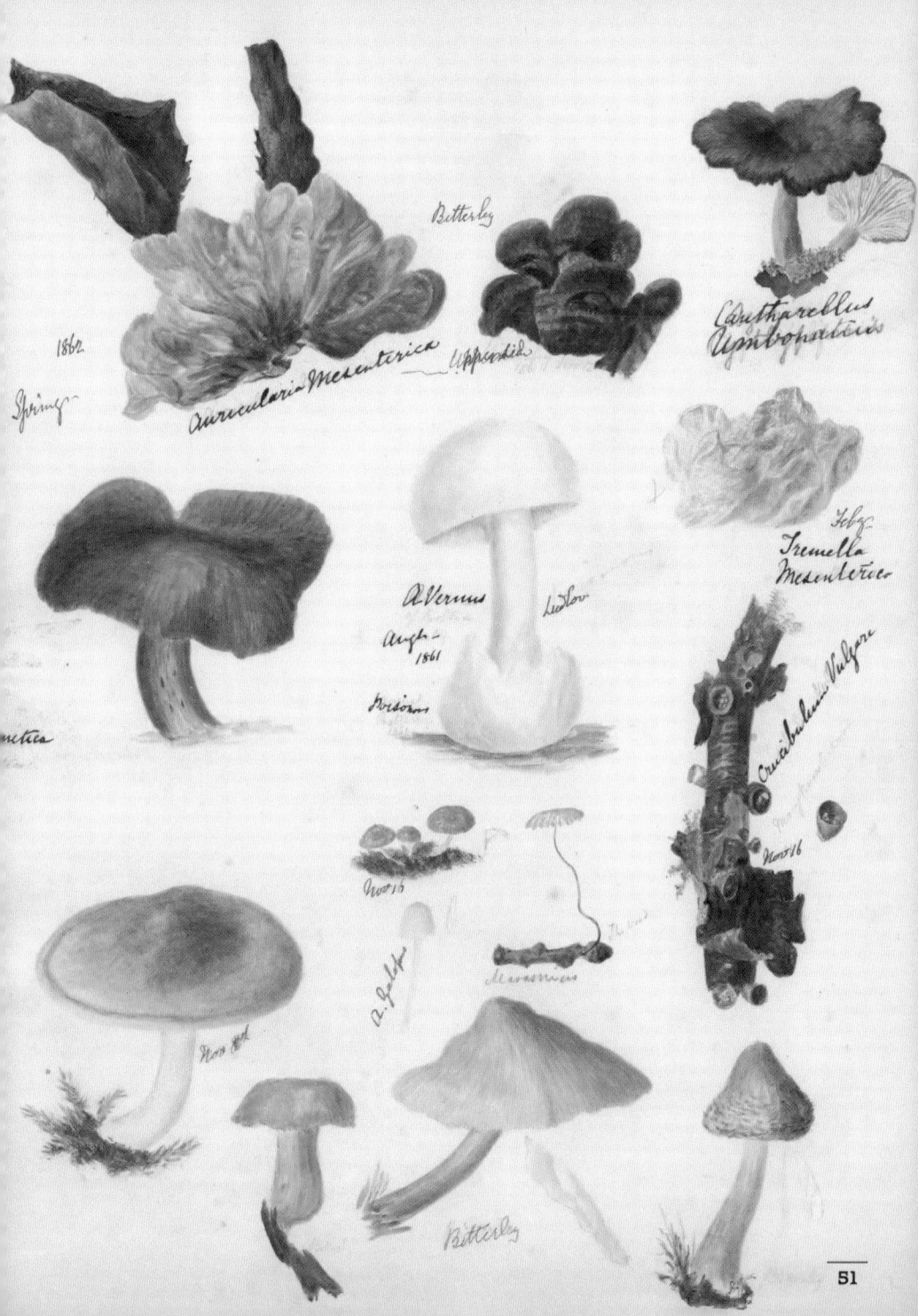

Bitterley

1862
Spring

Auricularia Mesenterica Upperold

Cantharellus Umbropallidis

Febz
Tremella Mesentericos

A Vernus Ludlow
Augt 1861

Crucibulum Vulgare

Nov 16

Nov 16

A Galtps

Marasmius

Nov 4

Bitterley

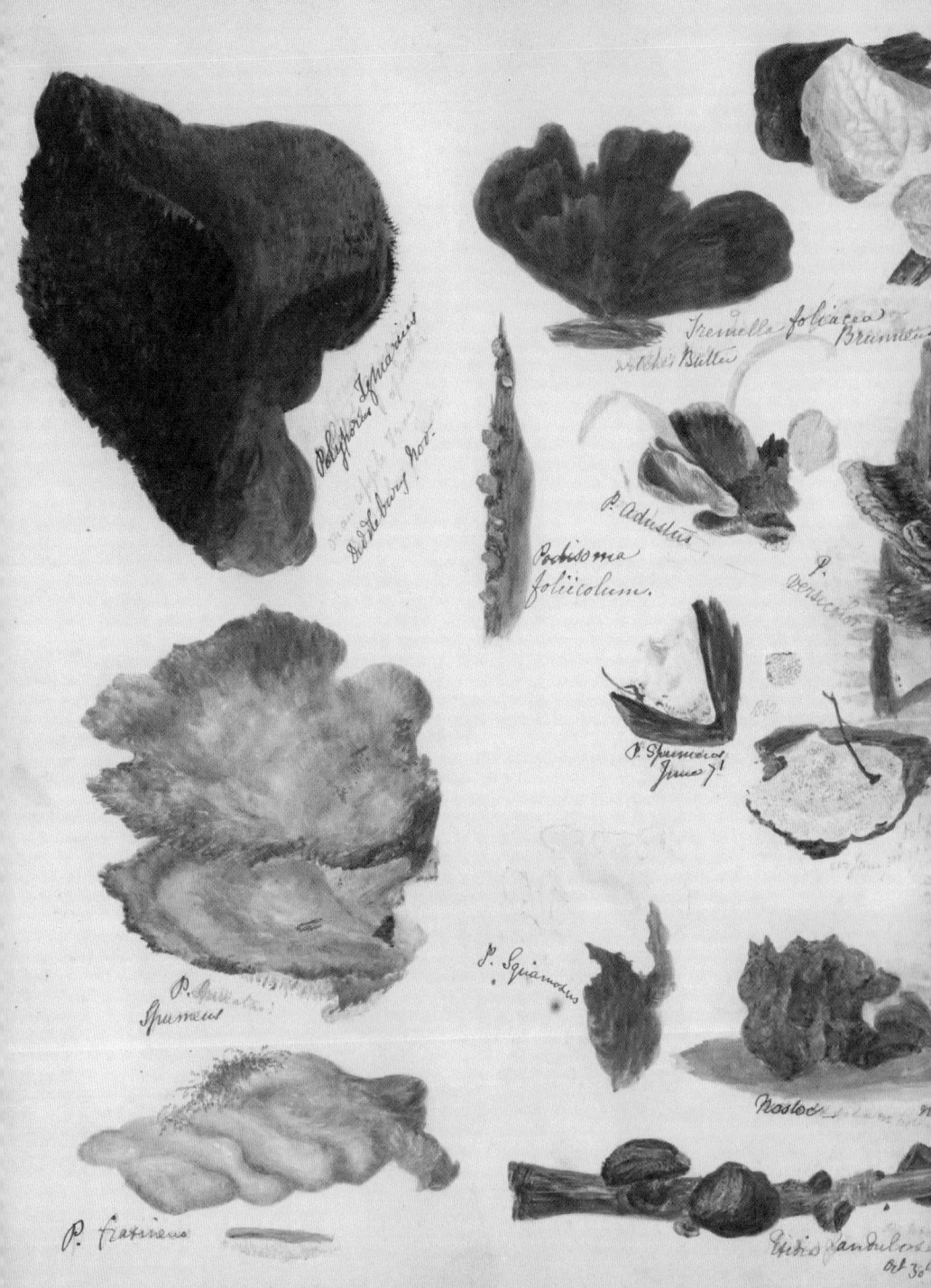

Polyphorus Ignarius

Shewn on apple tree
Dashebury Root.

Tremella foliacea
Wilches Butter

Brannen

P. Adustus

P. Squameus
June 7?

Protisoma
foliicolum.

P.
deuscator

P.
Spuneus
June

P. Squiamotus

P. Stellatus
Spumens

Nostoc

P. Fratineus

Cidio Sandulos
at 36

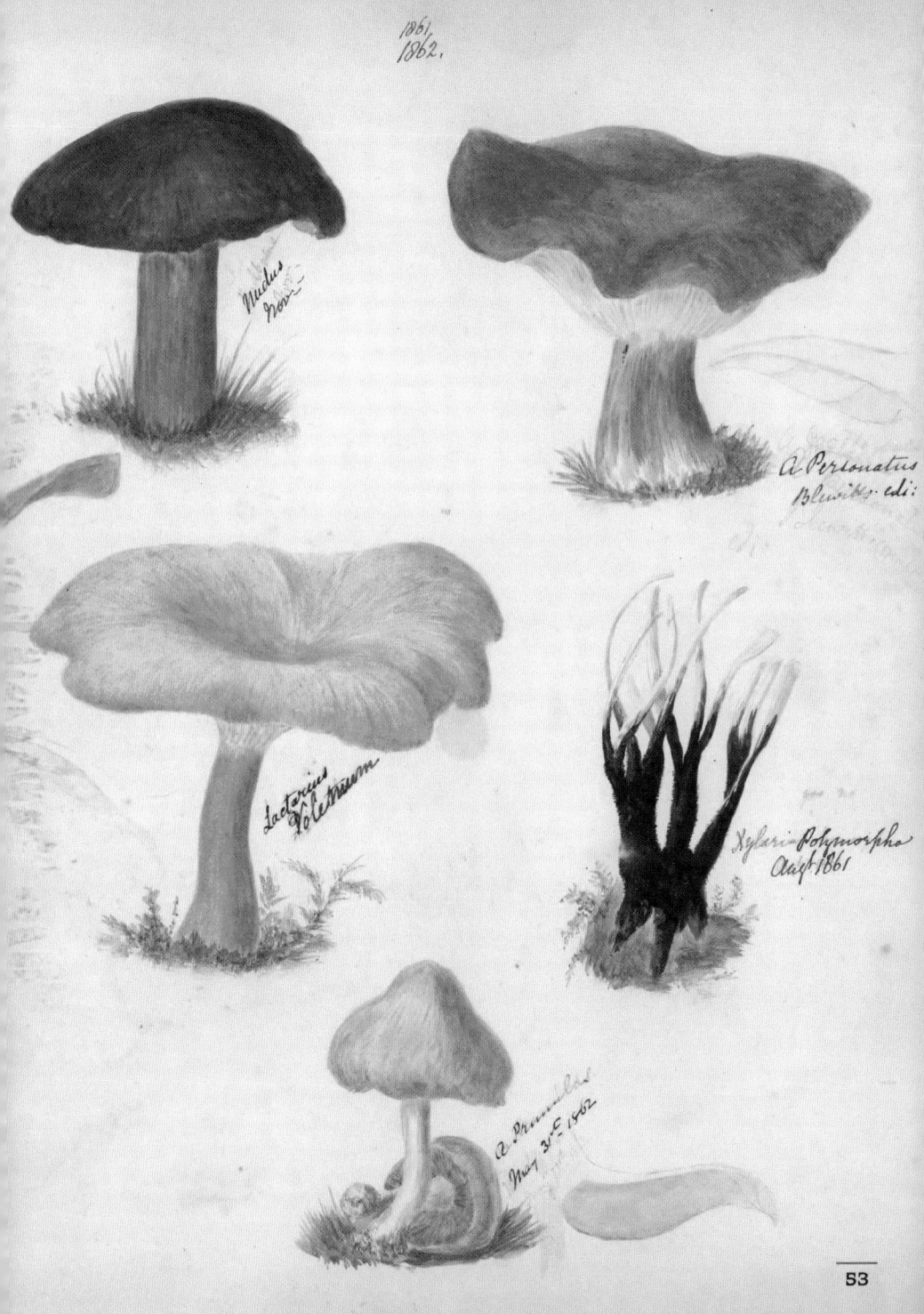

1861
1862.

Nudus Nov:

a. Personatus
Blewits edi:

Lactarius
Voletirum

Xylari Polymorpha
Aug 1861

a. Prunulus
May 3st 1862

53

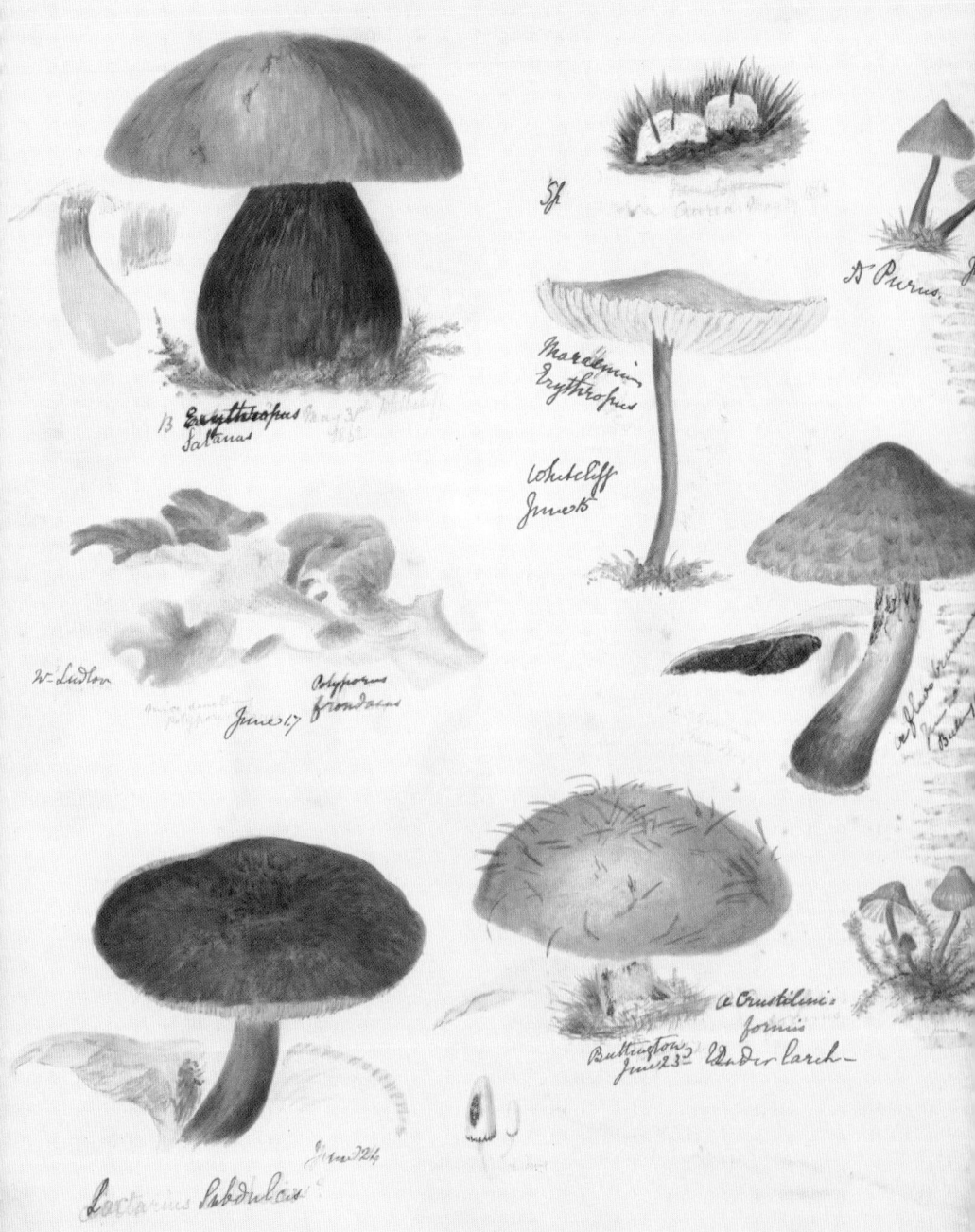

13 ~~Erythropus~~
Satanas

Sf

A Purus

Marasmius
Erythropus

Whitcliff
June 8

W. Ludlow

June 17 Polyporus
frondosus

A Crustilini:
formis

Buttington
June 23 Under larch

Lactarius Subdulcis

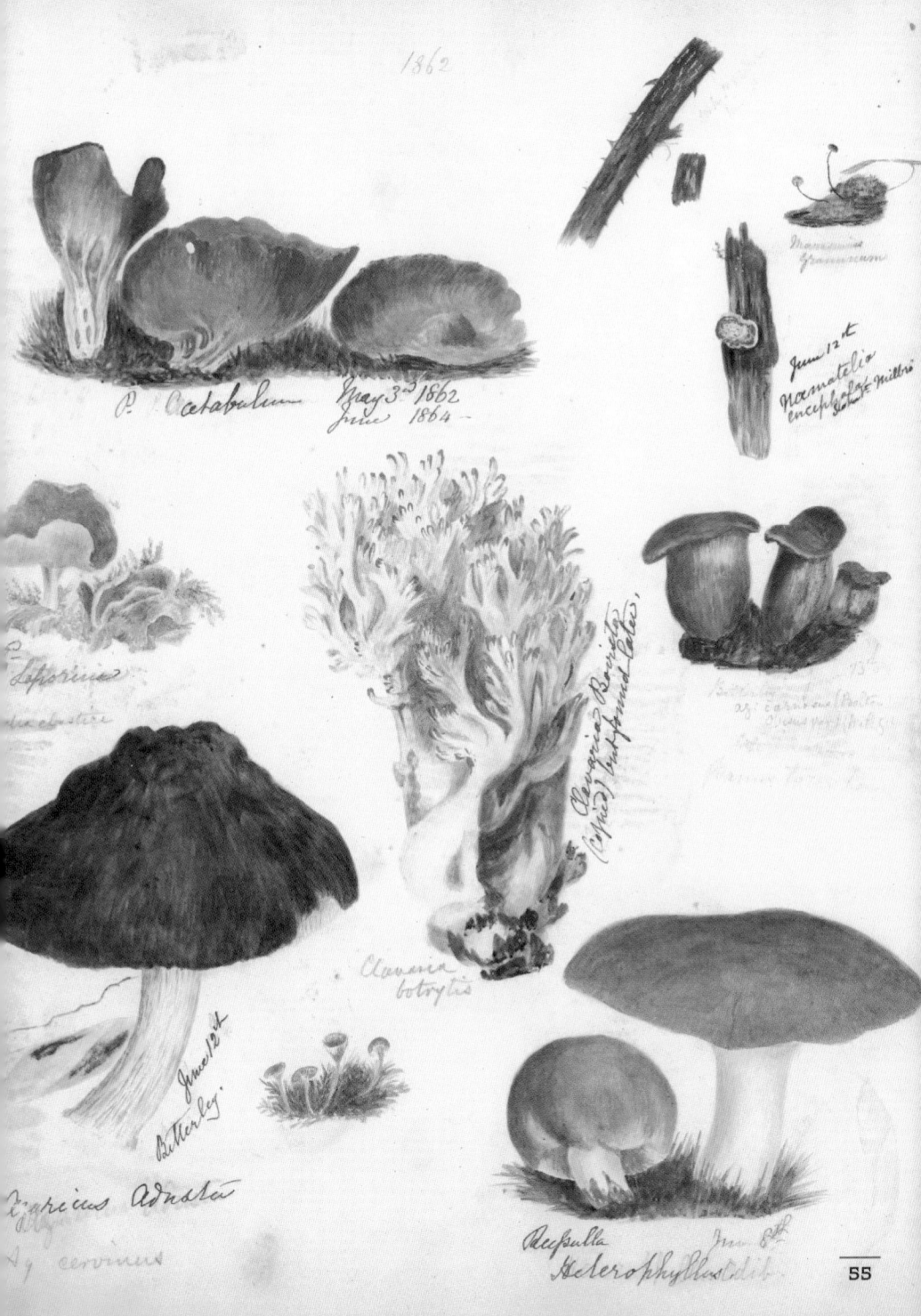

1862

P. Acetabulum May 3rd 1862
 June 1864

Marasmius
Graminium

June 12th
Naematelia
encephala Fries Willis

Leptonia

lampas hers

Clavaria Botrytis
(Pers) Conformed Fries

Bovista
aj cerinus (Pult)
Cinereus (Bull)

Clavaria
botrytis

Agaricus Adusta

Ag cervinus

June 12th

Better Ley

Russula
Heterophylla Fr Willis Jun 8th

VOLUME
II

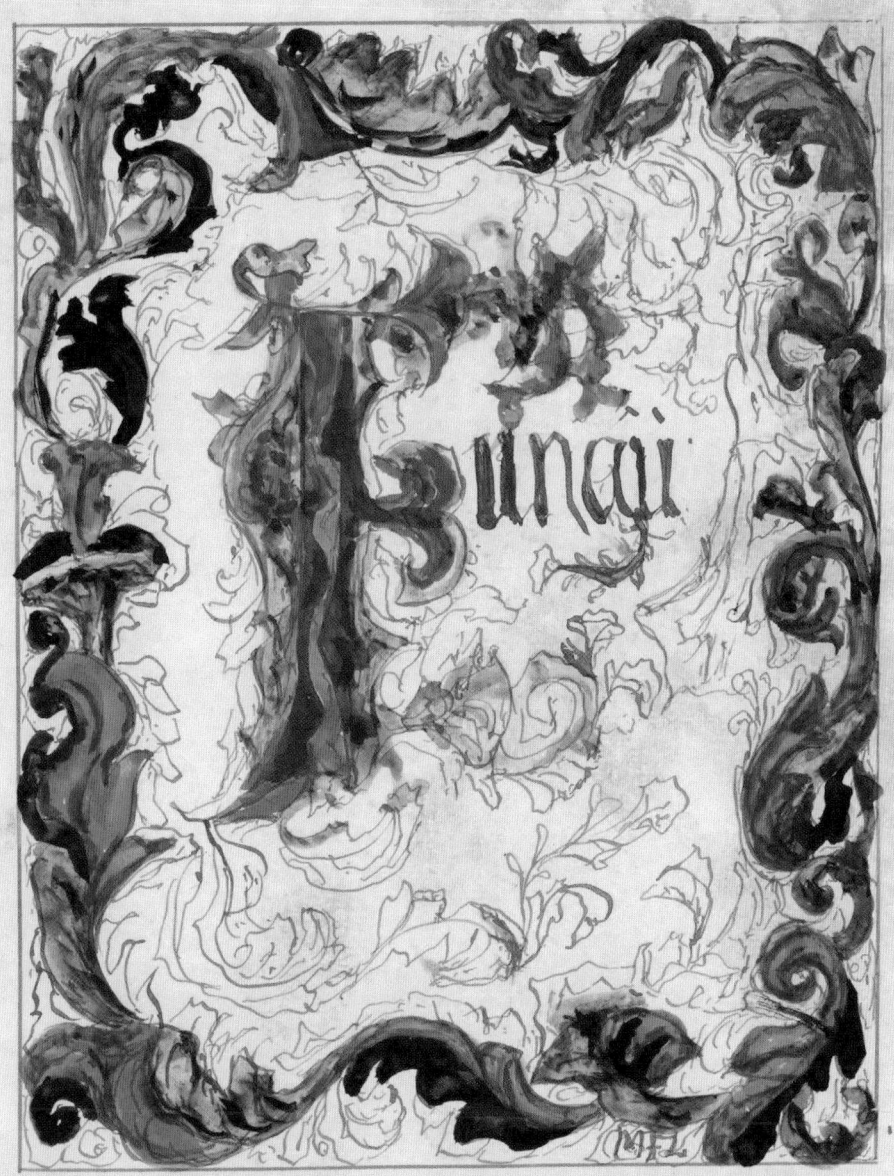

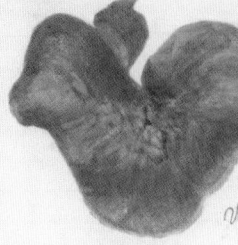

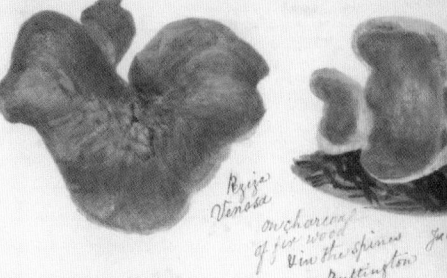

P. Sylva nitens?
Leucoderma

On fir spines
Bullington July 23º

Spathularia
flavida.

Peziza
Venosa

on charcoal
of fir wood
Vin the spines July
Bullington

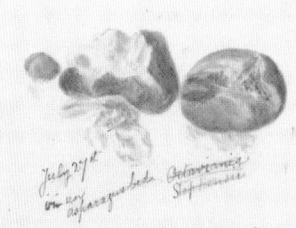

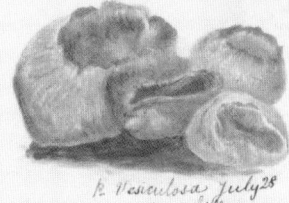

July 27th
vin my asparagus beds
Octo vienna
Stephensoni

Sclerodarma geaster

P. Vesculosa July 25
Amphille
Nellie Andrews Green
Vin Woted?

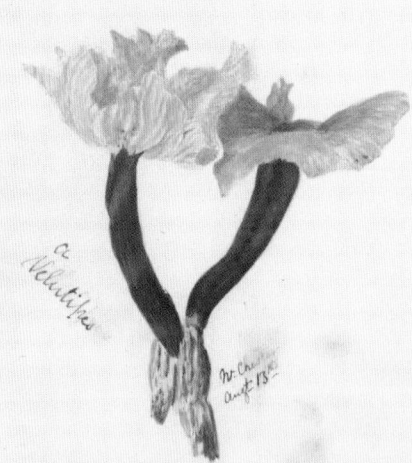

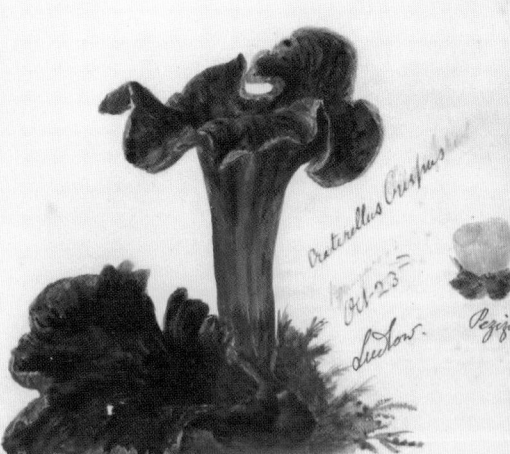

a
Velutipes

W. Cruft
Augt 13th

Craterellus Crispus

Oct 23º

Sunton.

Peziza

Craterellus cornucopioides

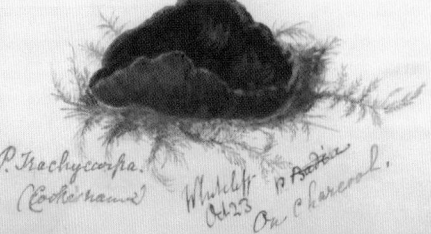

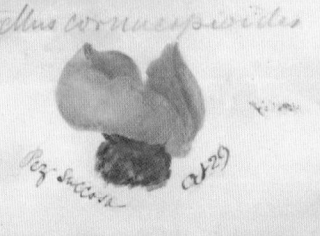

P. Trachycarpa.
(Cooke name)

Whitcliff P. Andiga
Oct 23 On Charcoal.

Peg. succosa Oct 29

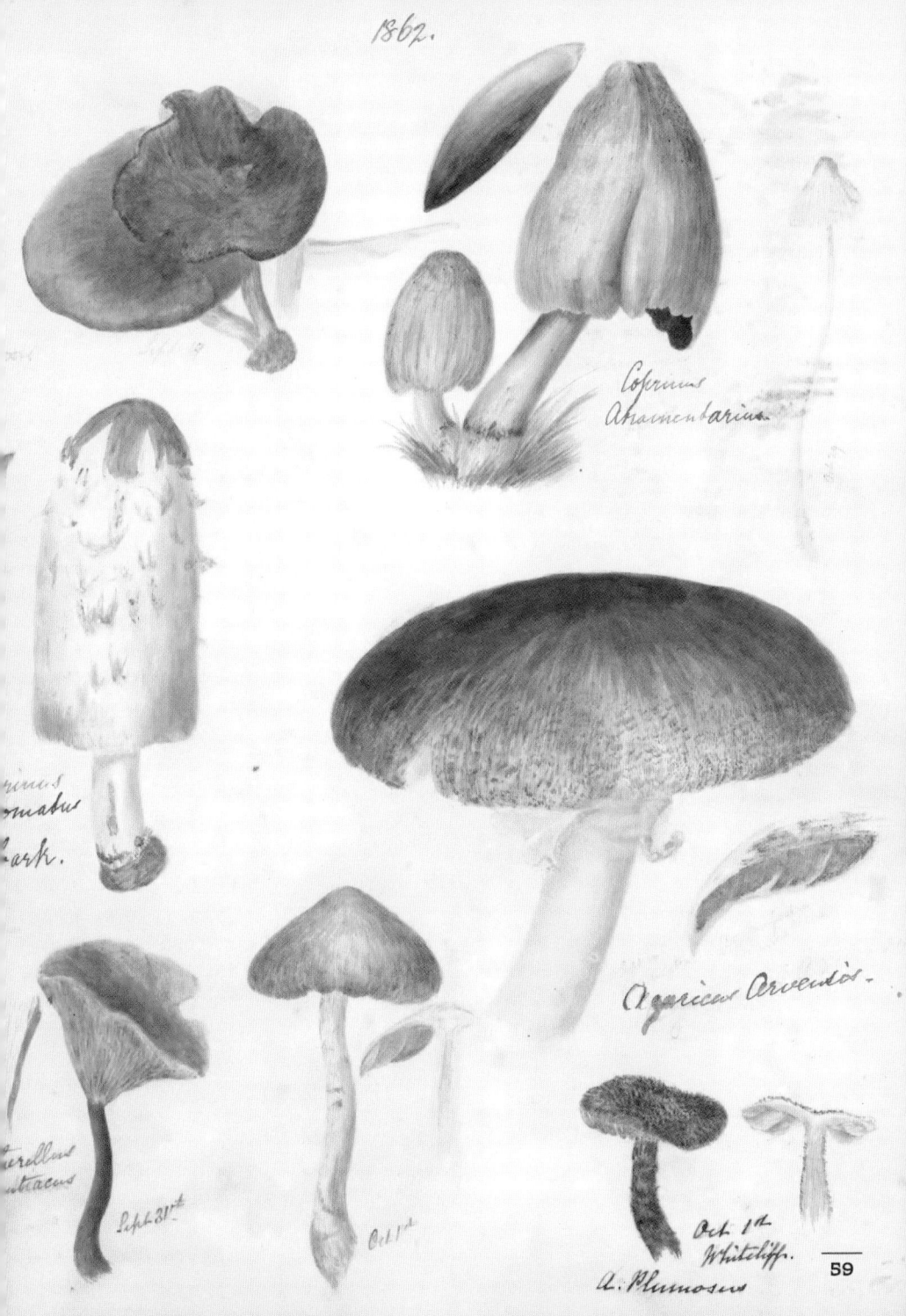

1862.

Coprinus Atramentarius

[...]rinus
[...]matus
[...]ark.

Agaricus Arvensis.

[...]urellus
[...]ntiacus
Sept 31st

Oct 1st

Oct 1st
Whitcliffe.

A. Plumosus

59

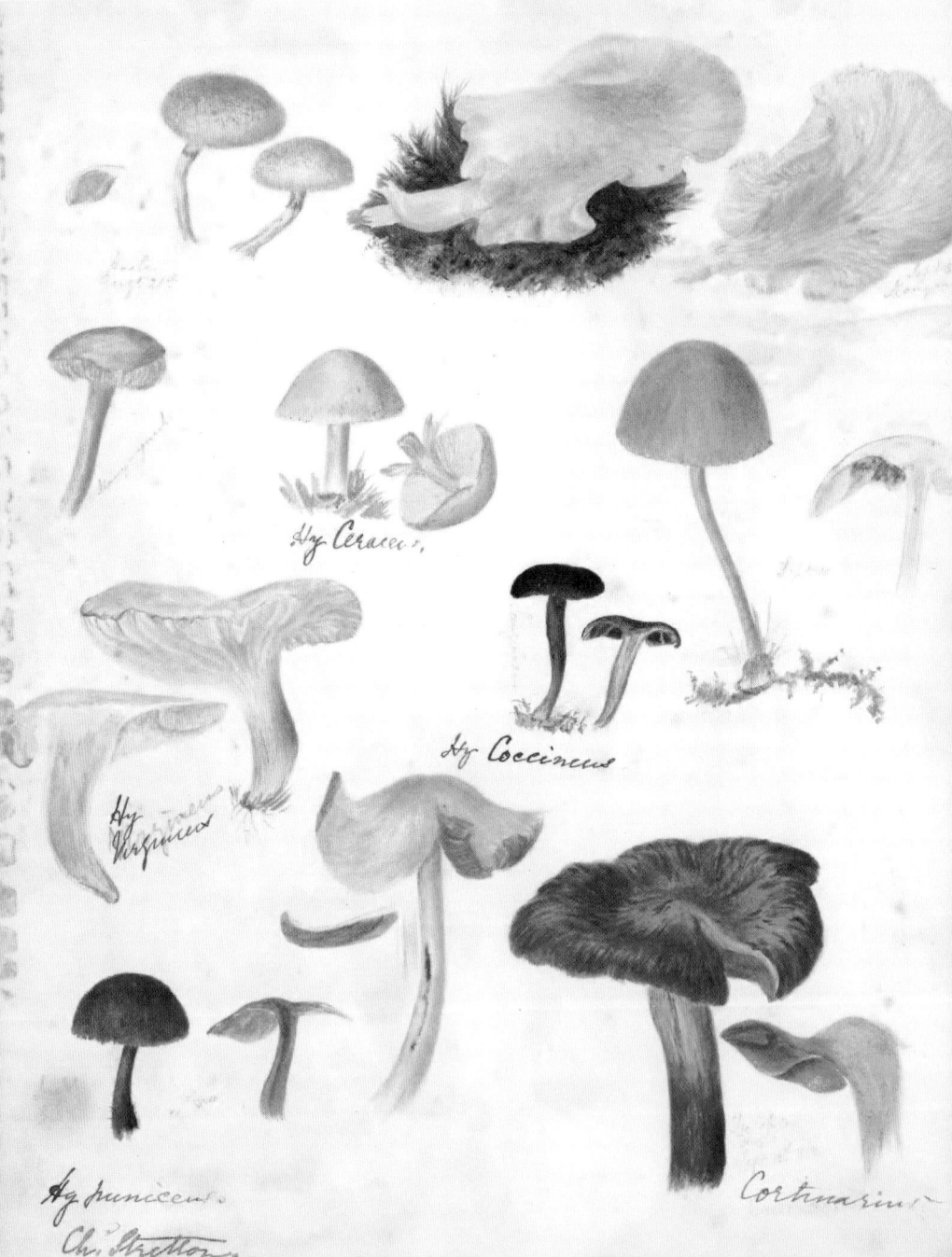

1862

Hy Ceraceus,

Hy Coccineus

Hy
Virgineus

Hy puniceus.
Ch. Stretton,

Cortinarius

1863
Mr Welchpool.
& Ludlow.

61

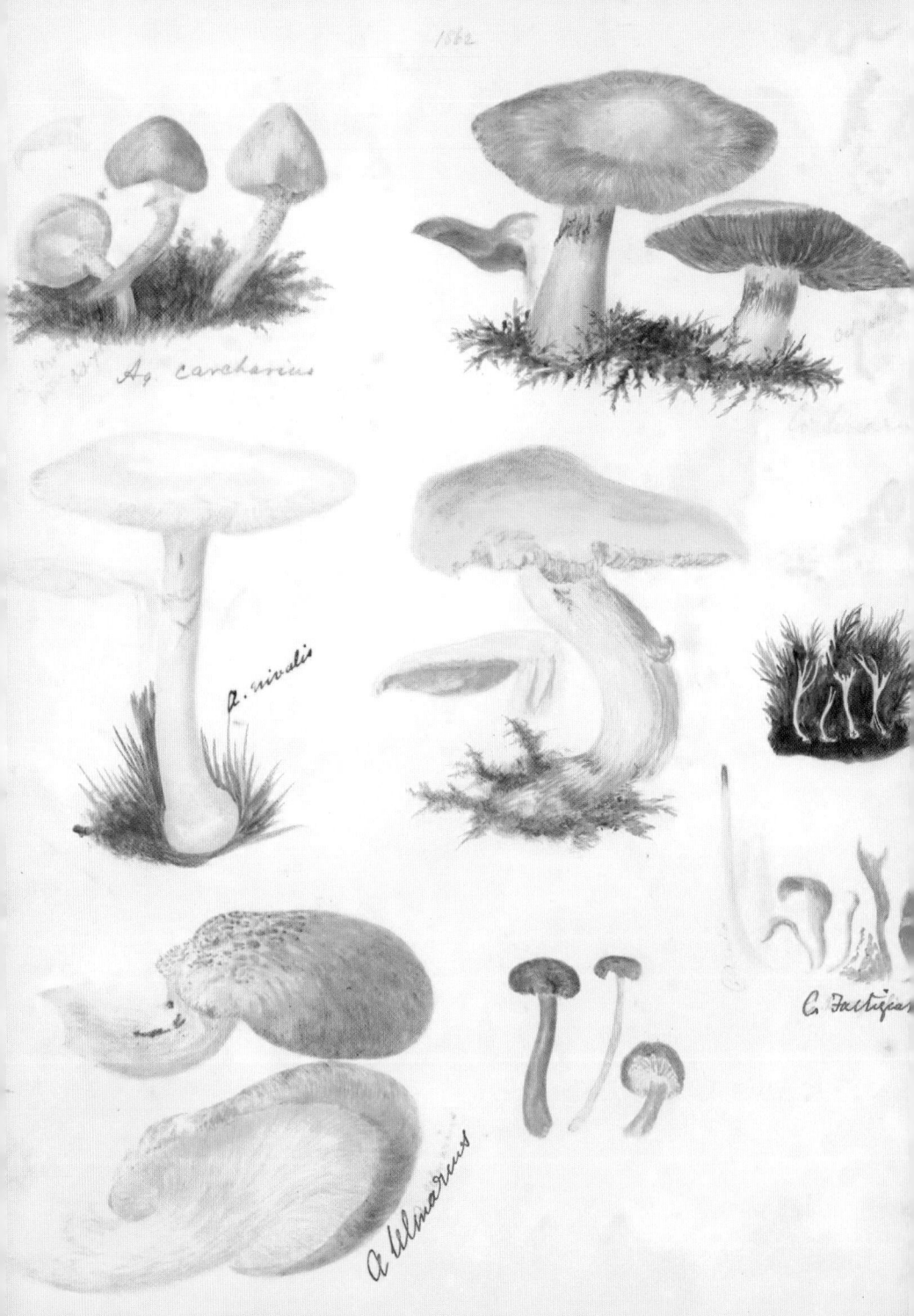

1562

Ag. caracharius

A. nivalis

C. Factigea

A. Ulmarius

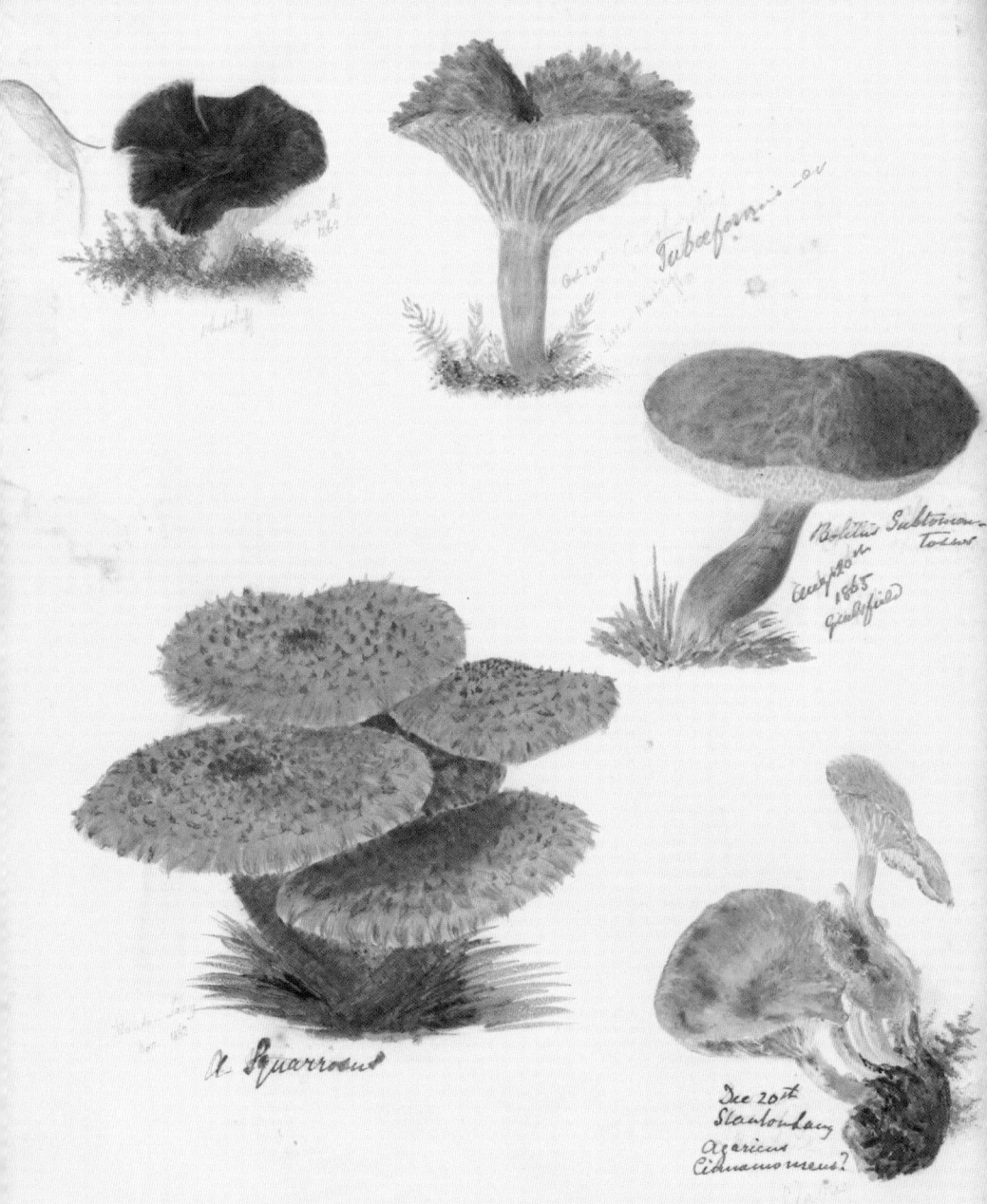

Tubaeformis ov

*Boletus Subtomen-
Tosus*
Aug 20 th
1865
Guildfield

A. Squarrosus

Dec 20 th
Stanton hary
Agaricus
Cinnamomeus?

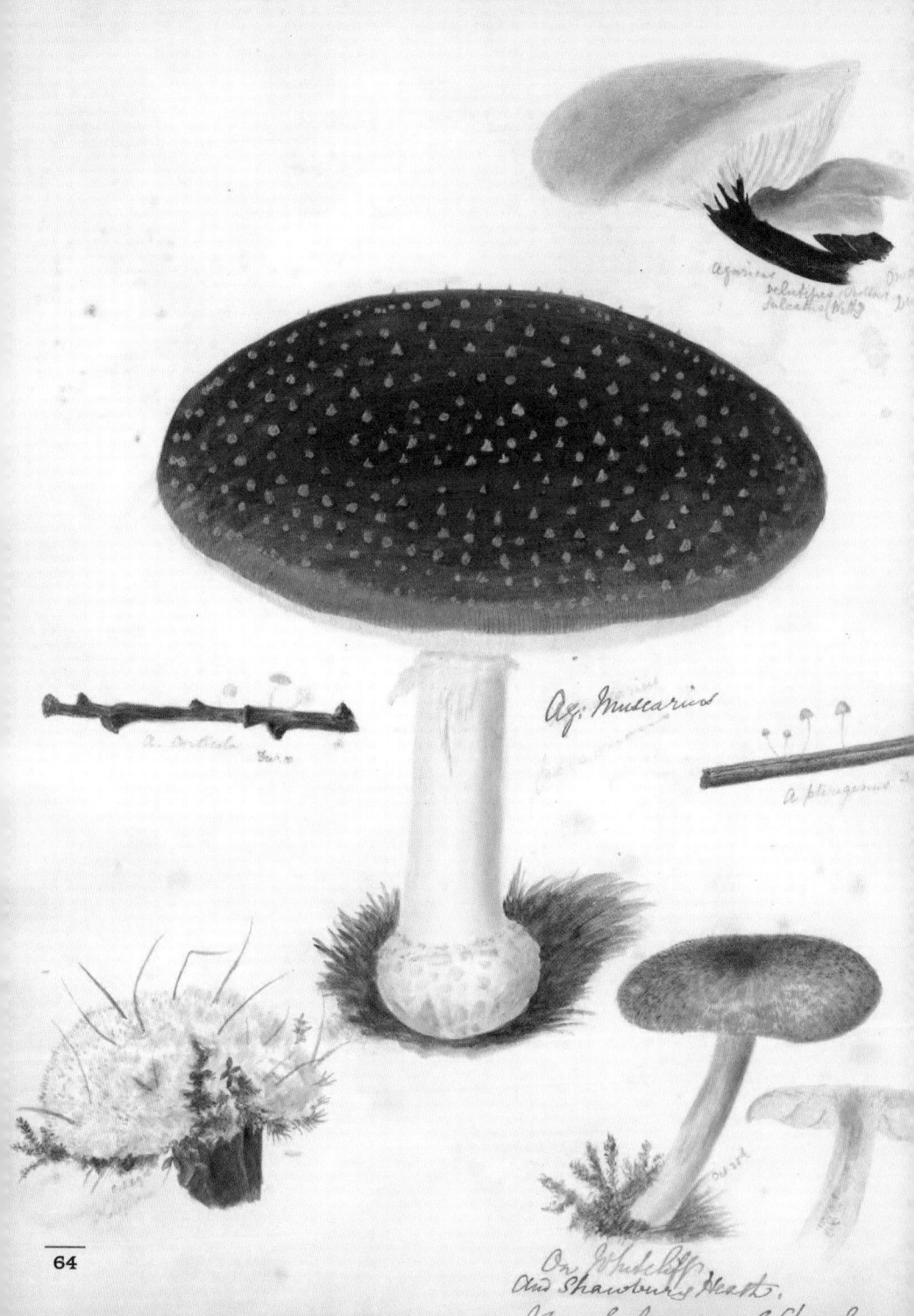

Agaricus
velutipes Rother
silvaticus (Will)

A. orbicula Fr.

Ag: Muscarius

A: ptusgenus Fr.

On Whitcliff
and Shawbury Heath.

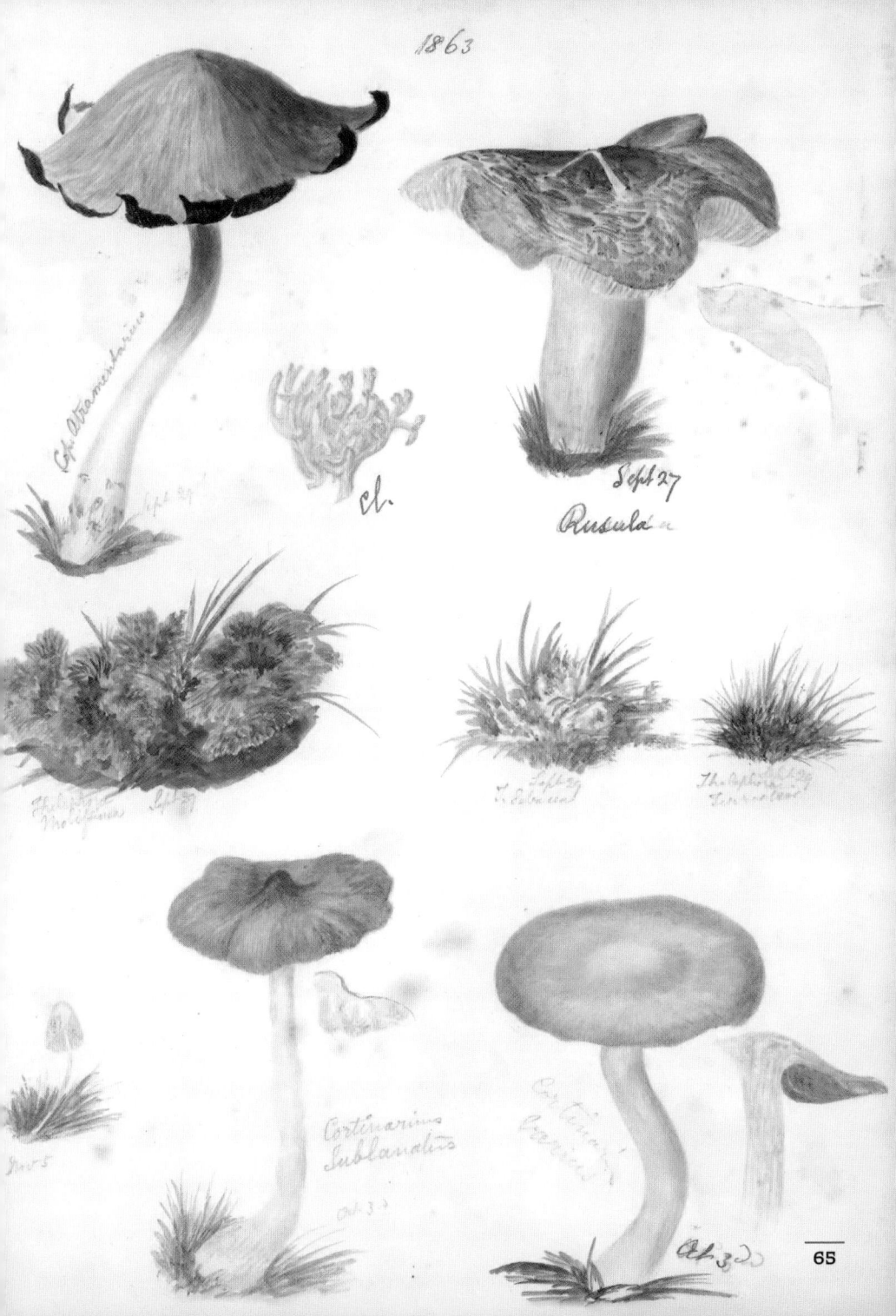

1863

Cop. Ultramontanina

cl.

Sept 27
Russula n.

Cortinarius
Sublanatus

Oct 3?

65

Ludford Park
P. Sulphureus

Jew's E
Castle wall
Ludlow

Mynogaster

Helvella Sulcata.
Helvella elastica

Pezija Cochleata.

Betterley
L. Moor

1562

Geaster rufescens
Oct 13th

Whitcliff —

Hyd zonatum

Maryflnowle
Wood ——

Sept & Oct

Cyathus
Nidularia albinicola

Helotium Pallescens
nov.

Tremella Albida

Corticium Quercinum

Sept & Oct 1562

Agaricus melleus

67

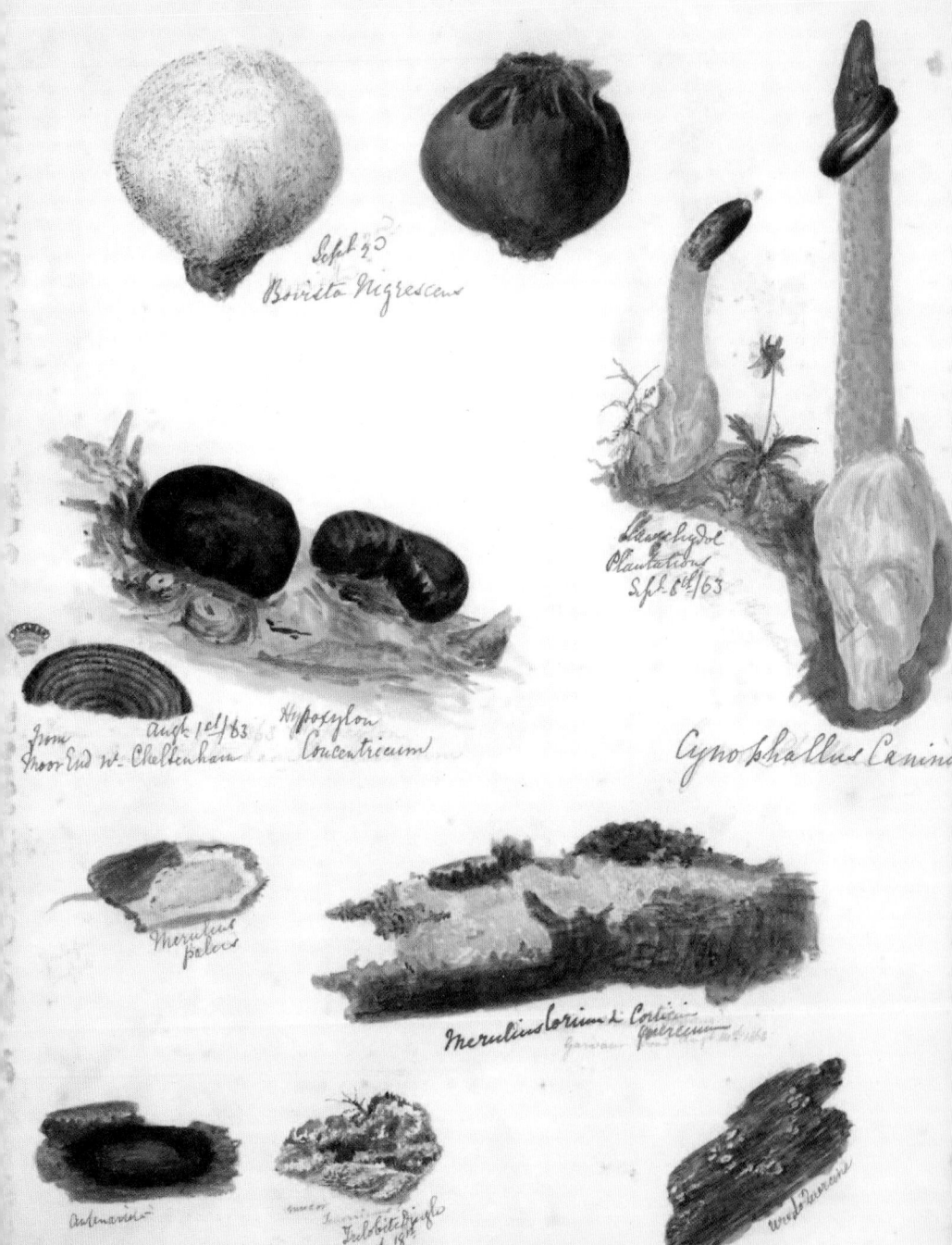

1862 & 1863

Sept 25
Boursta Nigrescens

Hypoxylon
Concentricum

from Aug 1st /83
Moor End nr Cheltenham

Leasehydol
Plantations
Sept 6th /63

Cynophallus Canina

Merulius
Pelosa

Merulius Corium & Cortium

Antennaria Trichobotrys
 Aug 18th

1863

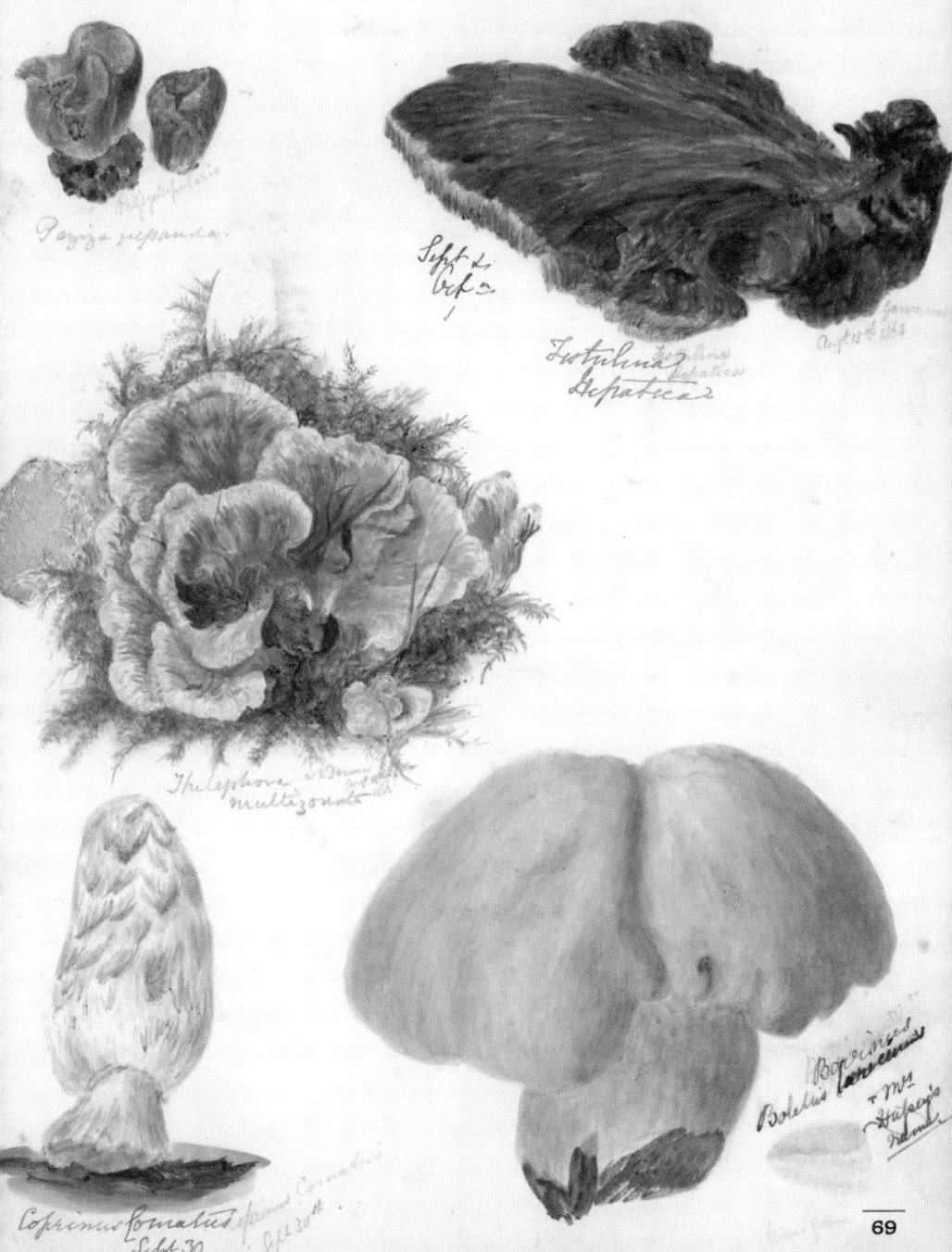

Peziza repanda.

Peziza repanda.

Sept &
Oct

Fistulina
lina
hepatica
hepatica

Genere
Aug 15th 1863

Thelephora vesterini
Aug 1863
multizonata 1863

Coprinus comatus
Sept 30

Coprinus Comatus
Sept 30th

Boprinces
Boletus aereus
+ Mrs
Halsey's
name

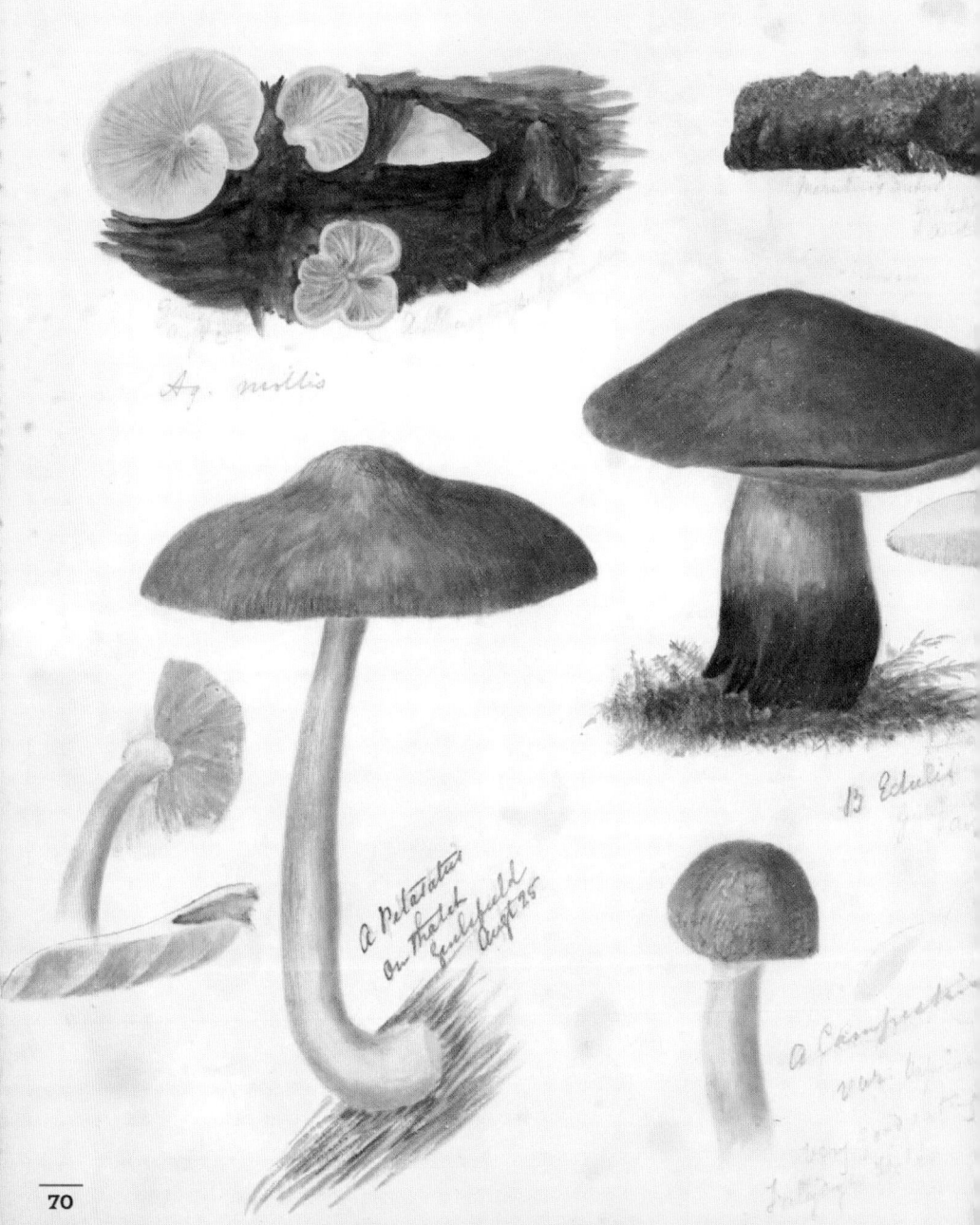

Ag. mollis

A. Petasates
On thatch
Guildfield
Augt 95

B Edulis

A Campestris
var ?

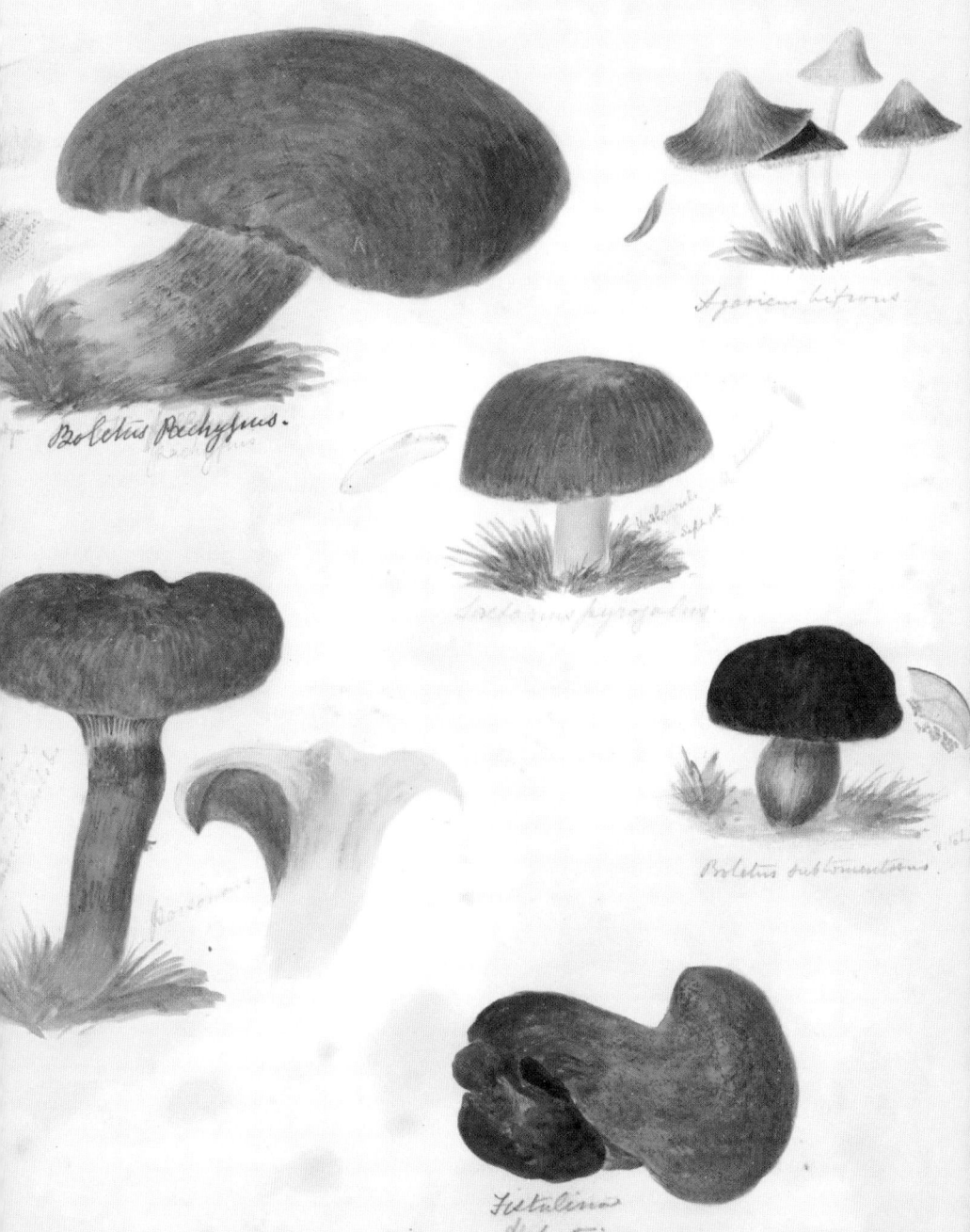

1863. *Aug. & Sept.*

Boletus Pachypus.

Agaricus hiltonus

Lactarius pyrogalus

Boletus subtomentosus.

Fistulina Hepatica

71

1864

Sphaerobolum
Stellatus
Marghnowle Oct 12th/63

Coprinus

A. Procerus
Trelydem Lane
Sept 19th 1863

Oct 18th Grombstow

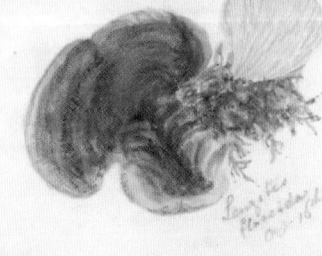

Coprnolin
Virescens

Oak

Senzetis
Elmenden
Oct 16th

P. Leiocarpa
Oct 8
NDu

Oct 8th OnElmcliff
On turf
Pez. brunnea

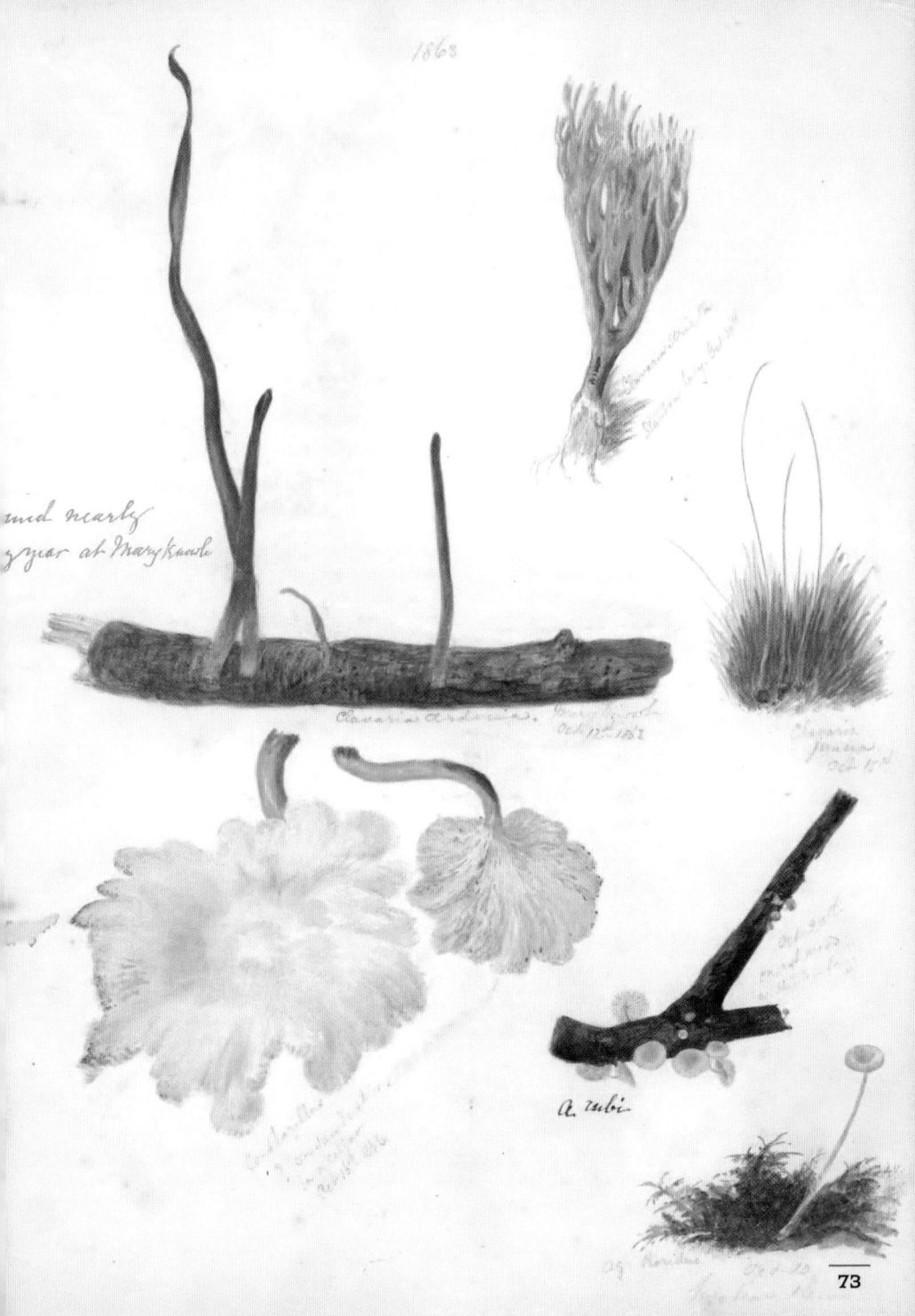

1863

and nearly
a year at Marykanle

Clavaria Ardenica. *Oak Grove*
Oct 12th 1863

Clavaria fusea
Oct 16th

A. rubi

73

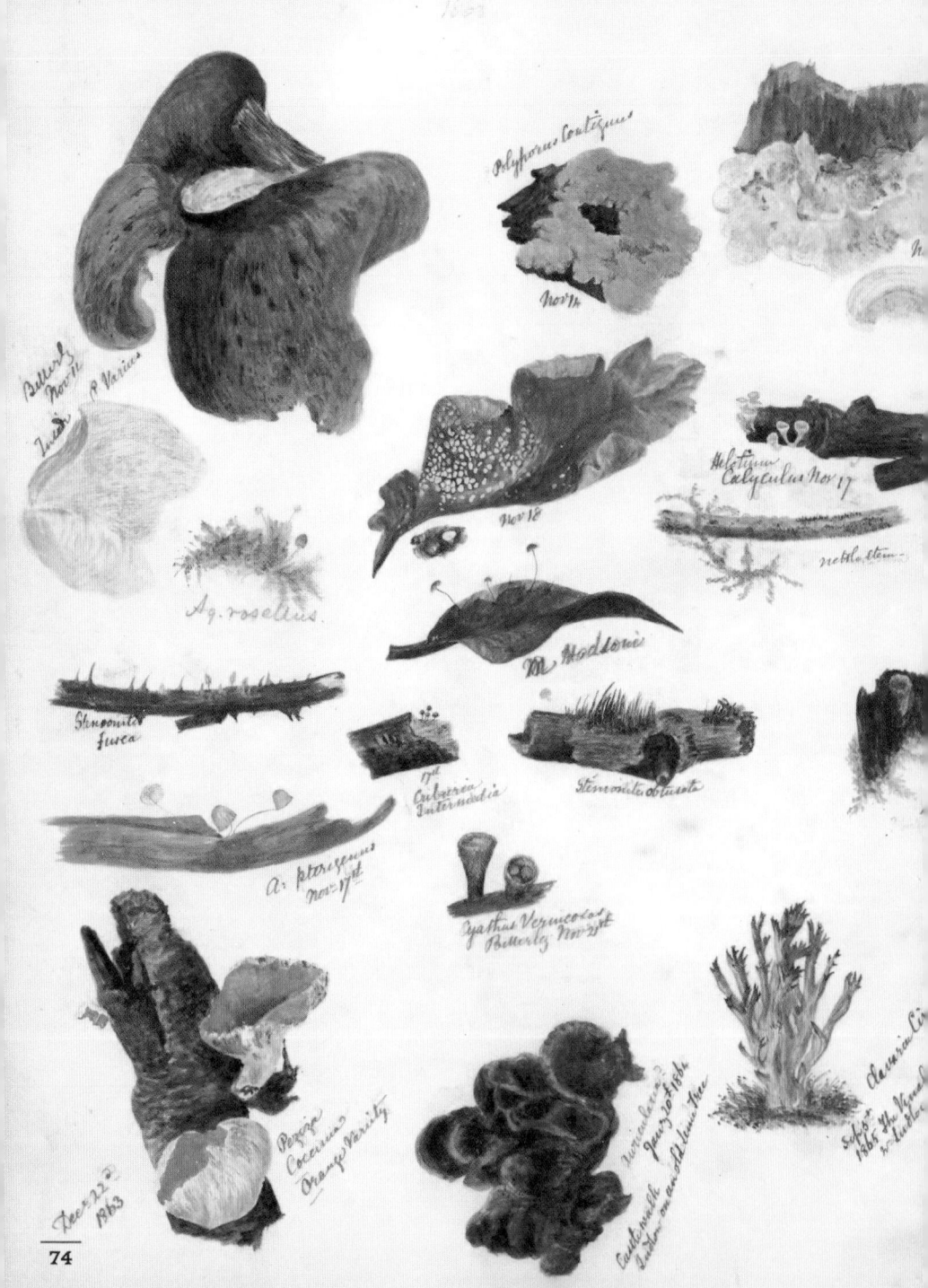

1863

Polyporus contiguus
Nov 14

Butterly
Nov 11
Zuidi ... P Varius

Helotium
Calyculus Nov 17

Nov 18

nethlotium

Ag. rosellus.

M. Madsoni

Stemonites
fusca

Cubaria
Intermedia

Stemonites obtusata

A. pterigenus
nov 1718

Cyathus Vernicolor
Butterly Nov 25

Peziza
Coccinea
Orange Variety

Dec 22
1863

verticillus?
Jan 30 1864
Castleworth
Hostess on an old time Tree

Clavaria
1863 The Signals
2 Hutton

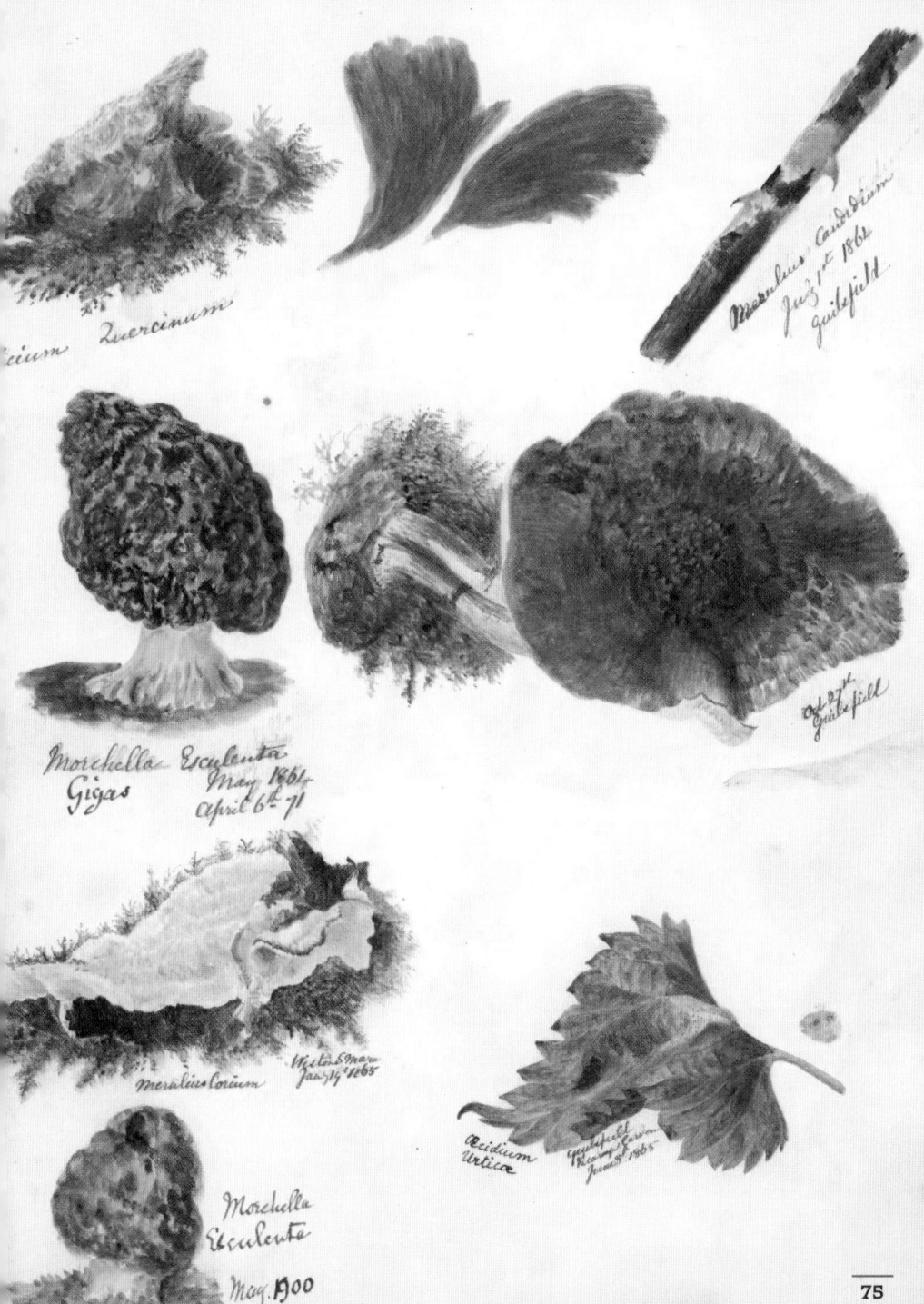

...cium Quercinum.

Merulius Candidum
July 1st 1862
Guilsfield

Morchella Esculenta
Gigas May 1861
 April 6th 71

Oct 21st
Guilsfield

Merulius Corium
Victor S Mary
Jan 31, 1865

Morchella
Esculenta

May 1900

Æcidium
Urtica
Guilsfield
Vicarage Garden
June 9th 1865

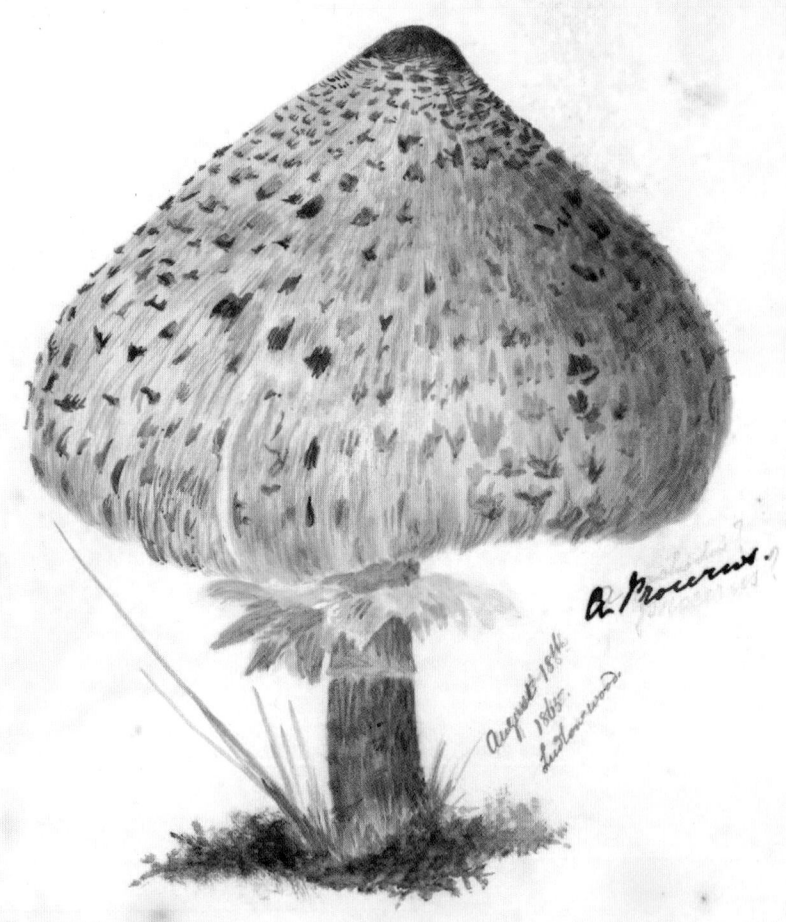

A. Procerus.

August 1884.
1885.
Latherwood.

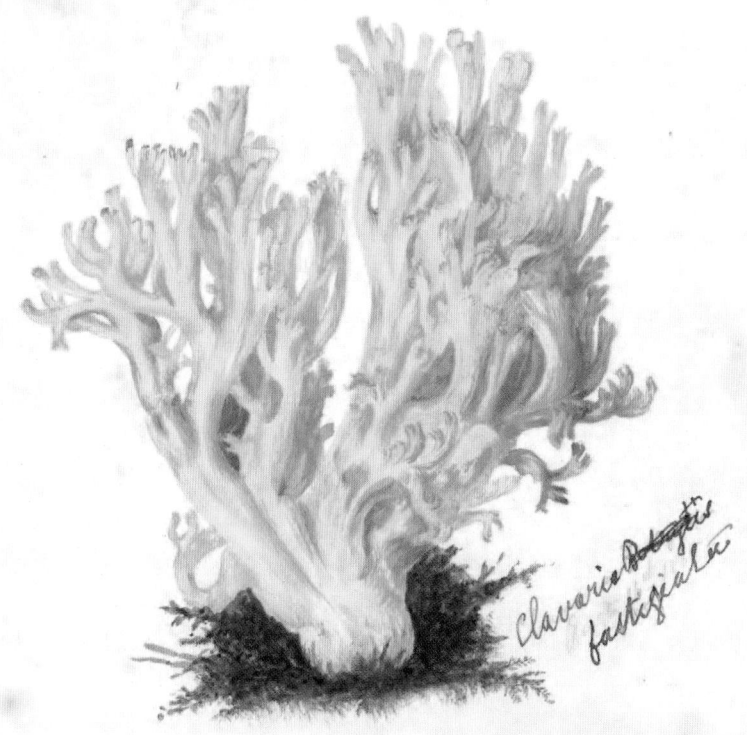

Clavaria ~~Botrytis~~
fastigiata

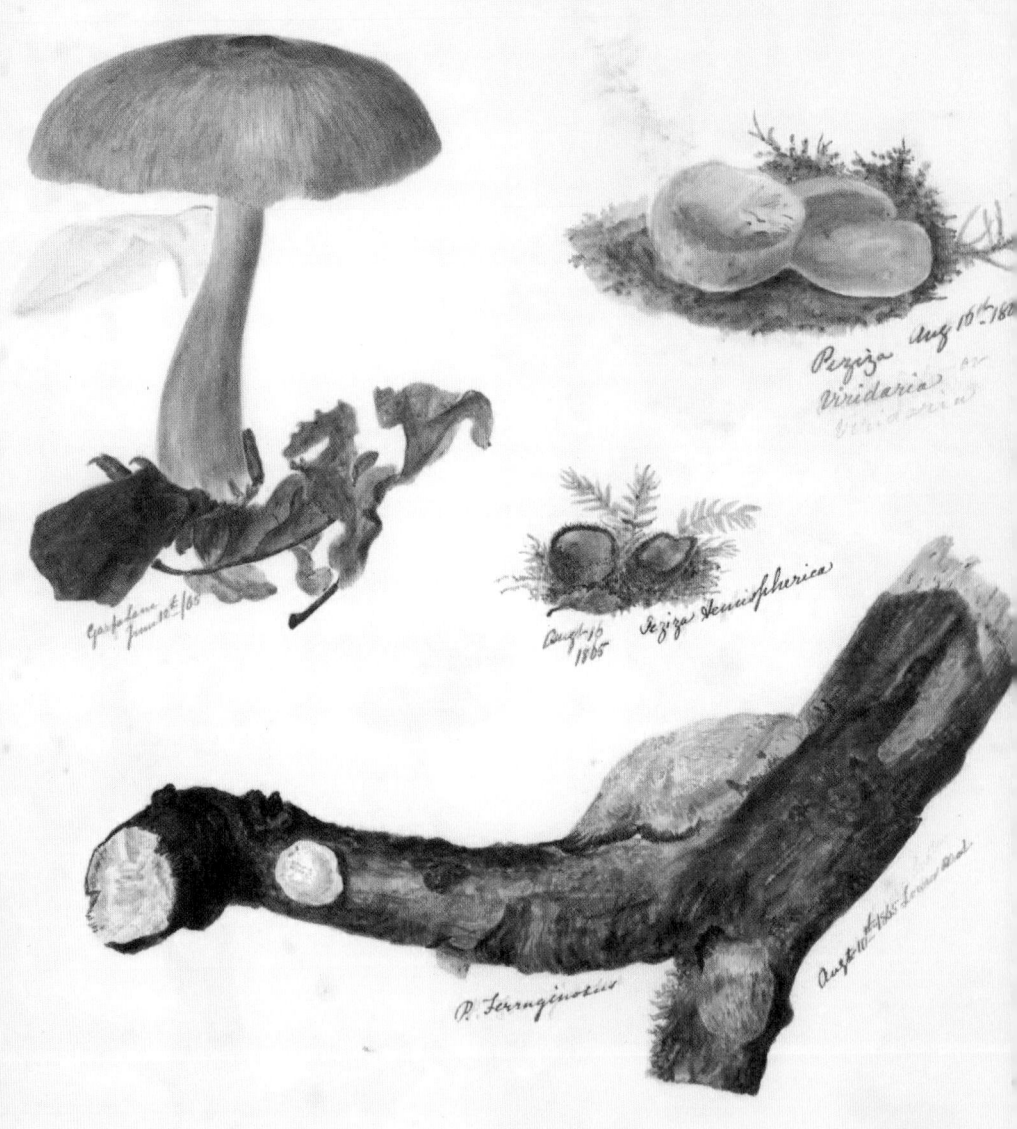

Garbolana
June 10th/65

Pezija Aug 16th 186
Viridaria

Aug 16
1865 Pezija Hemisphaerica

P. Ferruginosus Augt 10th 1865 Ilonar Wood

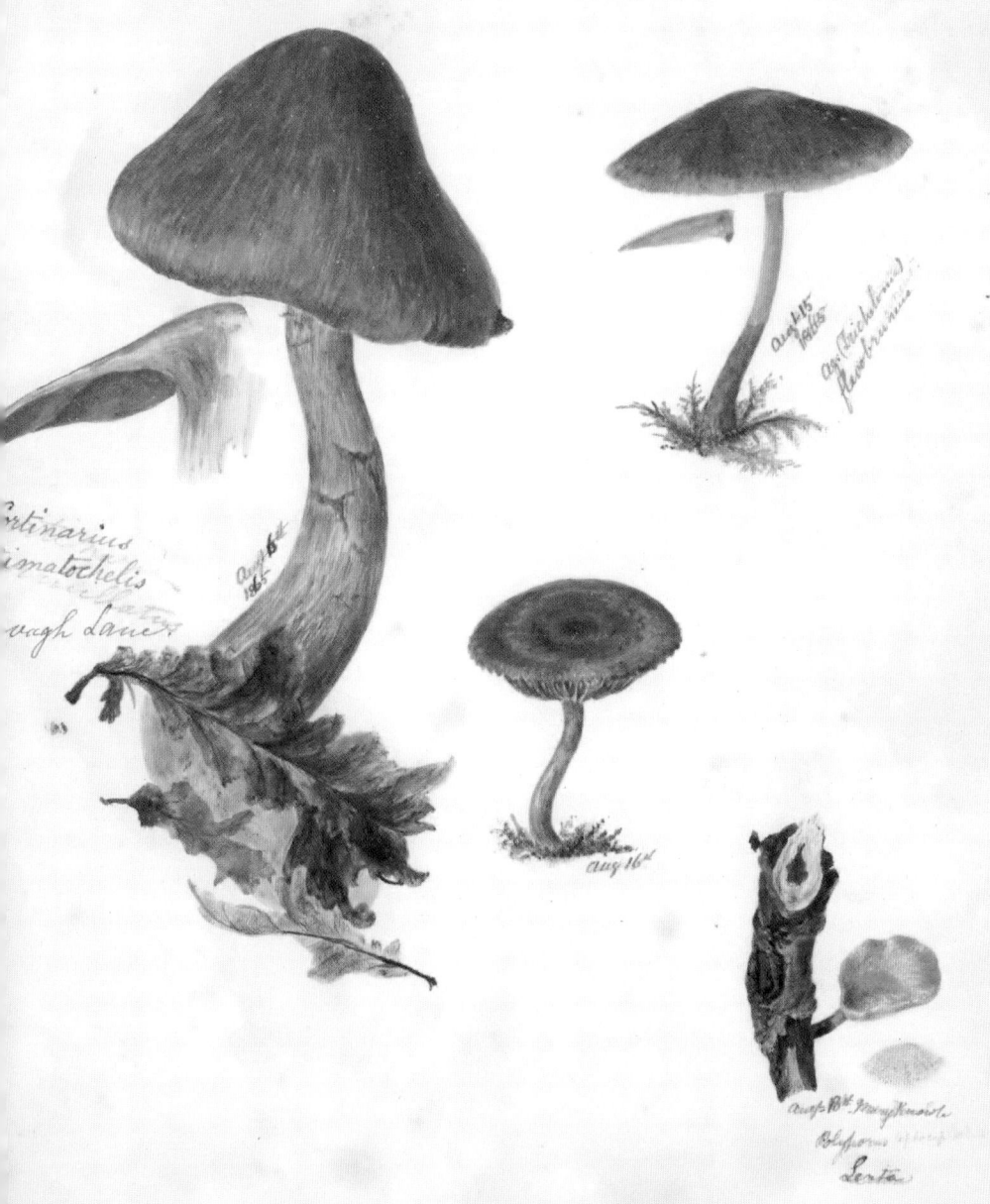

Cortinarius
imatochelis

vagh Lanes

Aug 6th
1865

Aug 15
bells

Agr(trichtoma)
flavobrunniii

aug 16t

Augs 18th Marysknoll
Polyporus n.
Lerta

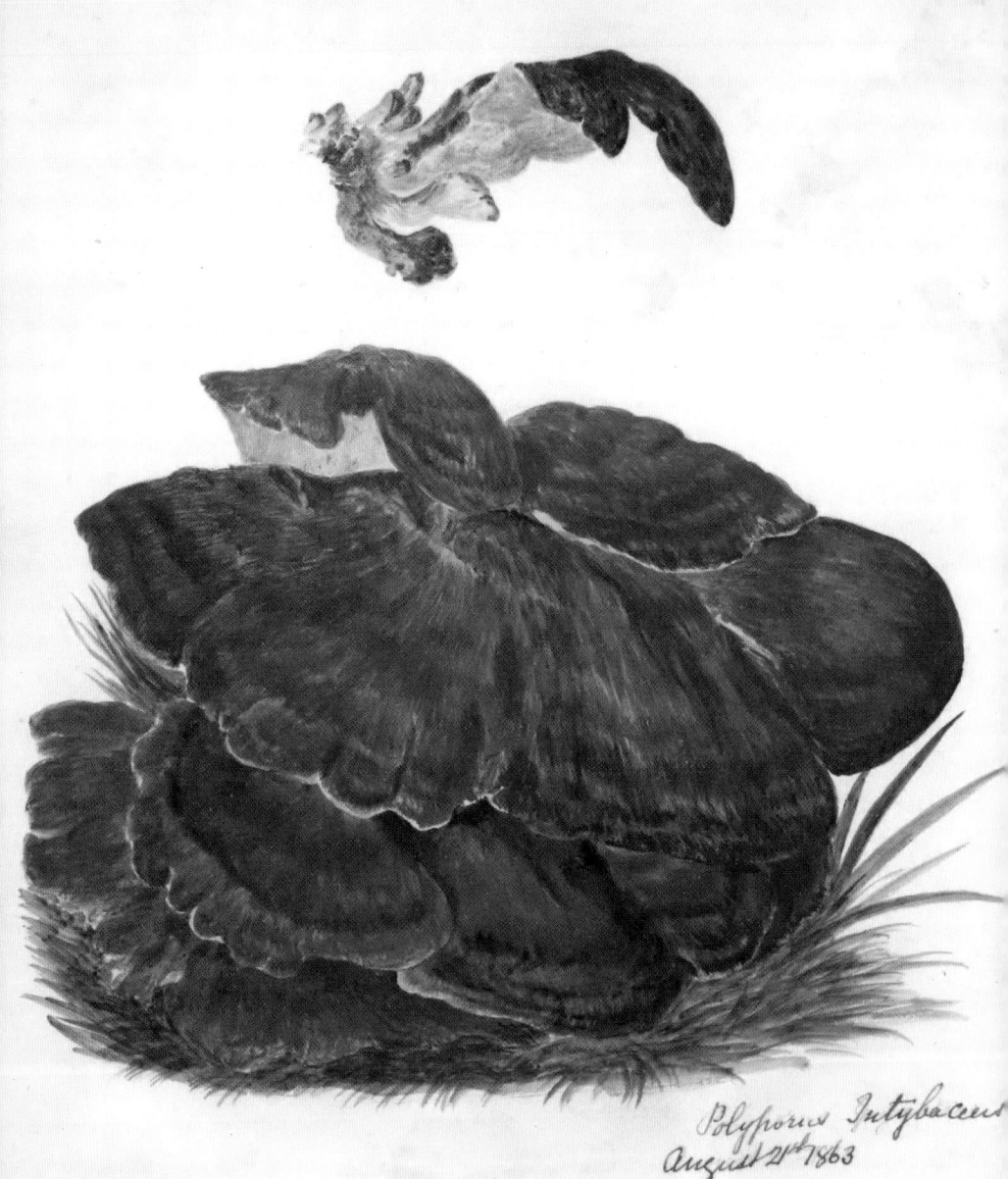

Polyporus Intybaceus
August 21st 1863

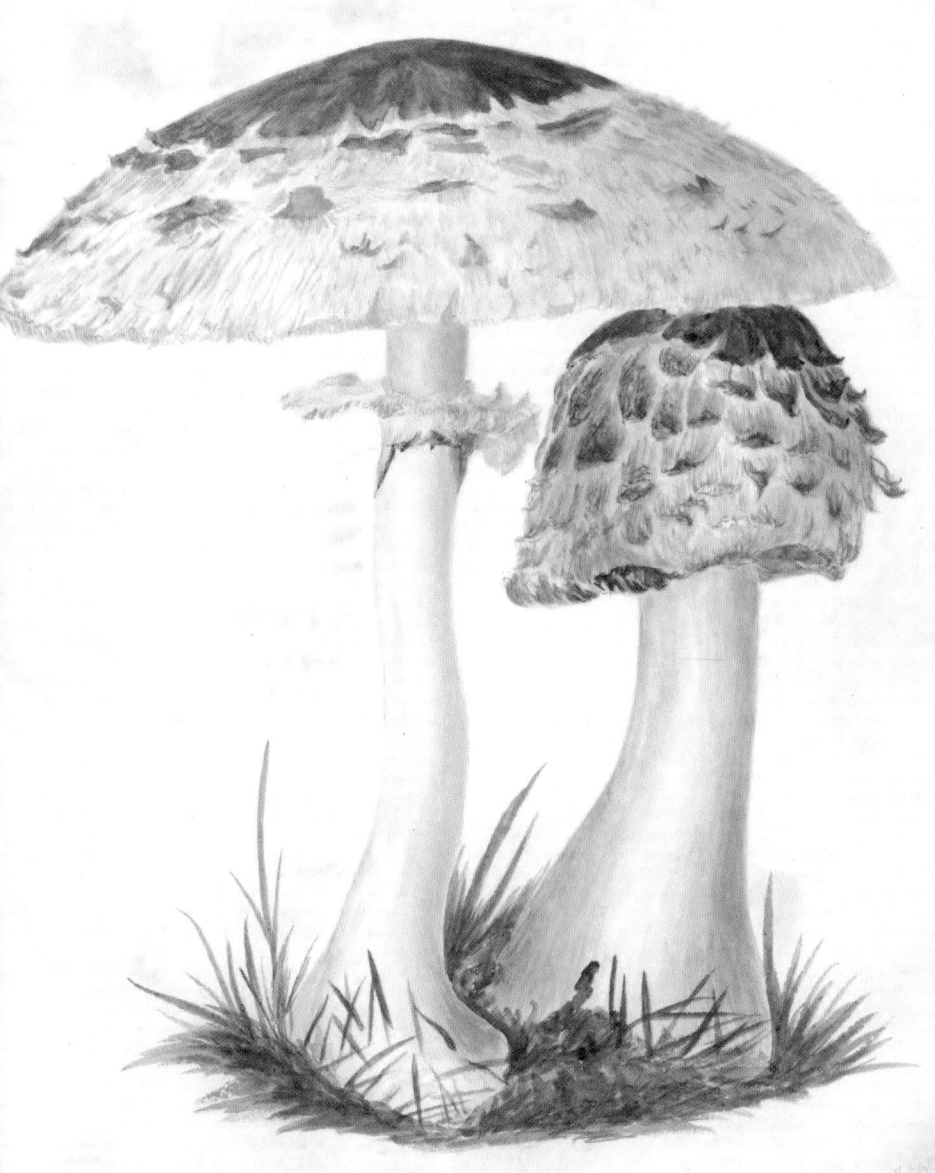

Agaricus Rhacodes

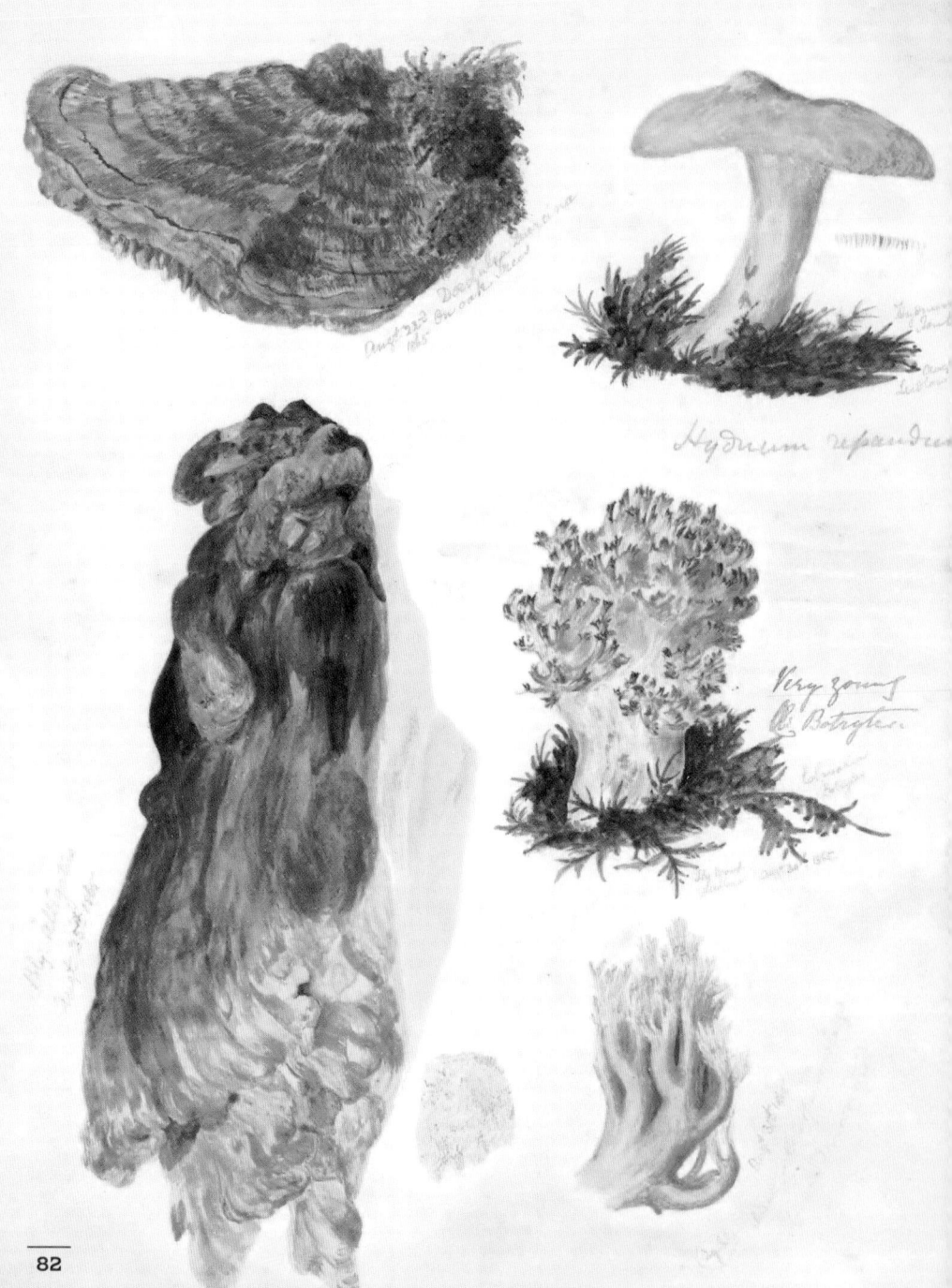

1865

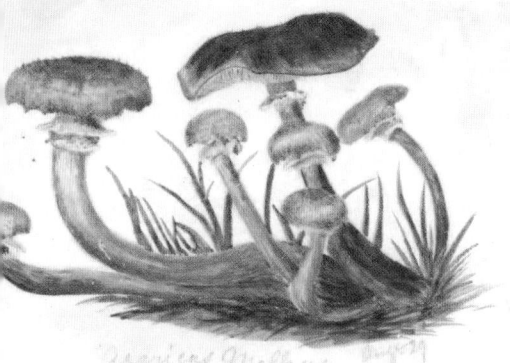

Agaricus Melleus Augt 29

augt 29
A. Sublateritius

Helvella Elastica (rare) Sept 9th *Virid*
The Wood—

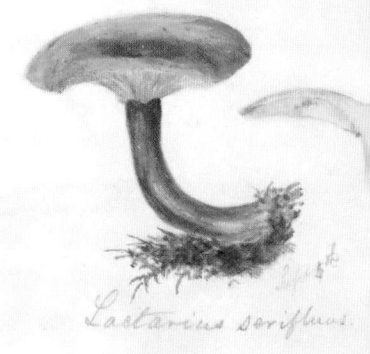

Sept 9th
Lactarius seriflens.

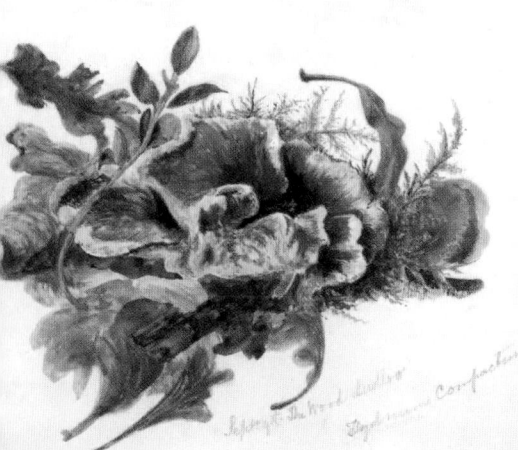

Sept 9th The Wood *Sudlow*
Hydnum Compactum

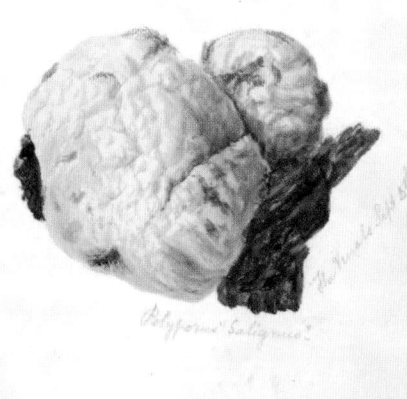

On Trunk Sept 8th
Polyporus Saligmus

83

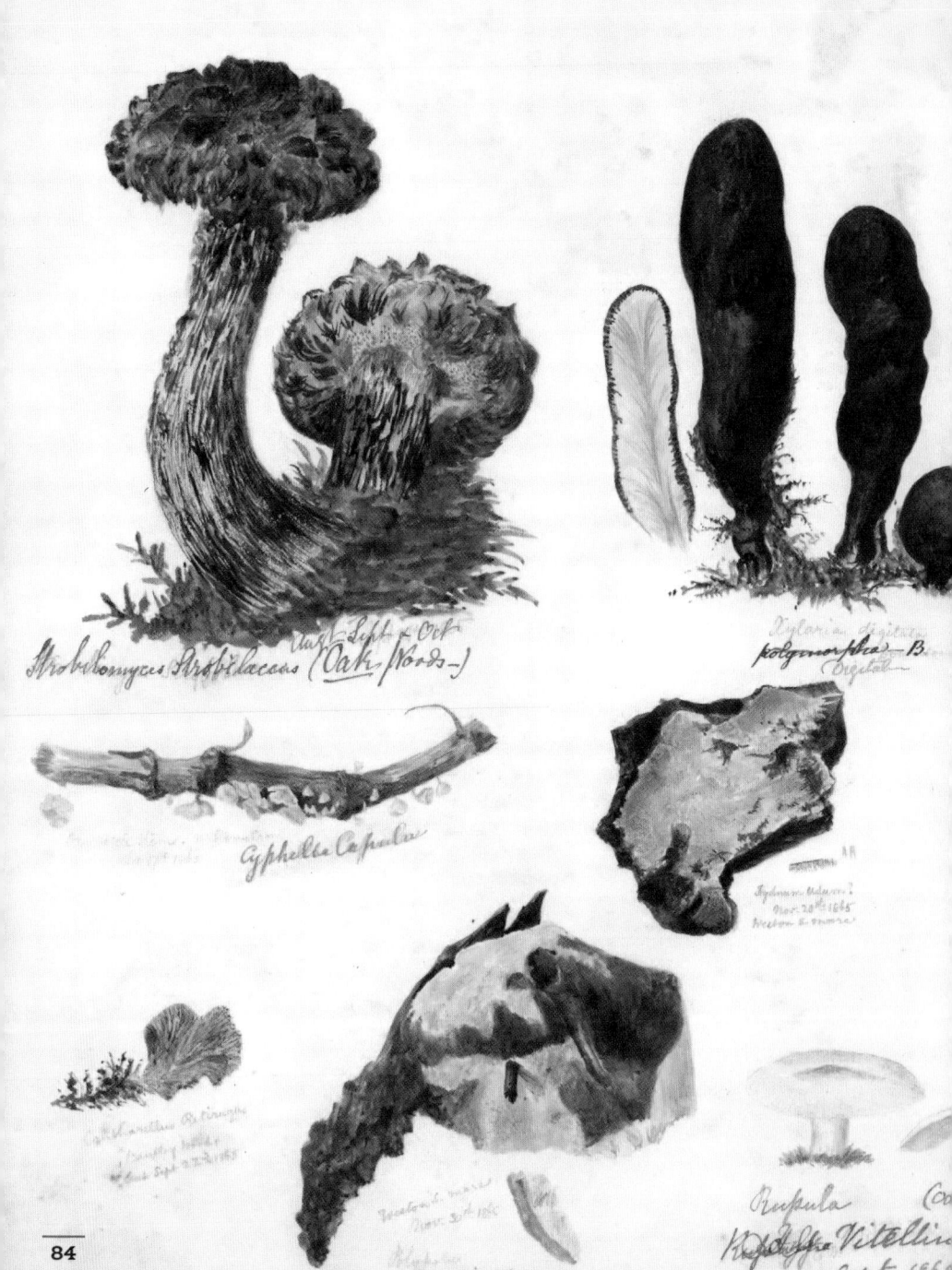

Strobilomyces Strobilaceus (Oak Woods -) *Aug. Sept. & Oct.*

Xylaria digitata polymorpha - B. digitata

Cyphella Capula

Hypoxylon Udum ? Nov. 20th 1865 Weston & more.

Helvellana Crispus

Mentone mare Nov. 3d 186

Hypholoma Quercinus.

Russula Vitellin Sept. 1868

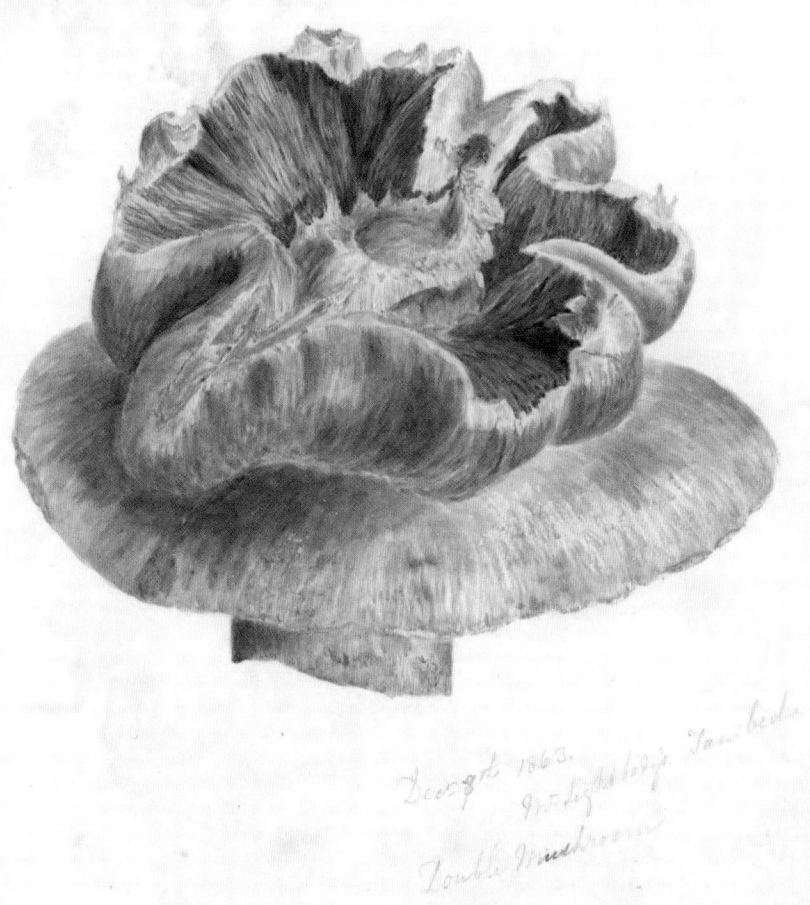

Deorgs 1863.
Intelightlodge Tambeda
Double Mushroom

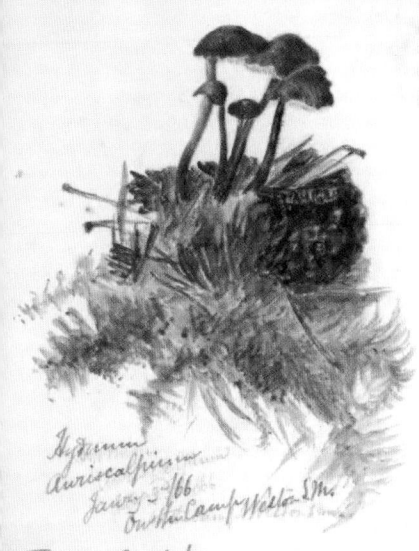

Hydnum
Auriscalpium
Jan 3/66
on the Camp Wilton Sur.

Camhan Capel /69

Polyporus. M.S.on

Polyporus annosus.

Arcyria Umbrina on an oak Stump
Guildfield June 4 of
1866

Guildfield Sept 1
Under the Knolls

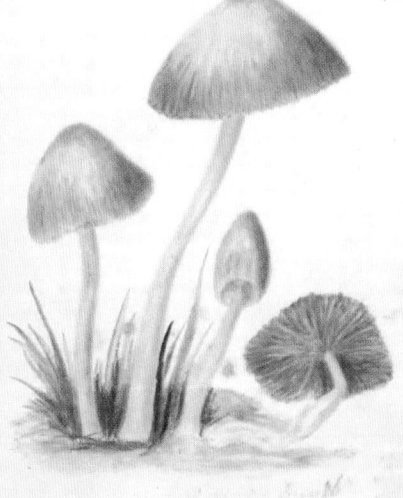

Ag spadicus greseus

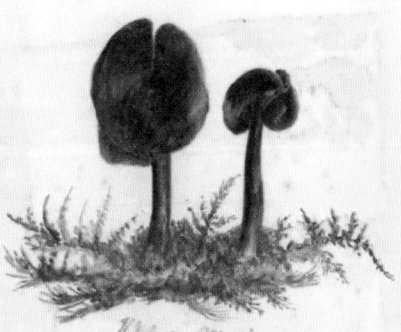

Helvella Ephippium
Oct 15th 1866 Boceyaned Place

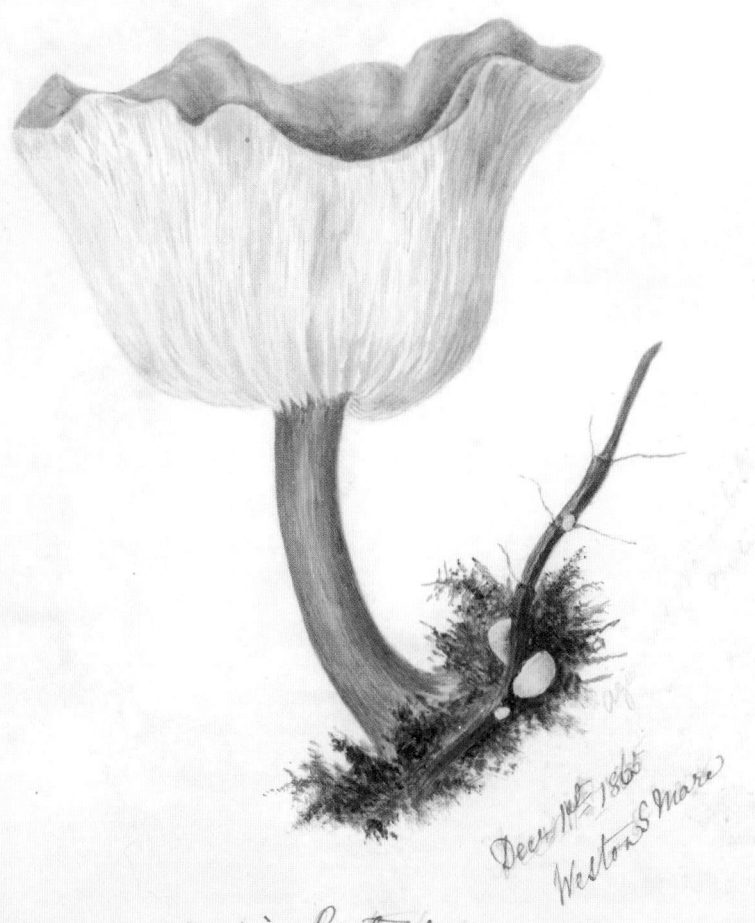

Agaricus Geotropus
De Witis

Dec 16th 1865
Weston S mare

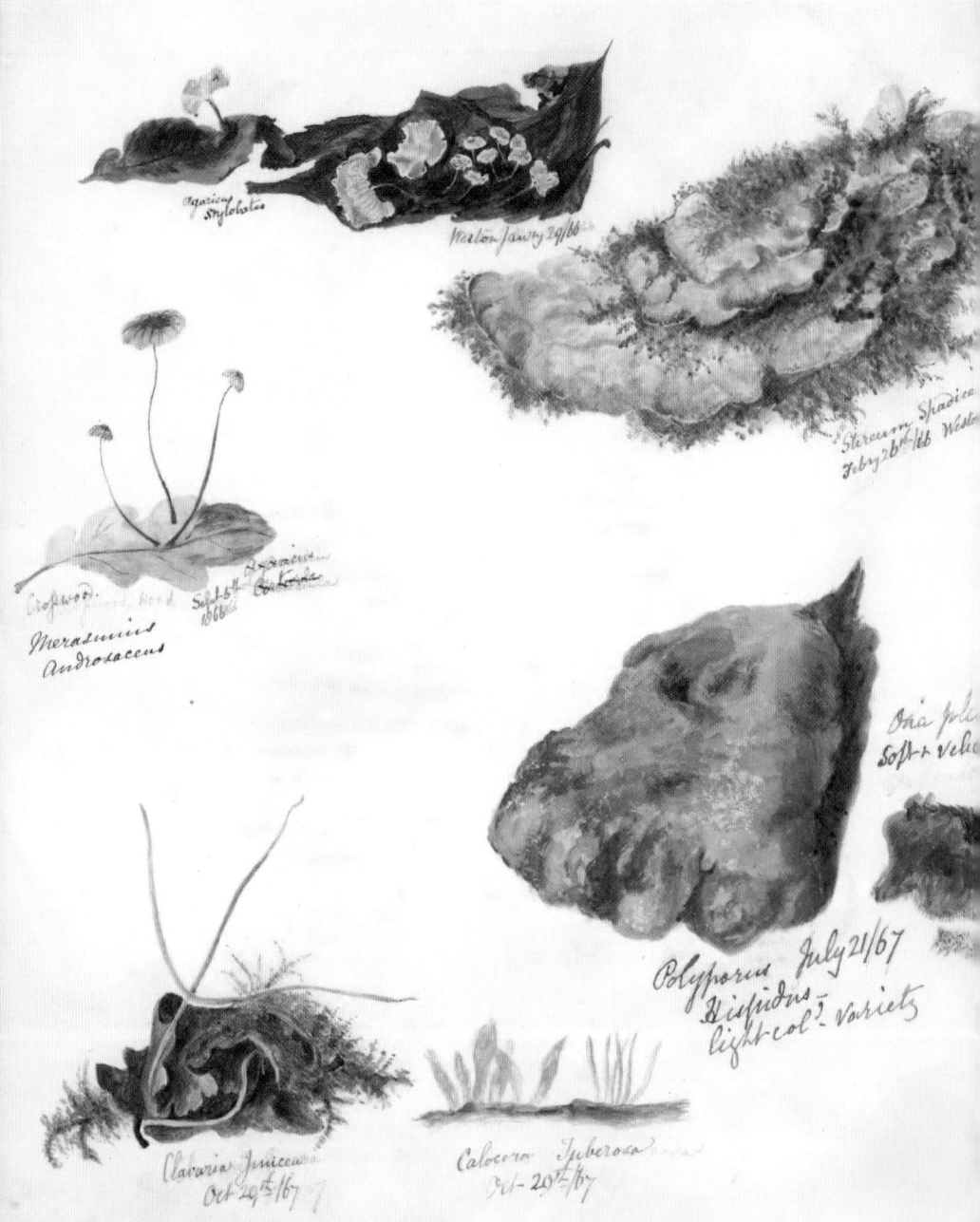

Agaricus
Stylobates

Melton Jan 29/66

Stereum Spadica
Feby 26th/66 Weston

Crofwood Wood Agaricus
Sept 5th Oakwood
1866

Merasmius
Androsaccus

Ovis pile
soft & velve

Polyporus July 21/67
Hispidus
light-col. variety

Clavaria Juncea
Oct 29th/67

Calocera Tuberosa
Oct 29th/67

1867

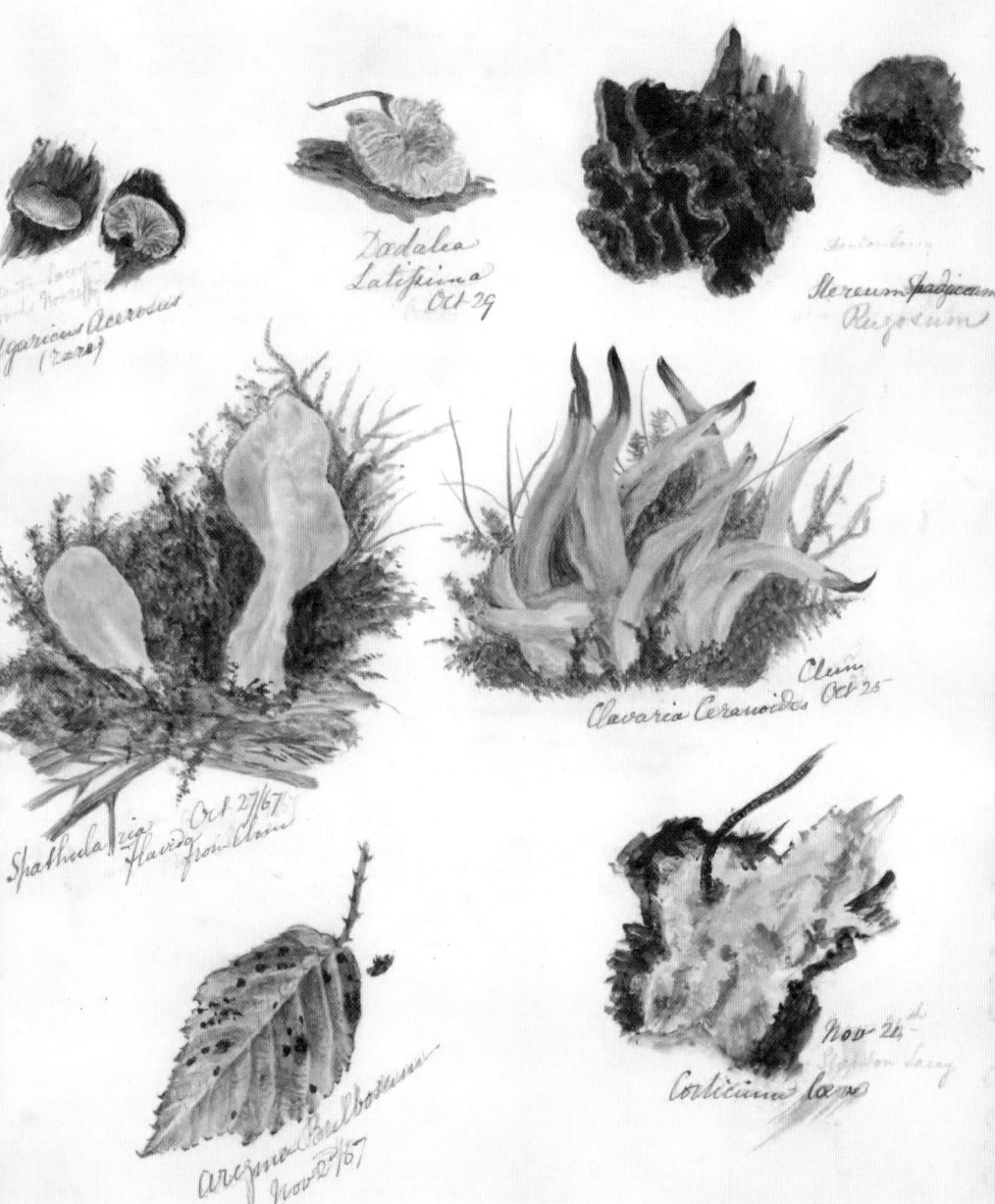

Agaricus Acerosus
(Varo)

Dadalea
Latifisma
Oct 29

Stereum Spadiceum
Rugosum

Spathularia Oct 27/67
Flavida from Clim

Clavaria Ceranoides Clim
Oct 25

Arejmea Pealbotiana
Nov 2/67

Nov 21st
Corticium Lave

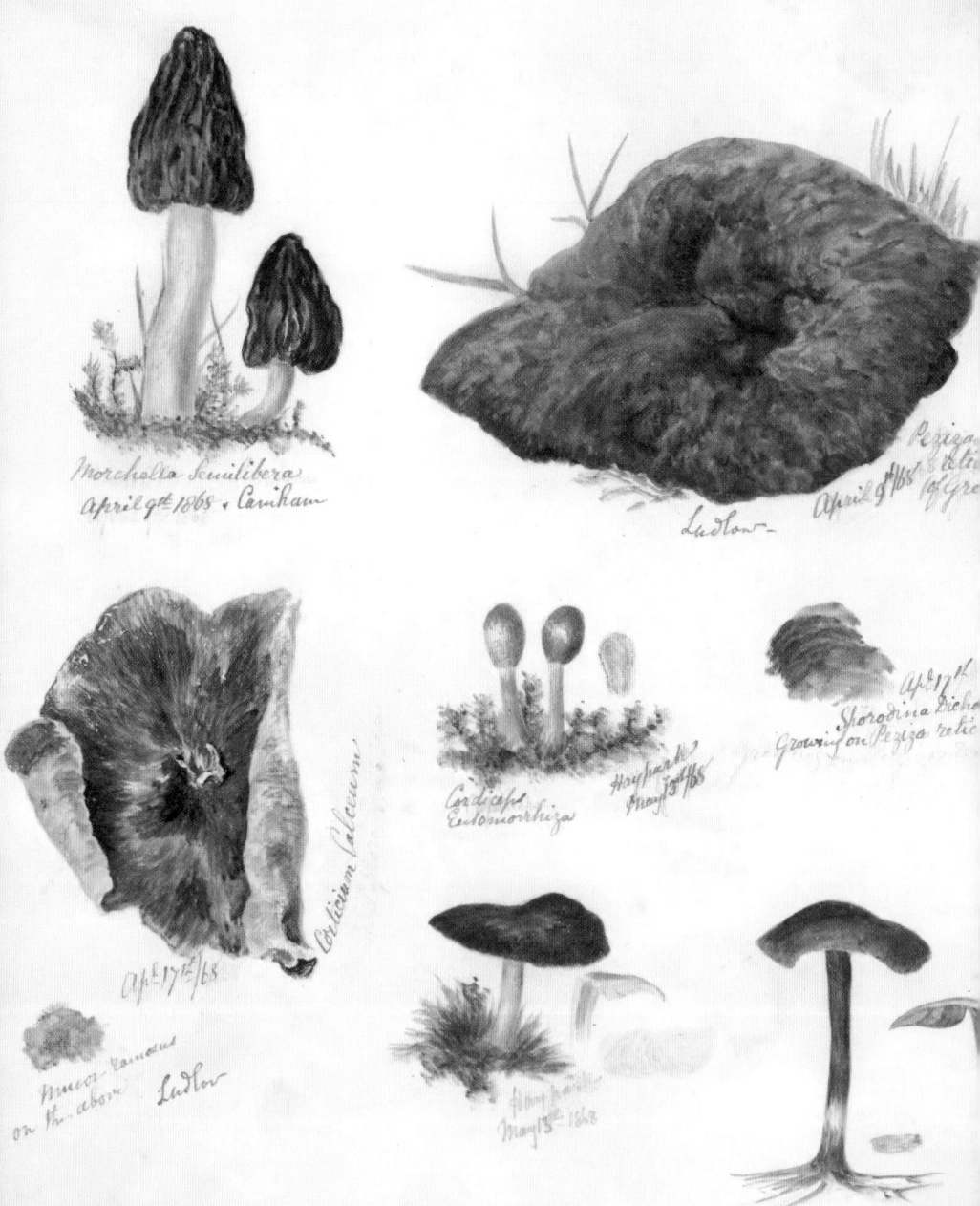

Morchella semilibera
April 9th 1868 & Carnham

Ludlow — April 9th/68

Peziza
aticea
(of Greg

Corticium calceum

Cordiceps
Entomorrhiza

Hazmarde
May 13th/68

Apl 17th
Sporodina Dicho
Growing on Peziza retic

Apl 17th/68

Mucor ramosus
on the above

Ludlow

Hazmarde
May 13th 1868

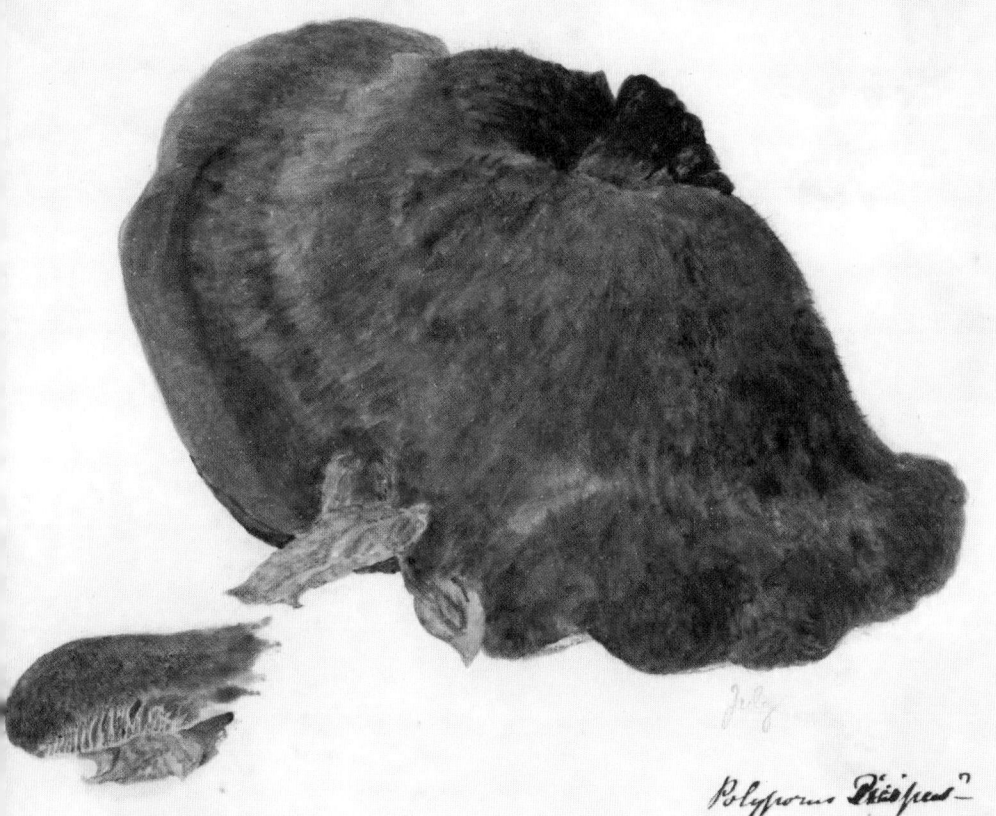

July

Polyporus Rhinoceros
Scales

91

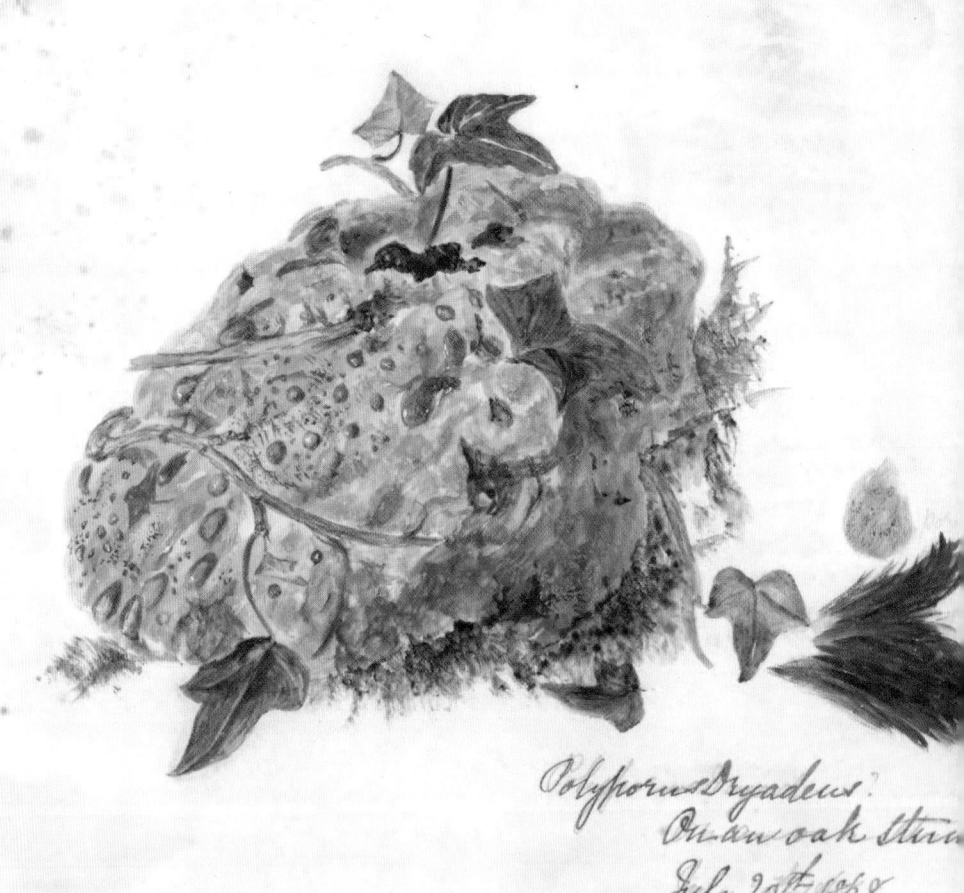

Polyporus Dryadeus?
On an oak stum
July 20th 1868

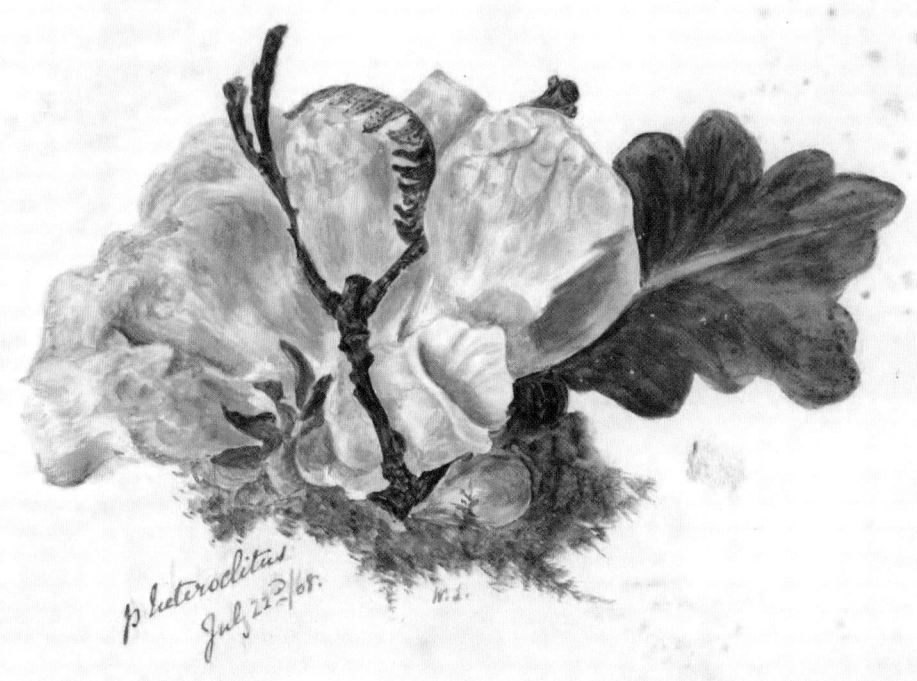

p. heteroclitus
July 22ᴰ/08.

W.S.

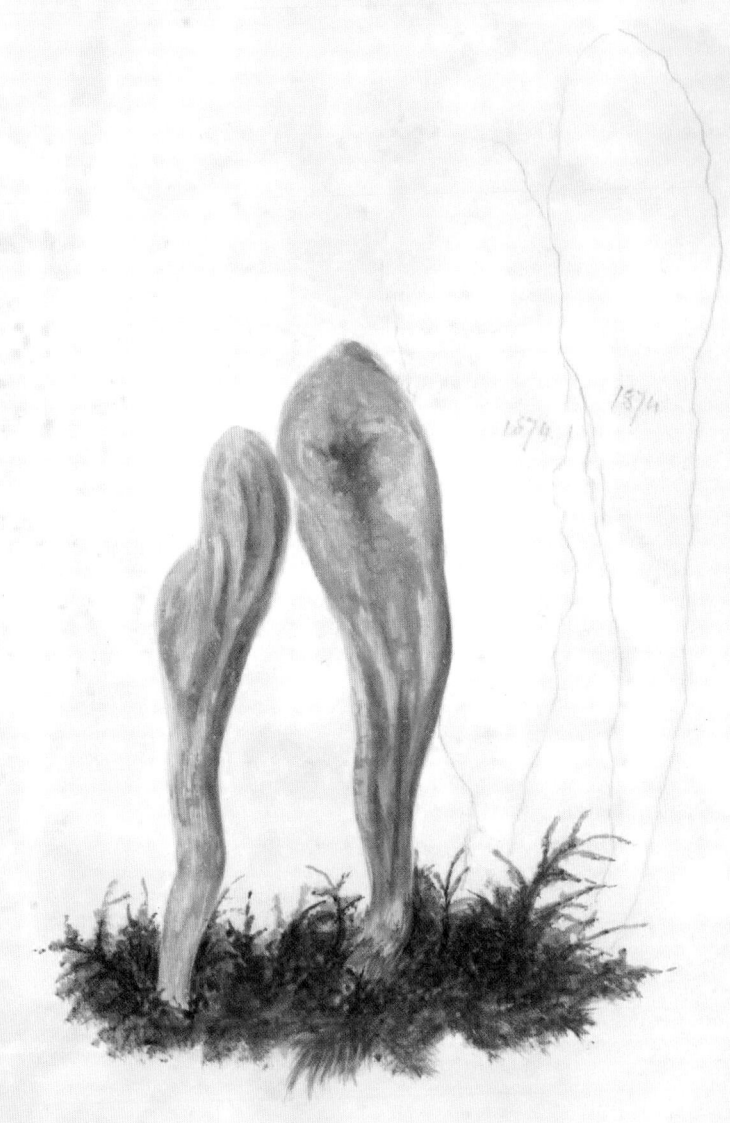

1874 1874

Clavaria Pistilla

Oct 16th
Oct 31st

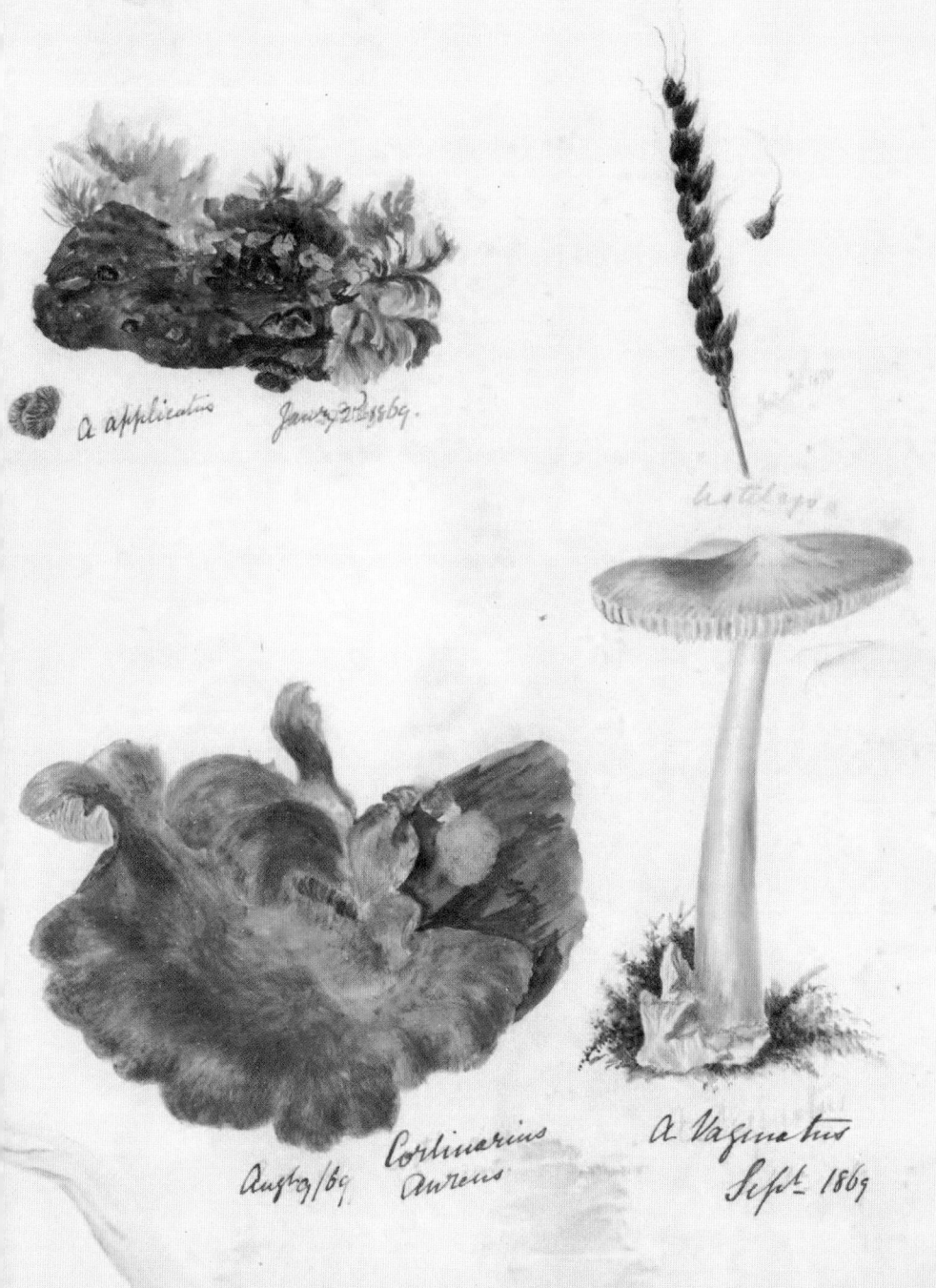

A applicatus Jan'y 2d 1869.

Cortinarius
Aureus
Aug 9/69

A Vaginatus
Sept 1869

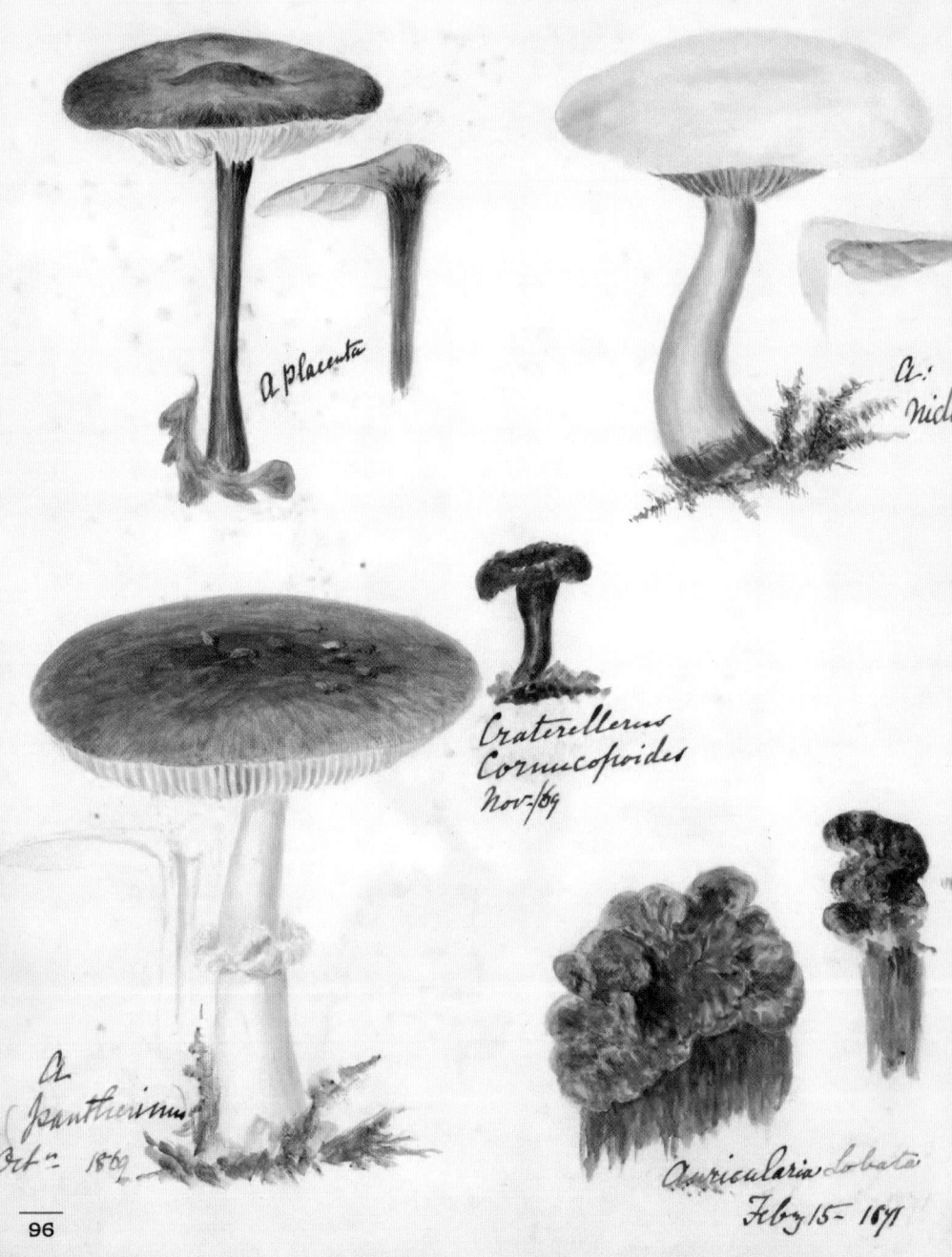

Ludlow

A placenta

A. nido

Craterellus
Cornucopoides
Nov-/69

A
pantherinus
Oct. 1869

Auricularia lobata
Feby 15- 1871

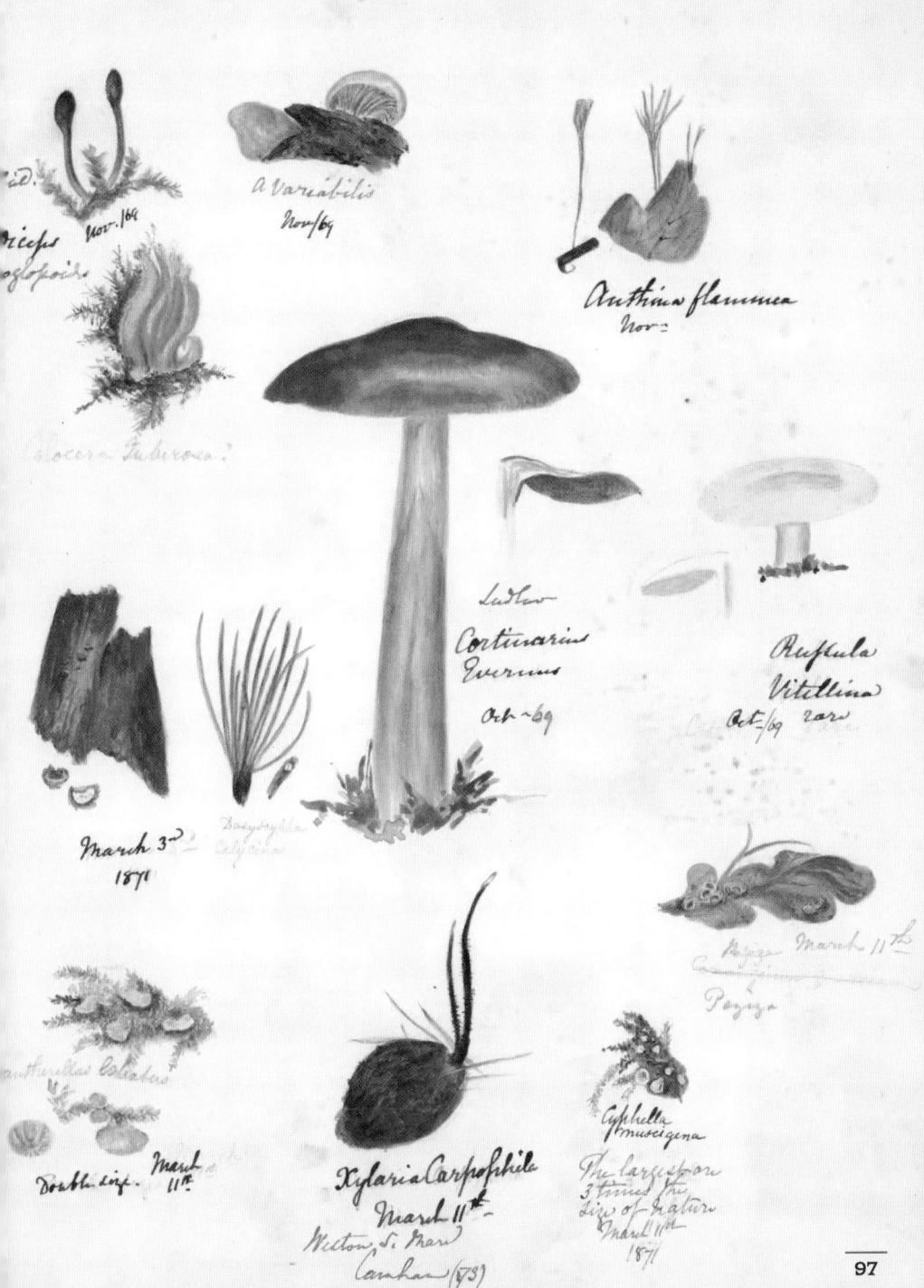

...id.

...iceps Nov. /69

...gospoides

...locera Tuberosa?

A. Variabilis
Nov/69

Anthina flammea
Nov -

Ludlow
Cortinarius
Everims
Oct~69

Russula
Vitellina rare
Oct./69

March 3rd
1871

Daedygrybla
Calycina

Peziza March 11th

Peziza

...antharellus Cellader

Double ing. March
11th

Xylaria Carpophila
March 11th
Welton S. Mary
Carnhan (73)

Cyphella
muscigena
The largest on
3 times the
Size of Nature
March 11th
1871

Oxford
July
1871 *Roestilia*
lacerata

Calocera Viscosa
Shawbury Heath.
Oct 17/71

*Cantharellus
aurantiacus*
White Variety

a Lorideluus
Oct 15th

Oct 15
*Hygrophorus
lilac variety*

Shawbury Heath
under fir trees

Lactarius controversus?
Caynham Camp Sketch 7th/71

Cor
Caynham Camp Callow

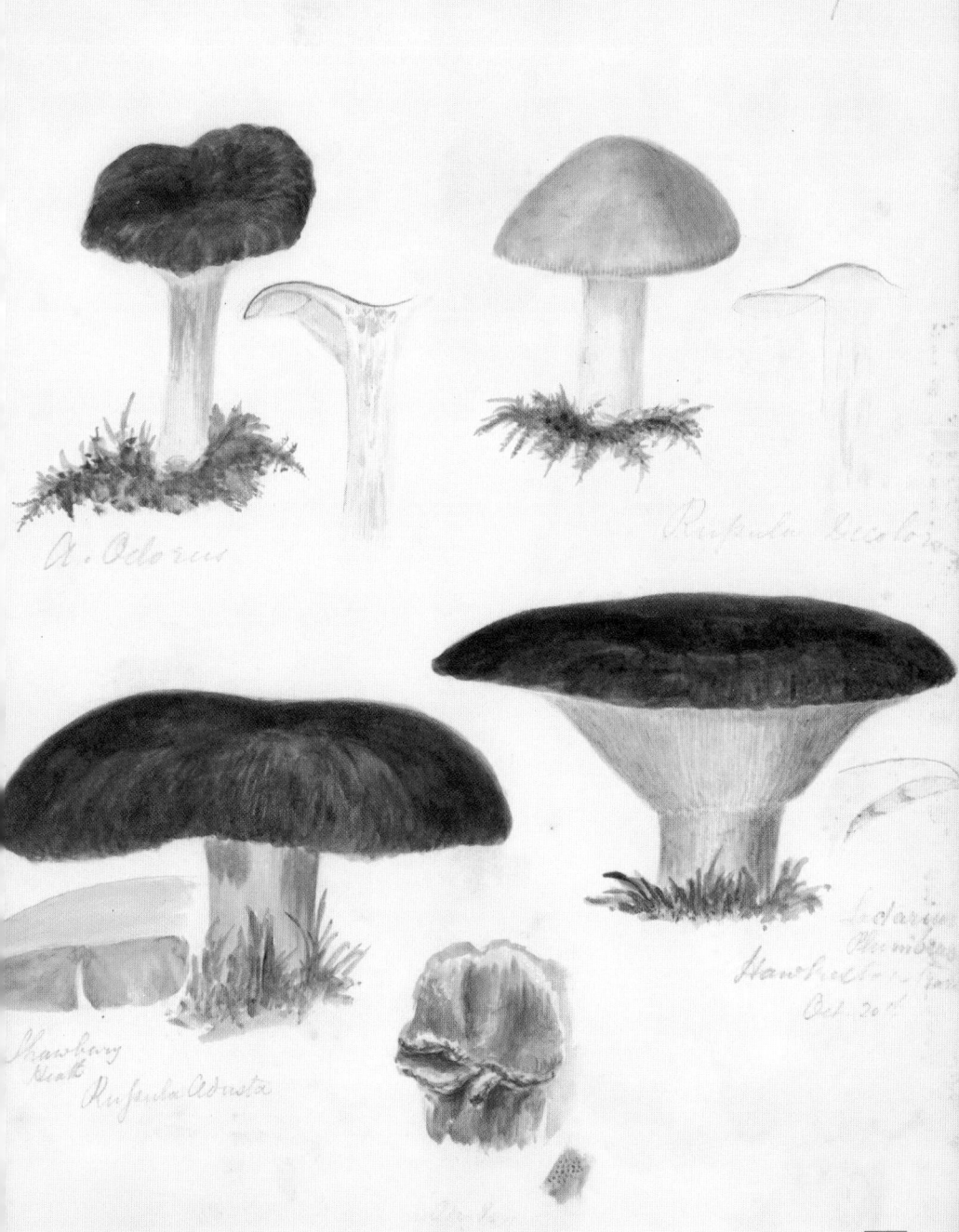

A. Odorus

Russula decolora

Strawberry
Heath
Russula Adusta

Lactarius
Plumbeus
Stansfield's farm
Oct. 20

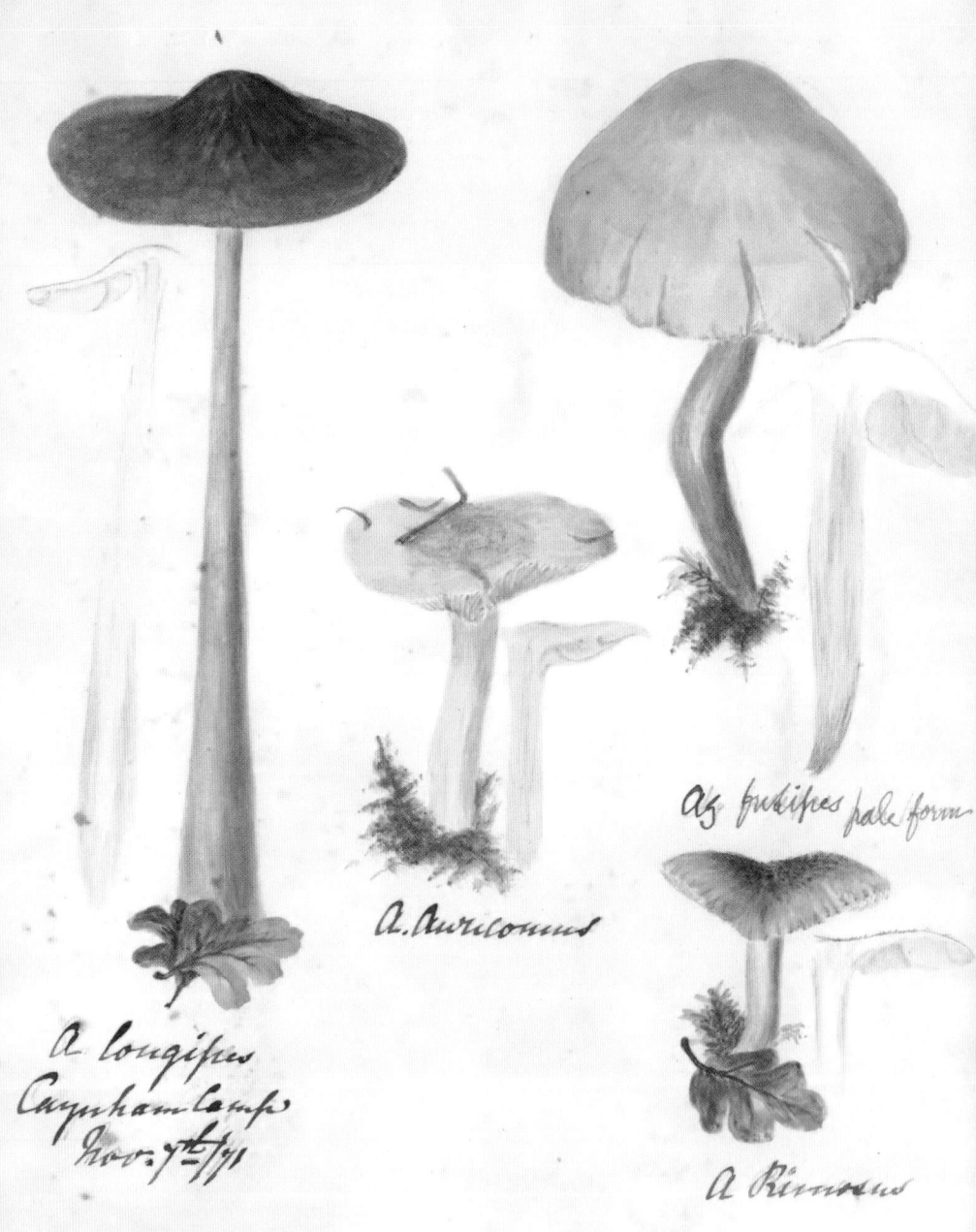

A. Auricomus

A'g. fuscipes pale form

A longipes
Caynham Camp
Nov. 7th/71

A. Rimosus

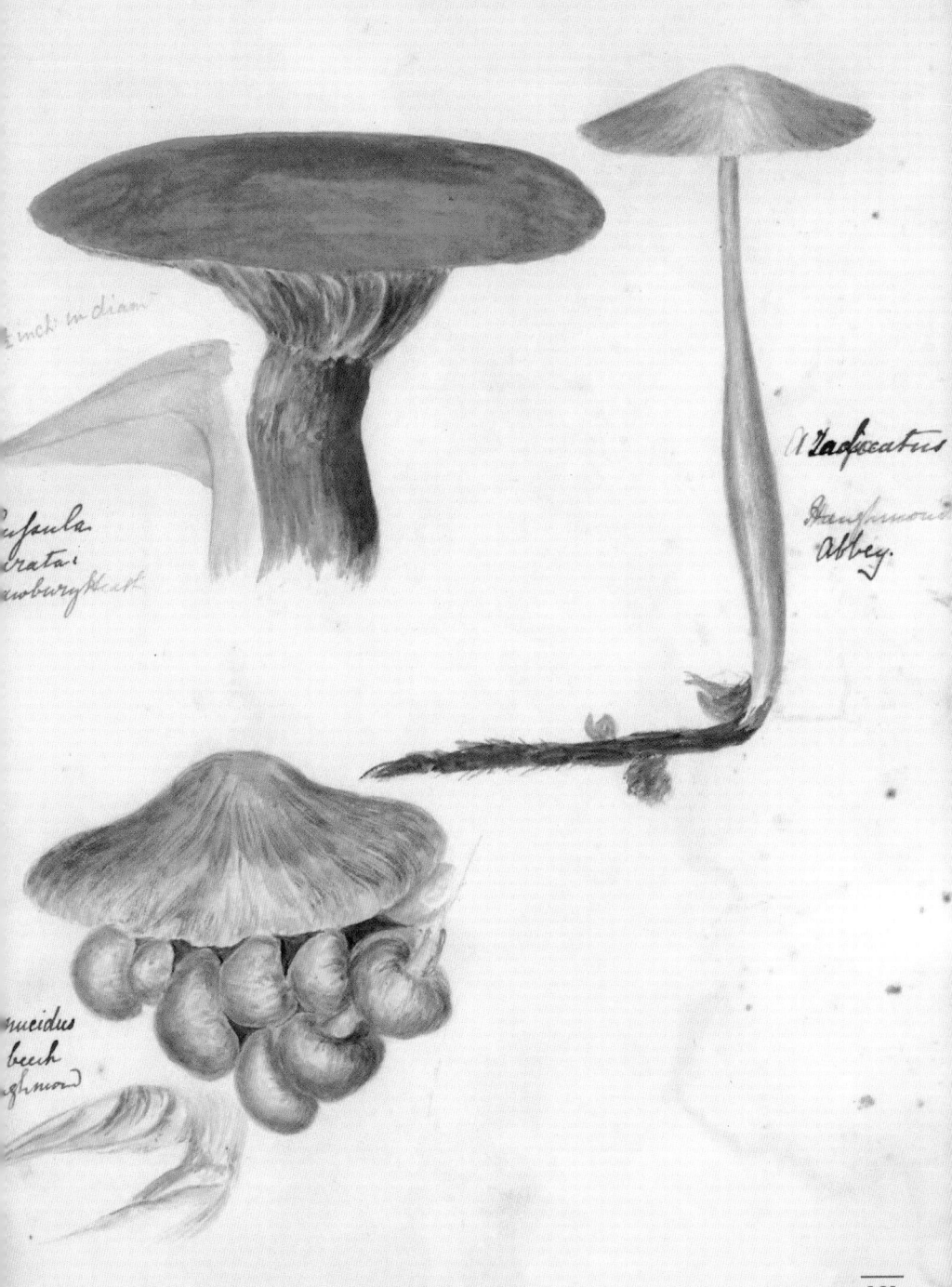

¾ inch in diam?

Russula
grata?
Shrewsbury Hunt

A radicatus

Dunkenwood
Abbey.

mucidus
beech
Highwood

Puccinia
Anemones

Caïnham Camp

Aecidium ? on one
March 13th 1873

Caïnham

Melampsora
Populina
V.

Uredo filicum
on Cystoperis fragilis

Russula
Ochraleuca
Fir woods
Shawburyheath

Lactarius de
Fir woods
Shawburyheath

Thelephora fastidiosa

Sept 18
1872

Smells like a
fox

Ann Churchyard.
June 2d 1886

Geaster Coryanti
under ye Tree

Sept 14
Oldfield

Oct 9th 1872

Geaster Hygrometricus
Rare rare. Middlebury
(named by Mr Broome).

VOLUME
III

Fungi

Collected

in Shropshire

and other

Neighbourhoods.

1896

Uricinula
Bicornis?

On Mountain
Ash leaves
Sept 6th/75

Puccinia
gracilis.
Sept 6th/75

Podisoma
Junipere - Sabinae. April 22/76
from Miss Hall.

Sunny gatten
May 18th/76

1873

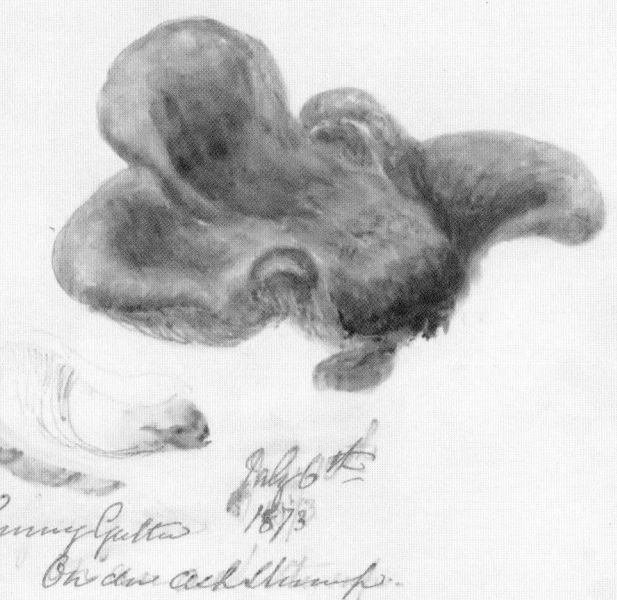

Coprinus
radians? Trowscoed July 12th

Butter Cross Ludlow

July 6th
1873

Lining Gutta

On an Oak Stump.

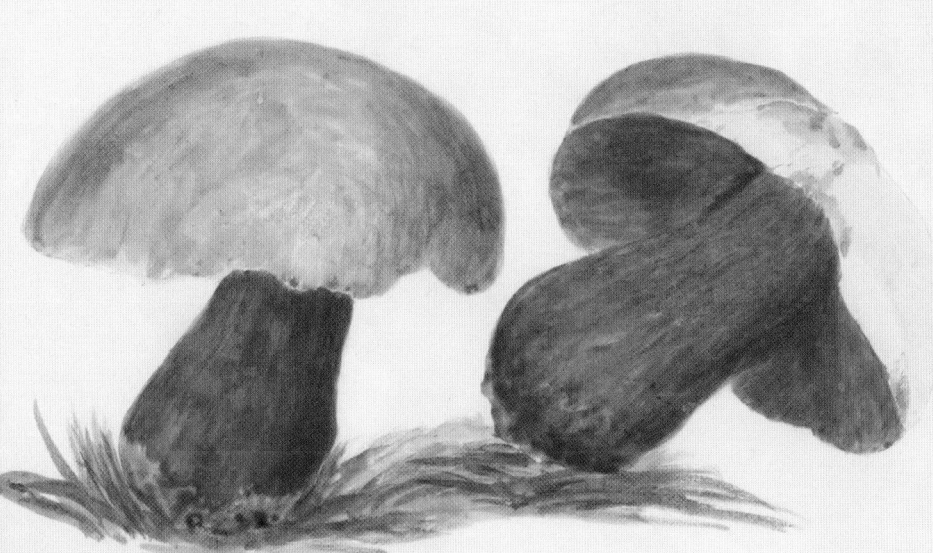

Boletus Satanas
Croft Sept 9th

107

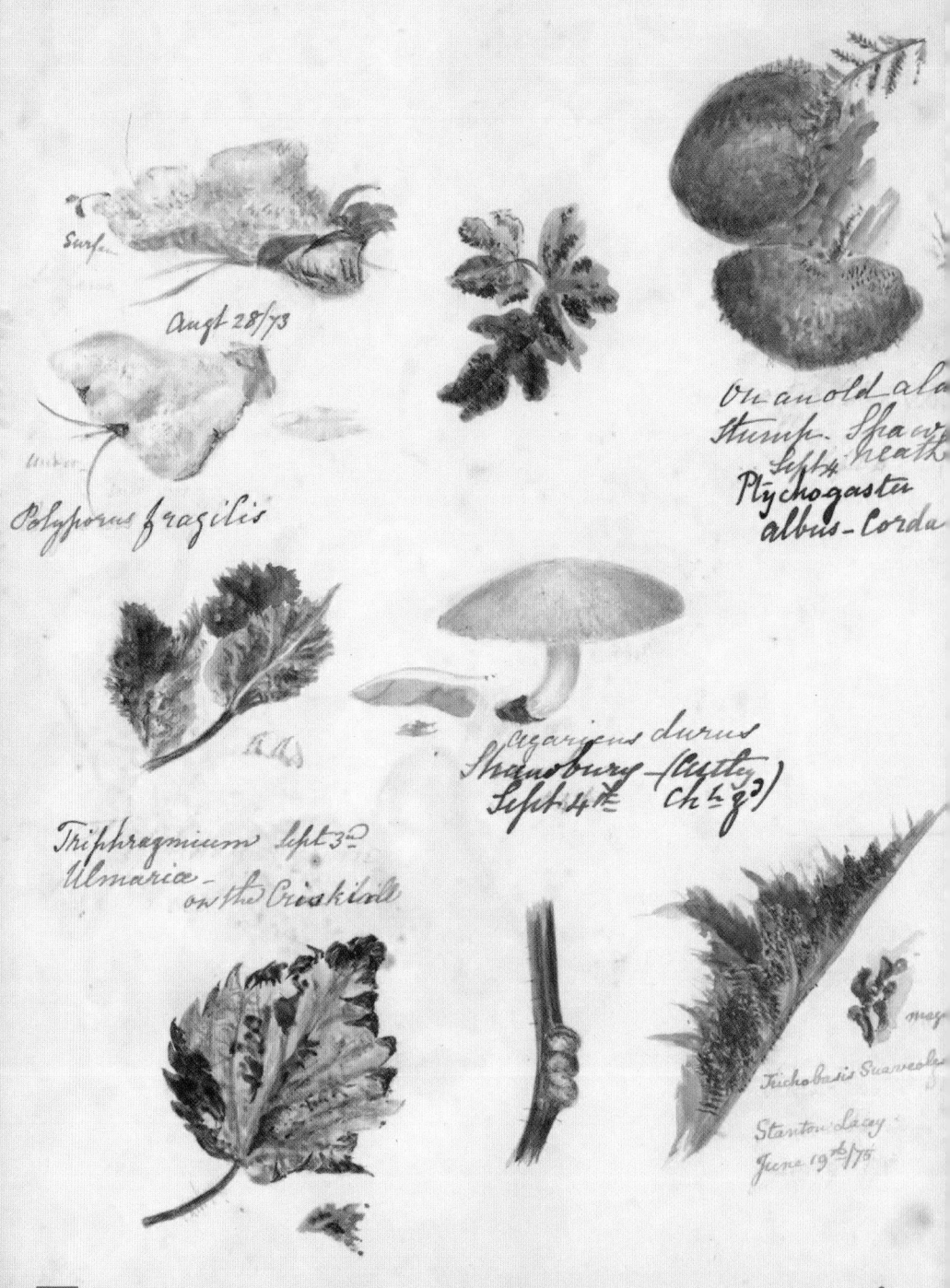

Surfer

Augt 28/73

Polyporus fragilis

On an old _ala_
Stump. Shaw
Sept 4 heath
Ptychogaster
albus - Corda

Agaricus durus
Shrewsbury - (Astley
Sept 4th (ch ↳ g?)

Triphragmium Sept 3d
Ulmaria -
on the Criskitoll

Trichobasis suaveolens

Stanton Lacy
June 19th/75

108

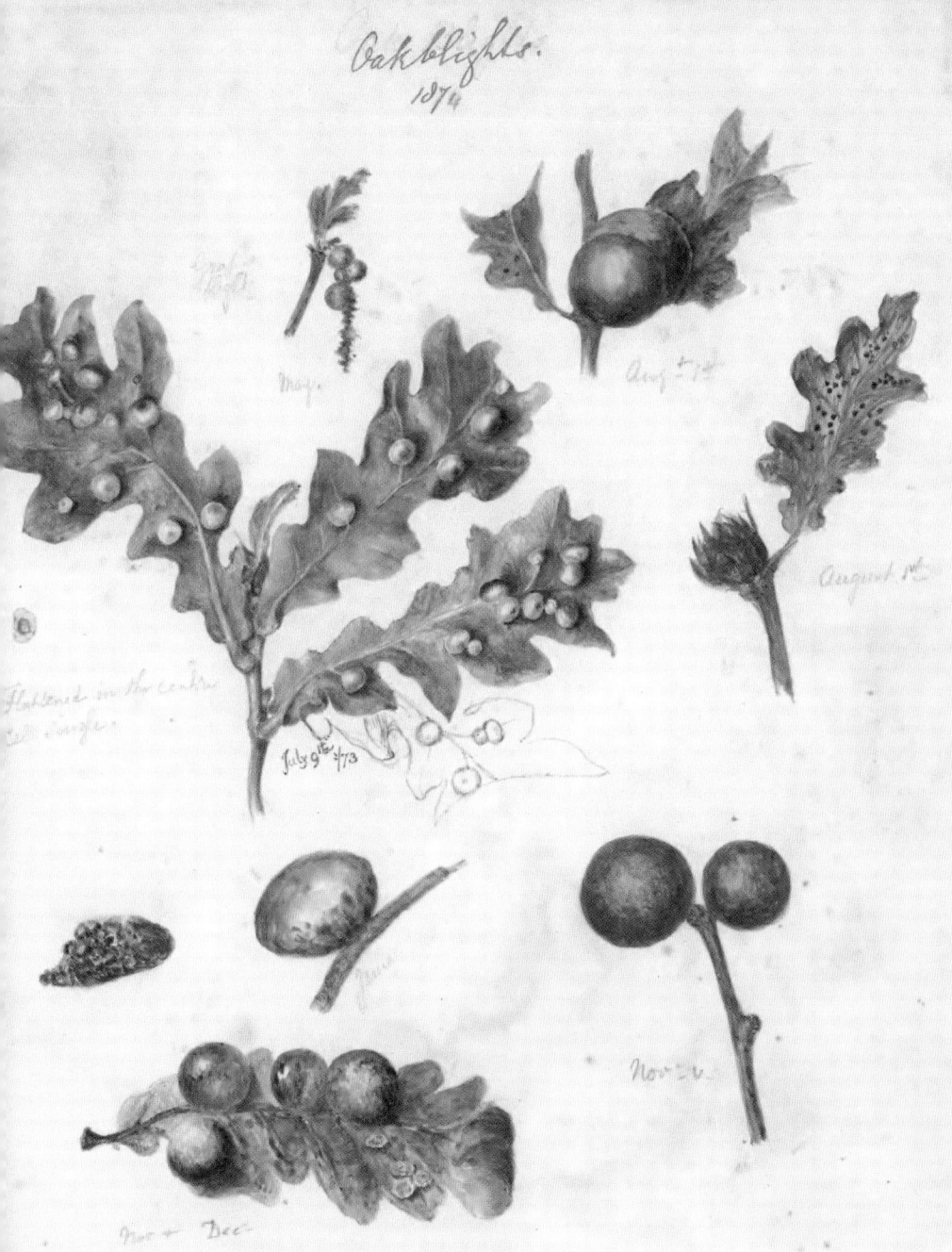

Oakblights.
1874

May.

Aug.t 74

August 1st

Flattened in the centre
Cell inside.

July 9th 7/3

June.

Nov r 26

Nov + Dec

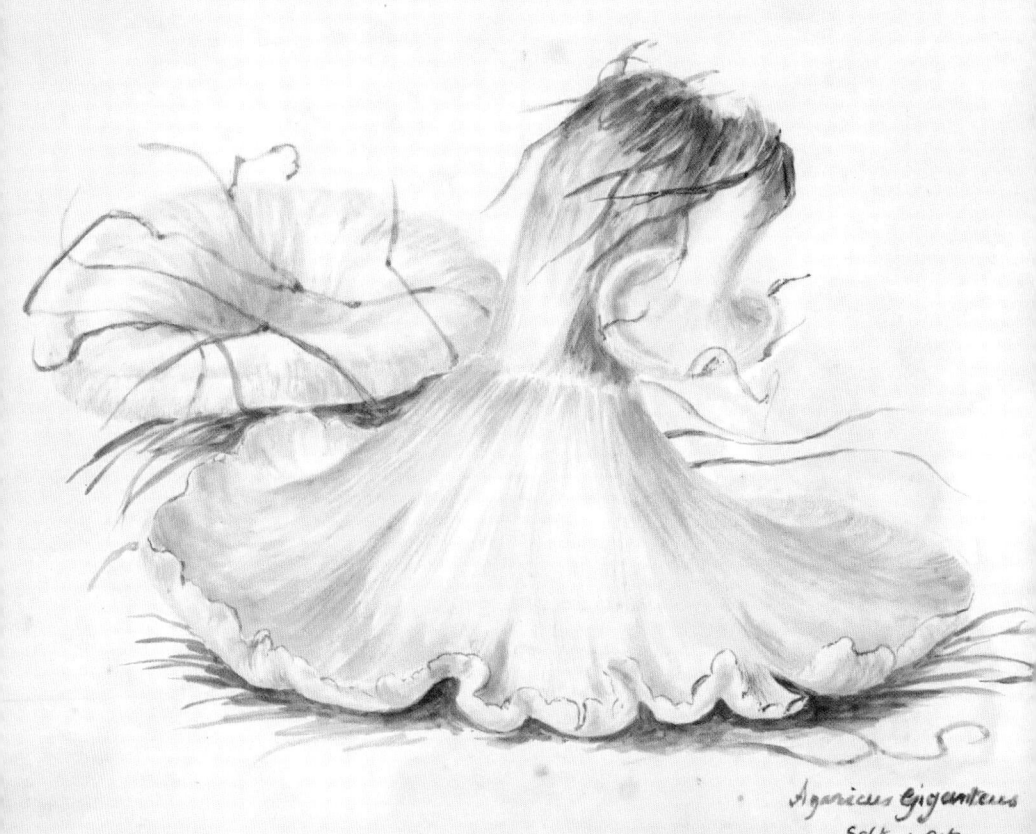

Agaricus Giganteus
Sept ~ Oct

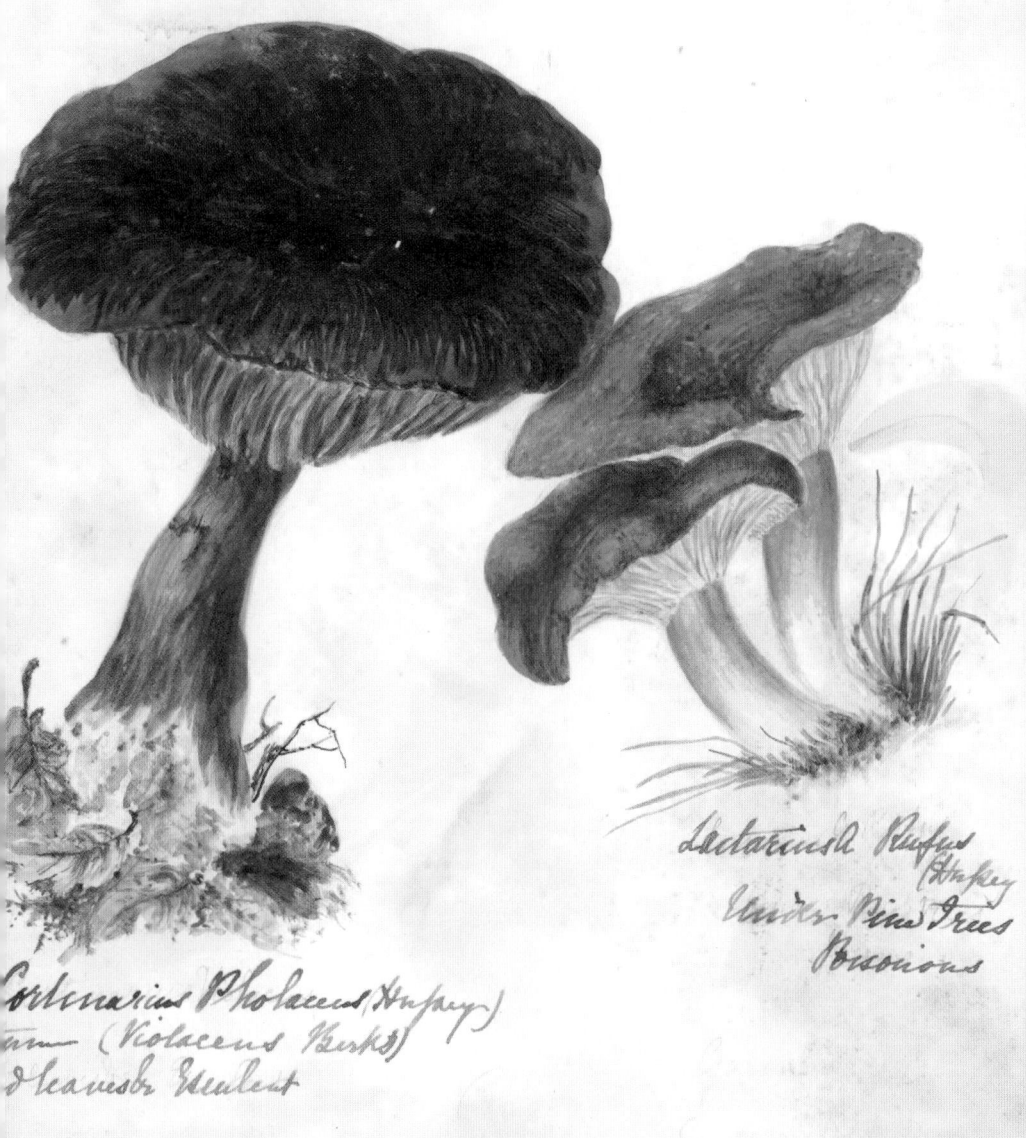

Lactarius Rufus
(Helfey)
Under Pine Trees
Poisonous

Cortenarius Pholaceus (Hefrey)
um (Violaceus Berks)
d'leaves to Esculent

Purple
Ferguson Poppy
heads. July 9th/75
Shawbury

July 22nd/75
Ringwood.

Peziza Hum...
Jany 11th

Puccinia
Feba
July 26th 1875.
Buck's barn.

Sept 1st/75

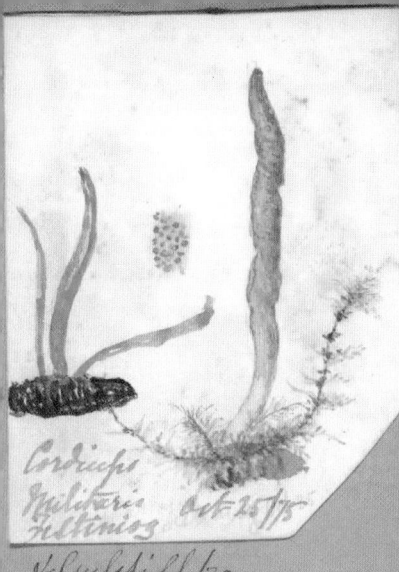

Cordiceps
Militaris
Robinios Oct 25/75

S. Guilsfield/79

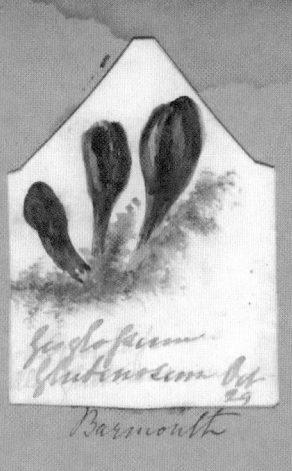

Geoglossum
Glutinosum Oct
29
Barmouth

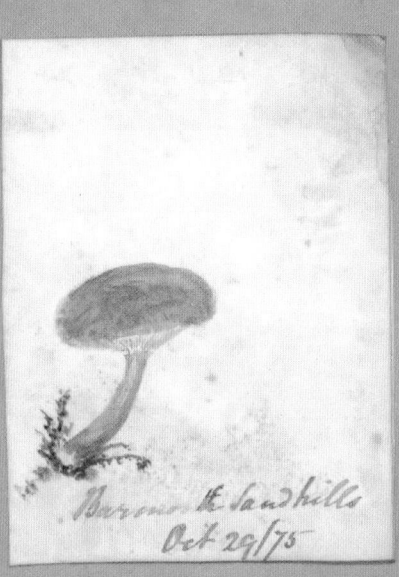

Barmouth Sandhills
Oct 29/75

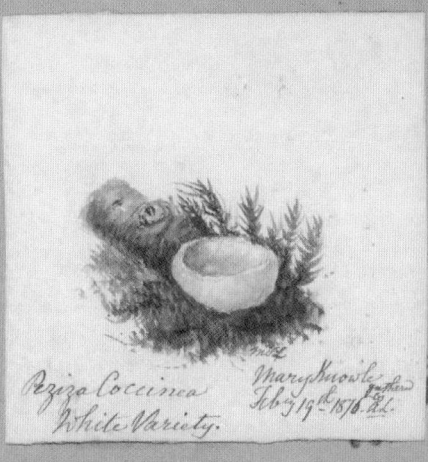

Peziza Coccinea
White Variety.

Mary Knowles
Feb y 19th 1876. AL

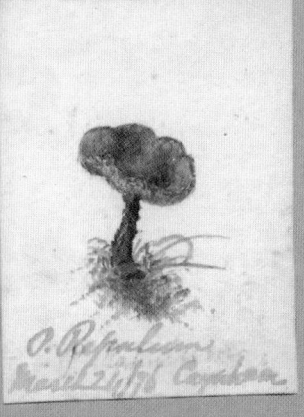

O. Populinus
March 21/76 Cynham

Aecidium
Euphorbiae
Mary Knowle
June 13/76

Uromyces
Appendularia?
June 14th/76
Bitterley

Aecidium
Tussilaginis Burla
June 17

Ustilago Typhoïdis
Buildwas

Peziza Succ
from Mr Nearu
Garden Oc

1877

Aecidium
Urtica
1877

Roestelia
Lacerata.

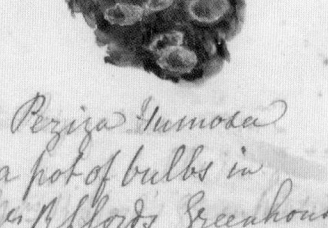

Peziza Tumosa
a pot of bulbs in
Mrs R Lloyds Greenhouse
March 2t 1878

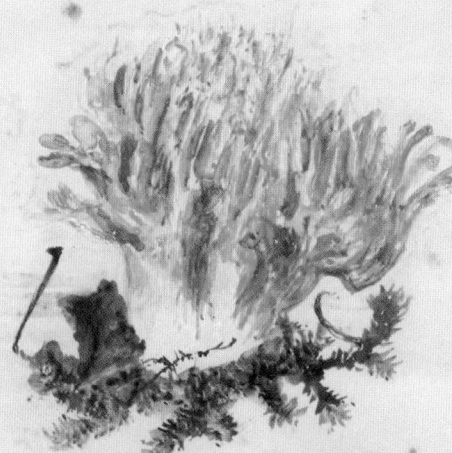

Clavaria Crispula?
Sunny Gutter — July 15th
from Mr Calver? 1878

1878

Boletus
Whixall Moss Aug
1878

Sept 28

P Coh.

Peziza liparina

Sept 28

Cortinarius sanguineus

Cantharellus Tuba

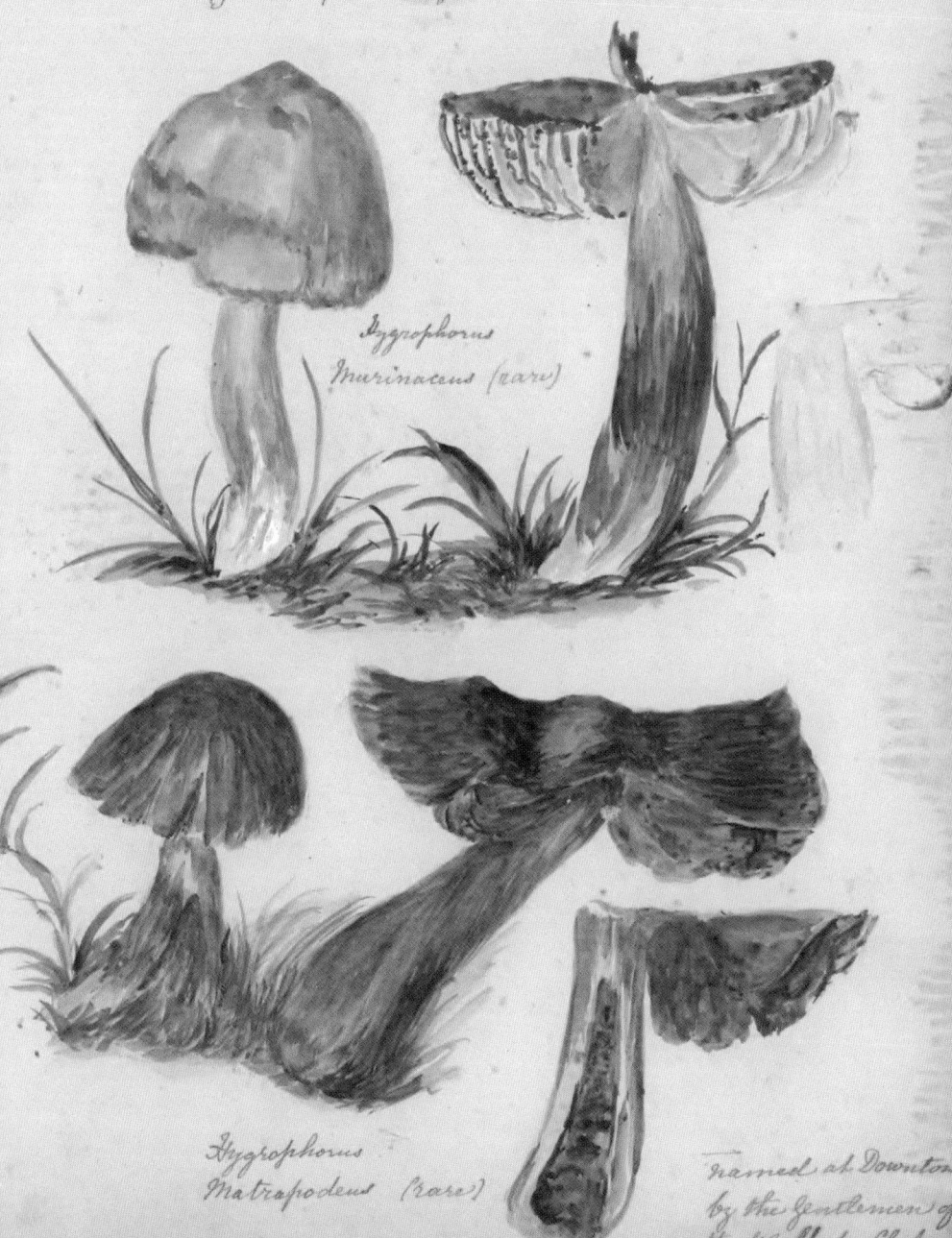

From View Edge Oct 2ᵈ 1878.

Hygrophorus
Murinaceus (rare)

Hygrophorus
Matrapodens (rare)

named at Downton
by the Gentlemen of
the Woolhope Club
Oct 4ᵗʰ

1878 Downton
Oct 4th

Clavaria
amethystina.
Oct 4th

Hygro: Adusta
Downton. Oct 4th

Alphouse
grown
Jany 8/80

Dadalea roseca
or latifima

Marasmius
archyropus?

Hyg.
Unguinosus

118

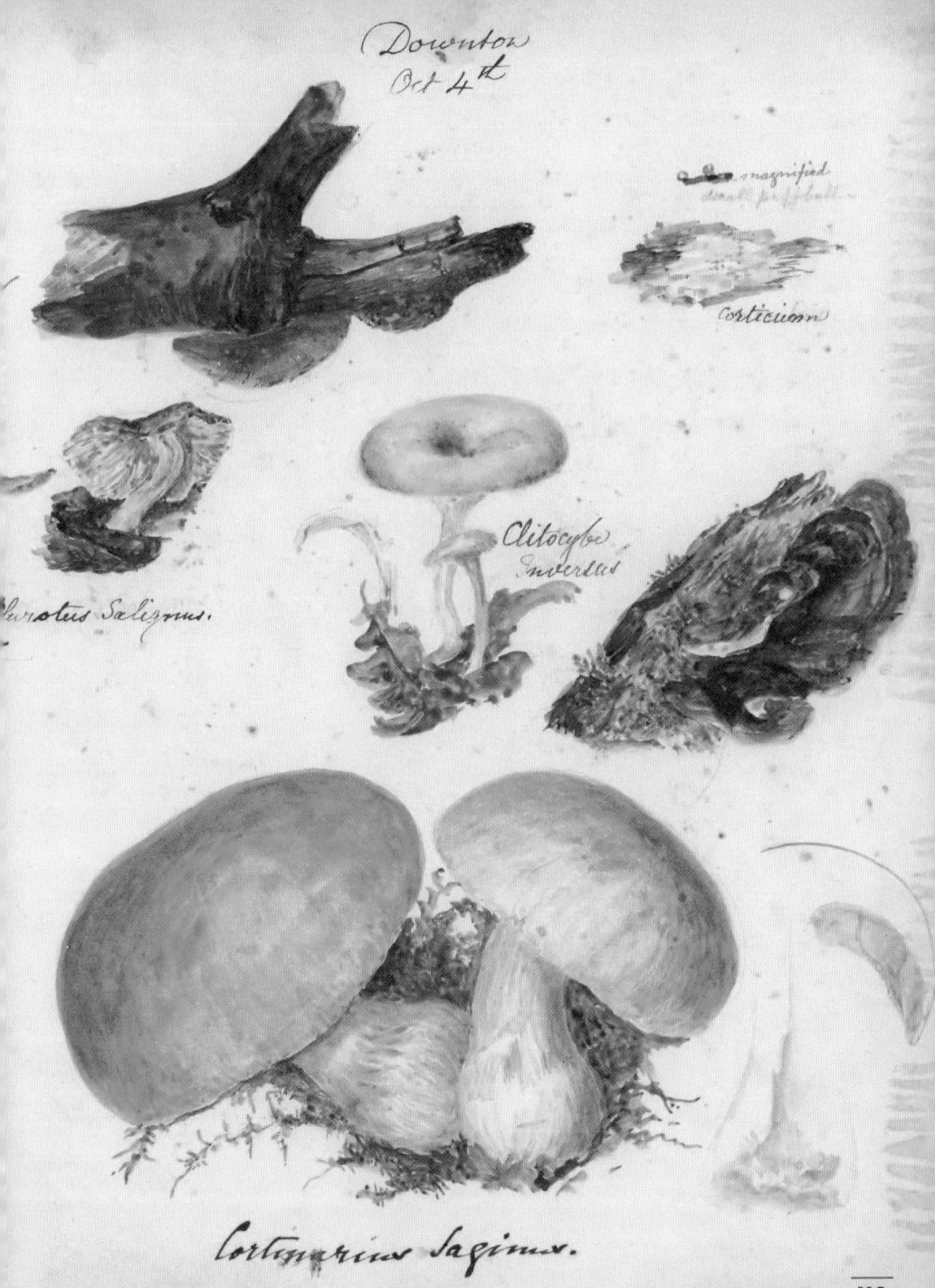

Downton
Oct 4th

magnified
small puffball

Corticium

Pleurotus Saligrans.

Clitocybe
Inverdus

Cortinarius Saginus.

Tricholoma
Coxxxxx

Tricoloma Sulphura
Downton
Oct 4th

Sepedonium
Chrysospermum.

Physarum Oct
Aureum bulbiforme
from Water's meet. Lyme

Thelephora

Marly Knowle xxx
Oct 13th

Lactarius
Deliciosus

Lactarius volemus

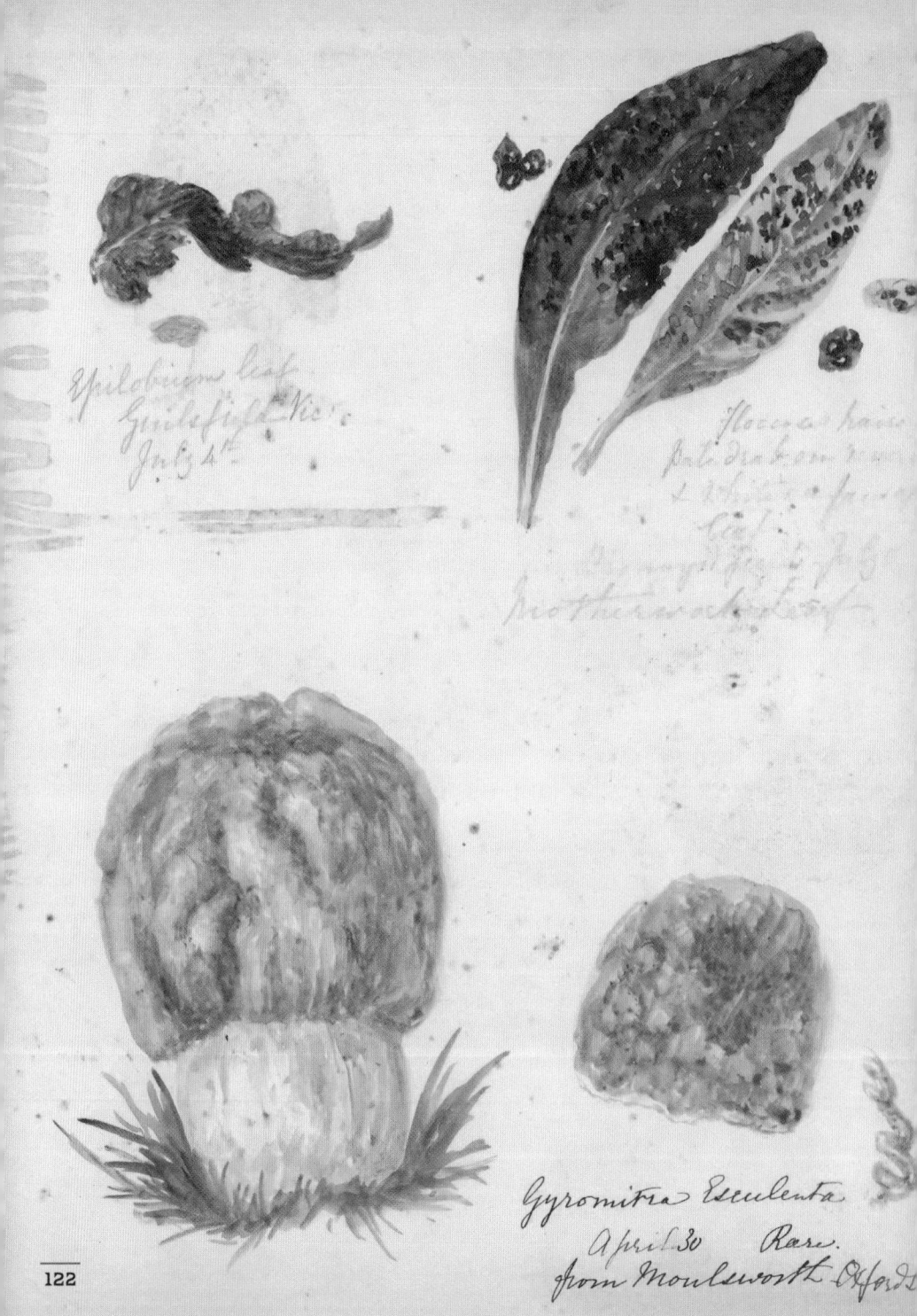

Epilobium leaf
Guilsfield Vic.
July 4th

flower from
pale drab on margin
+ white spaces
leaf
motherwort leaf

Gyromitra Esculenta
April 30 Rare.
from Moulsworth Oxfords

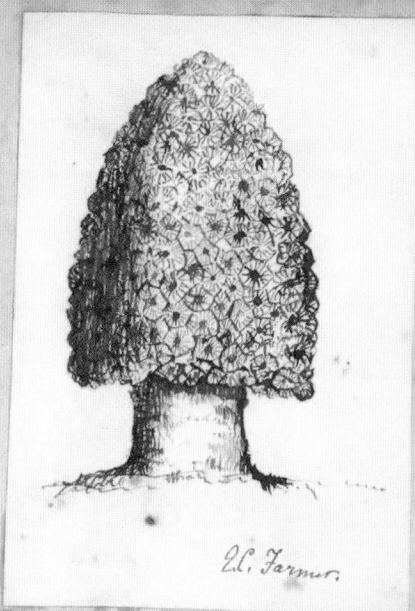

U. Farmer.

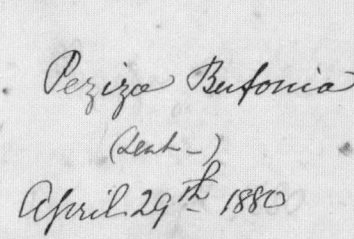

Peziza Bufonia?
(Leat.)
April 29th 1880

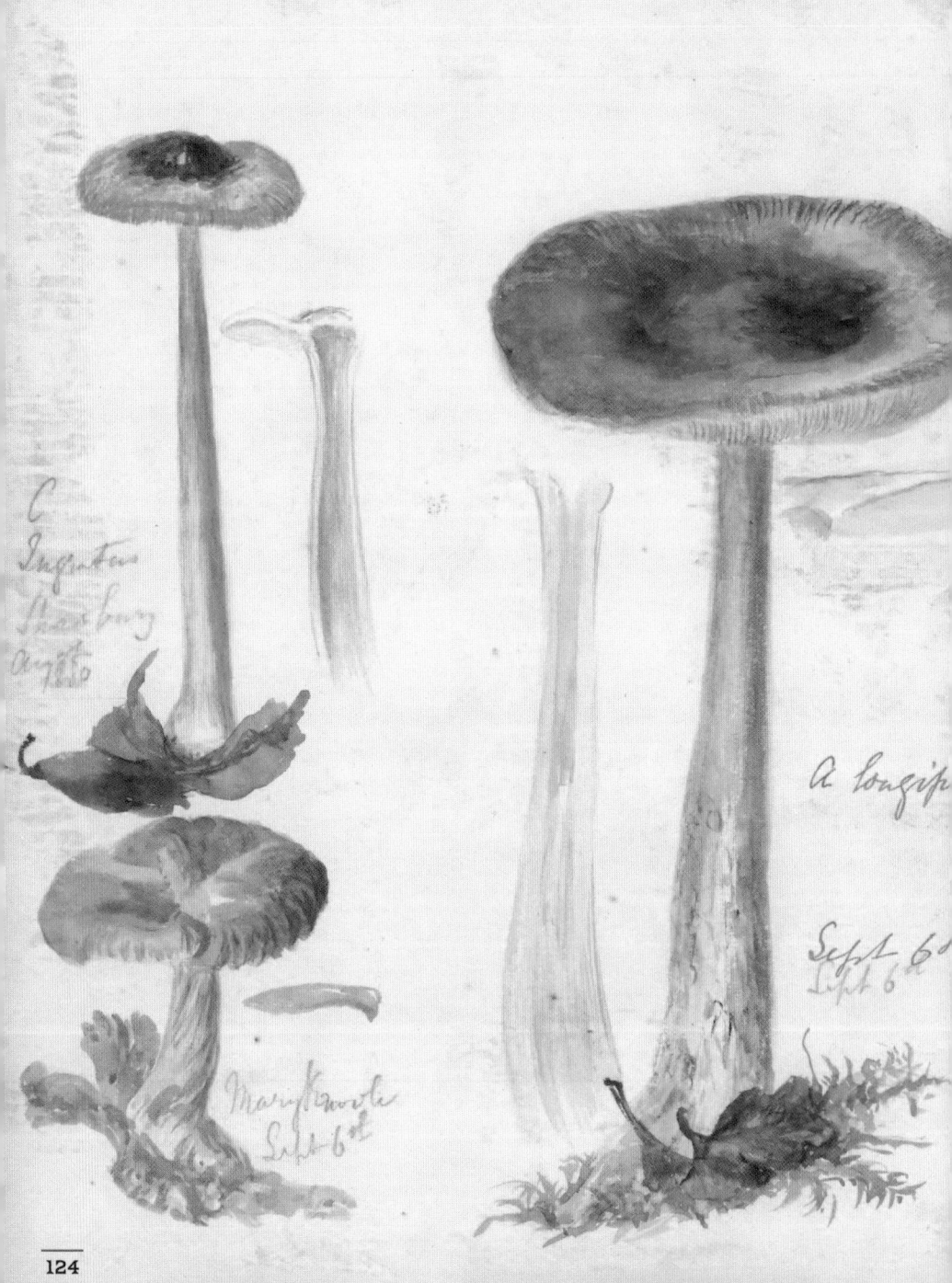

C
Ingratus
Shrewsbury
Aug 1860

Marylewode
Sept 6th

a longip.

Sept 6th
Sept 6th

omyces Intrusa
Lady's Mantle
May 28/80

Sept
6th

Craterellus
helvelloides
80 Sept 16 from
dons. Switzerland & Salzberg
aterellus latescens 1887

Clavaria
Contorta ♀
Sept 16th

Switzerland

Cantharellus
Infundibuliformis.

spula or
Flaccida
C.
Umbrina.
Switzerland.

125

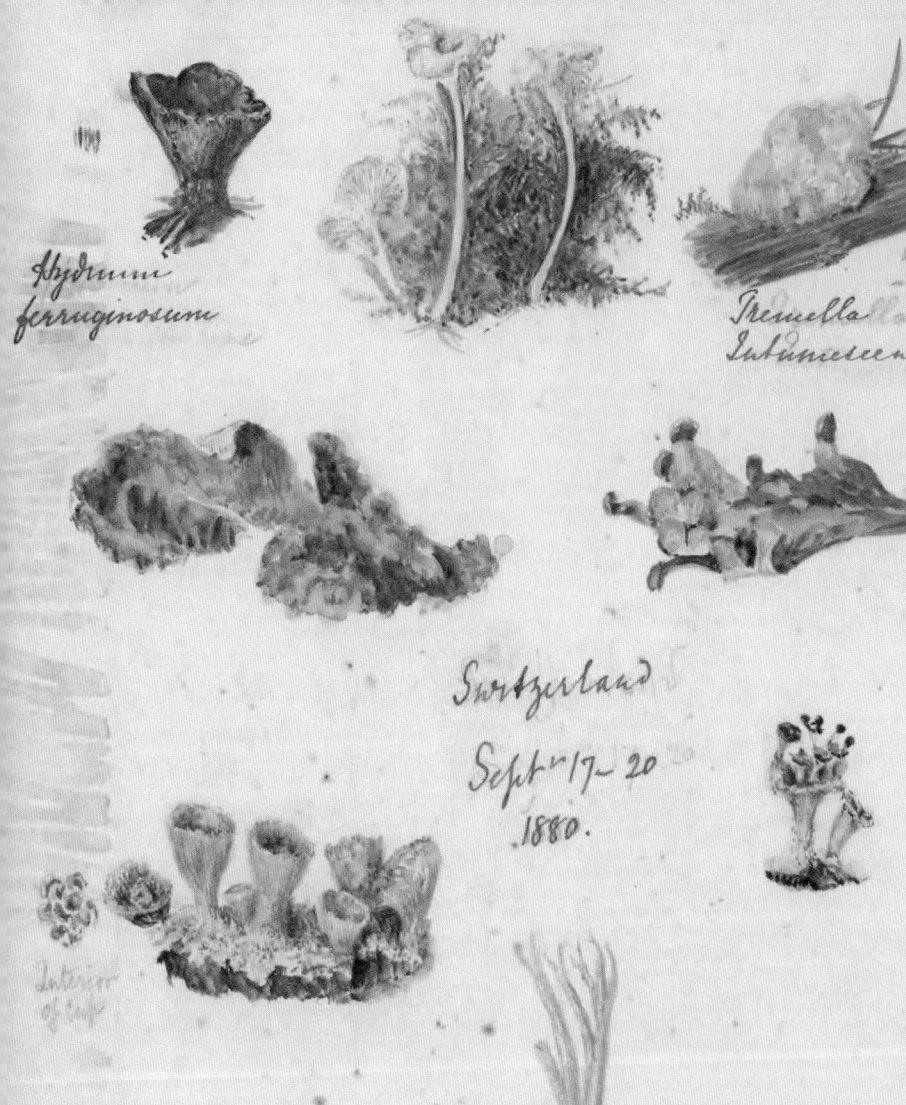

Hydnum
ferruginosum

Tremella
lutescens.

Switzerland
Sept 17 ~ 20
1880.

Interior
of cup

Clavaria
aurea.

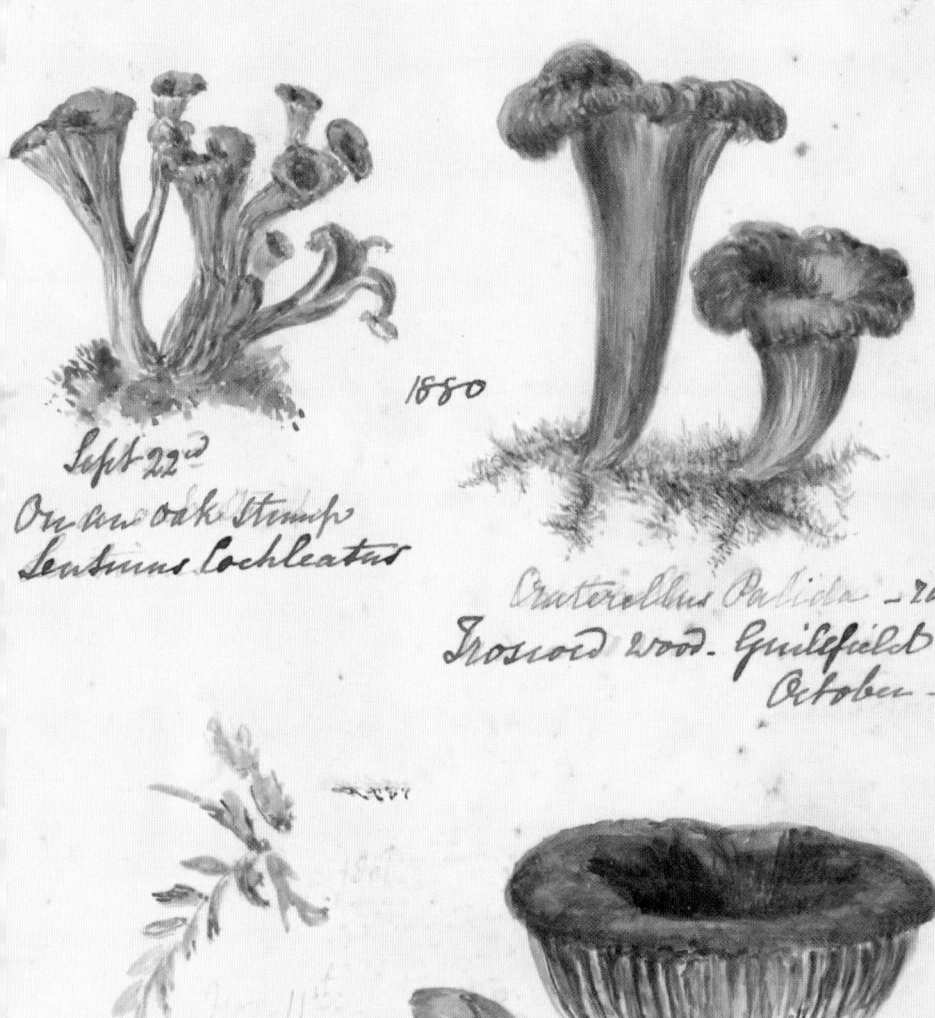

1880

Sept 22d
On an oak stump
Lentinus Cochleatus

Craterellus Pallida _ rare
Troswood wood. Guilsfield
October _

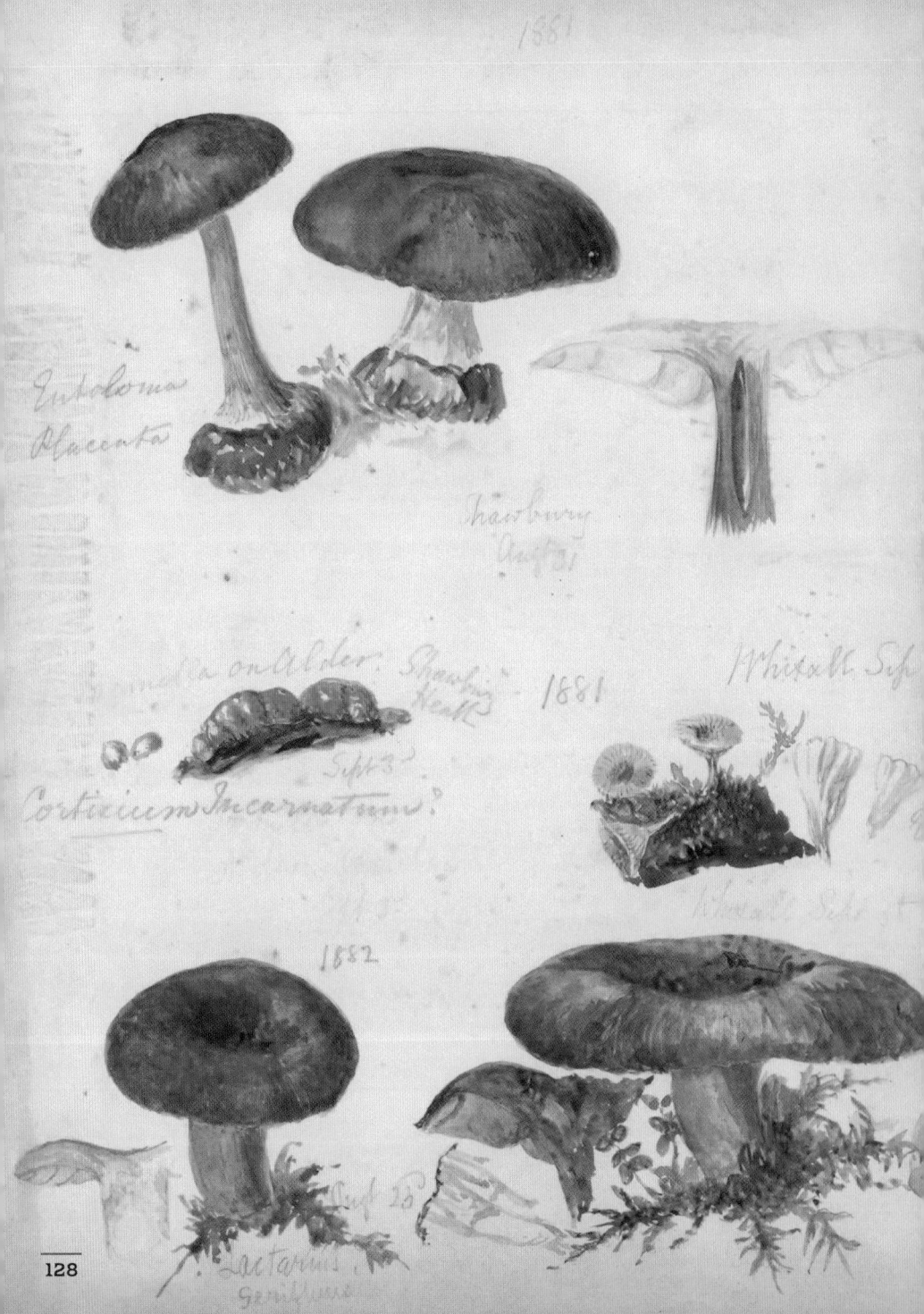

1881

Entoloma
Placenta

Shawbury
Aug 81

...nella on Alder: Shawbury 1881
Heath

Whitall Sch.

Sept 3

Corticium Incarnatum?

Whitall Seh.

1882

Aug 25

Lactarius
Geniflvus

Panus
Torulosus

Whitall Marsh
Oct 9/82

W. M

Marasmius
insititius

Clavaria
Argillacea?

In Calver's hot house
Jany 9th 1883.

1883
Feb 5th
Xylaria Bulbosa
From a pot of fern in Mr Peele's
hot house.

Sept 26th /85
Crucibulum
vernicosus
Stubble field

129

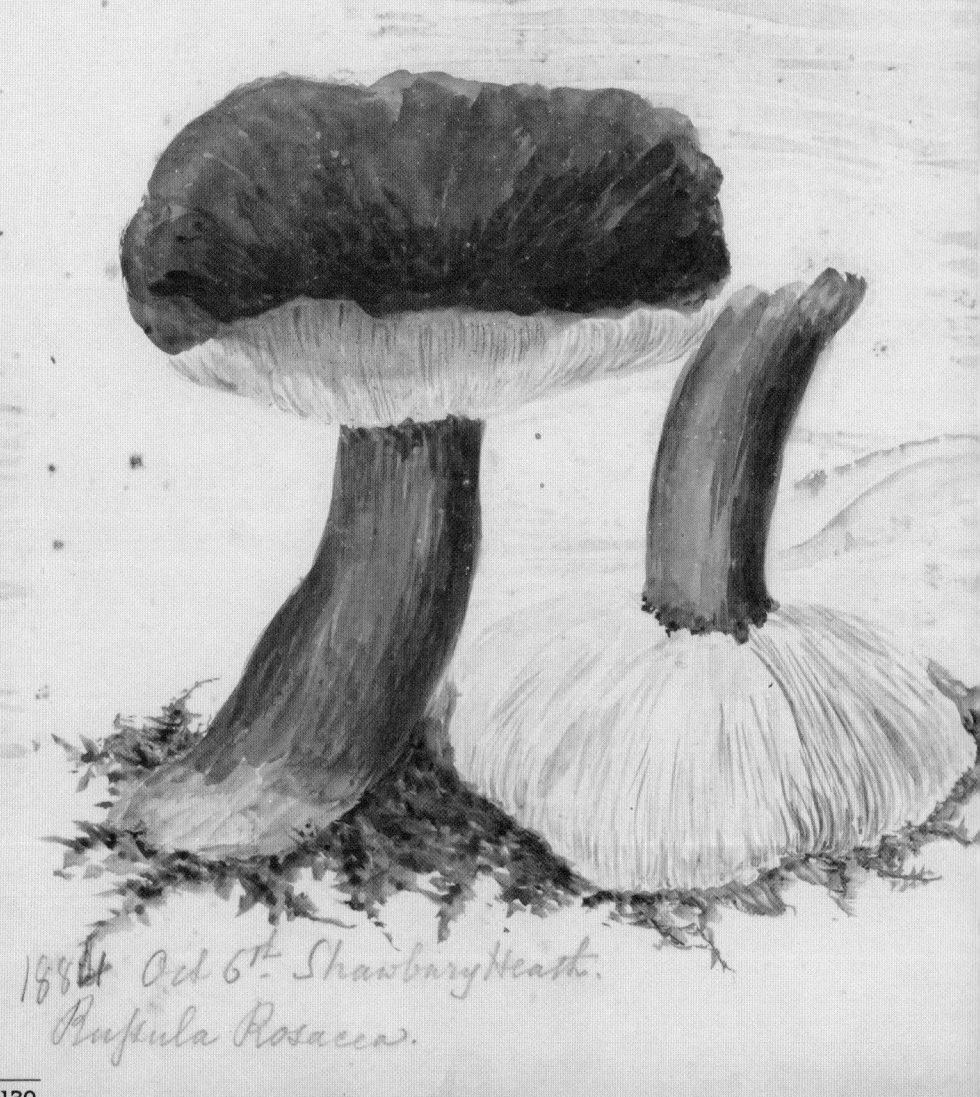

1884 Oct 6th Shawbury Heath.
Russula Rosacea.

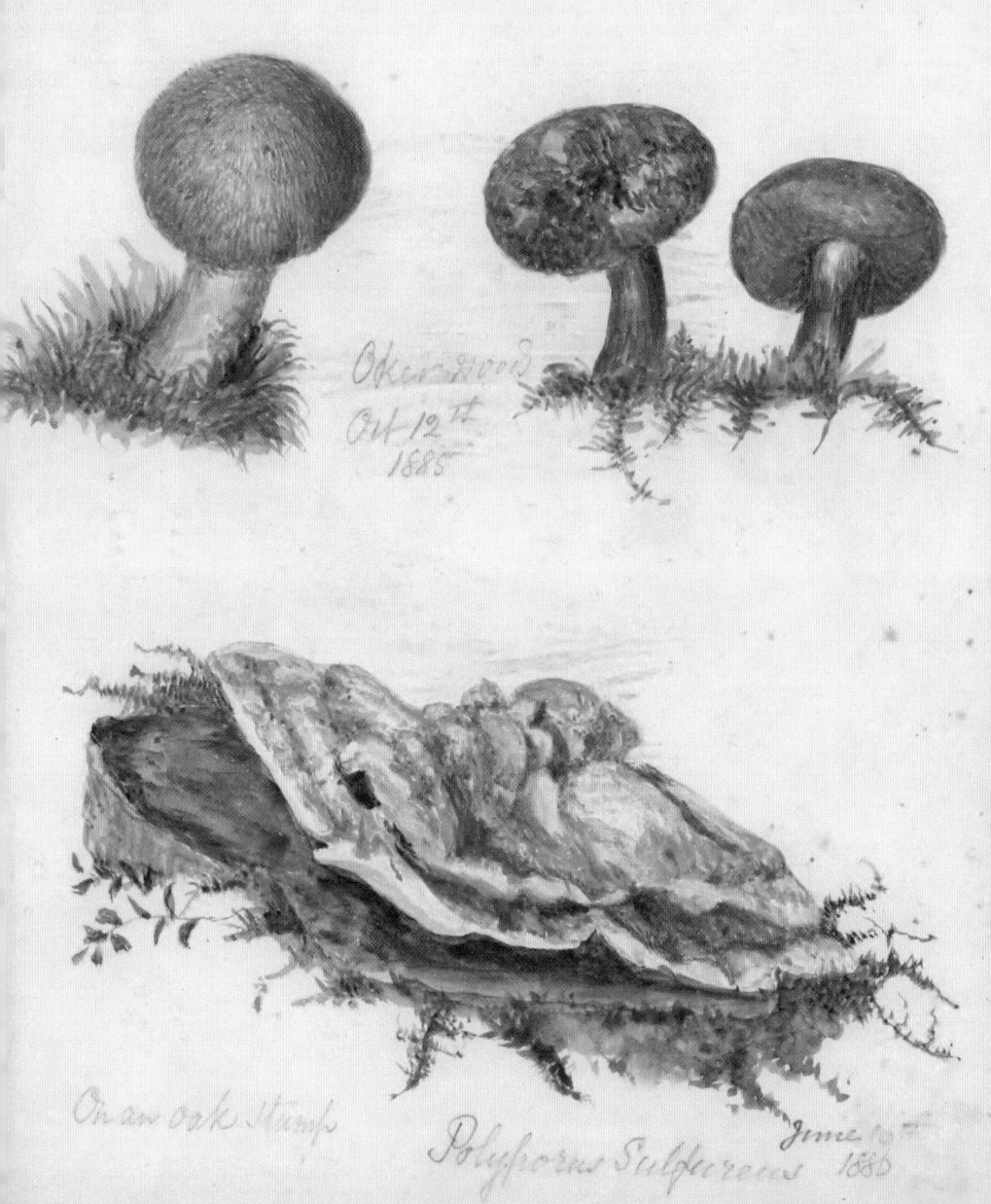

Okeswood
Oct 12th
1885

On an oak Stump

Polyporus Sulpureus

June 10th
1886

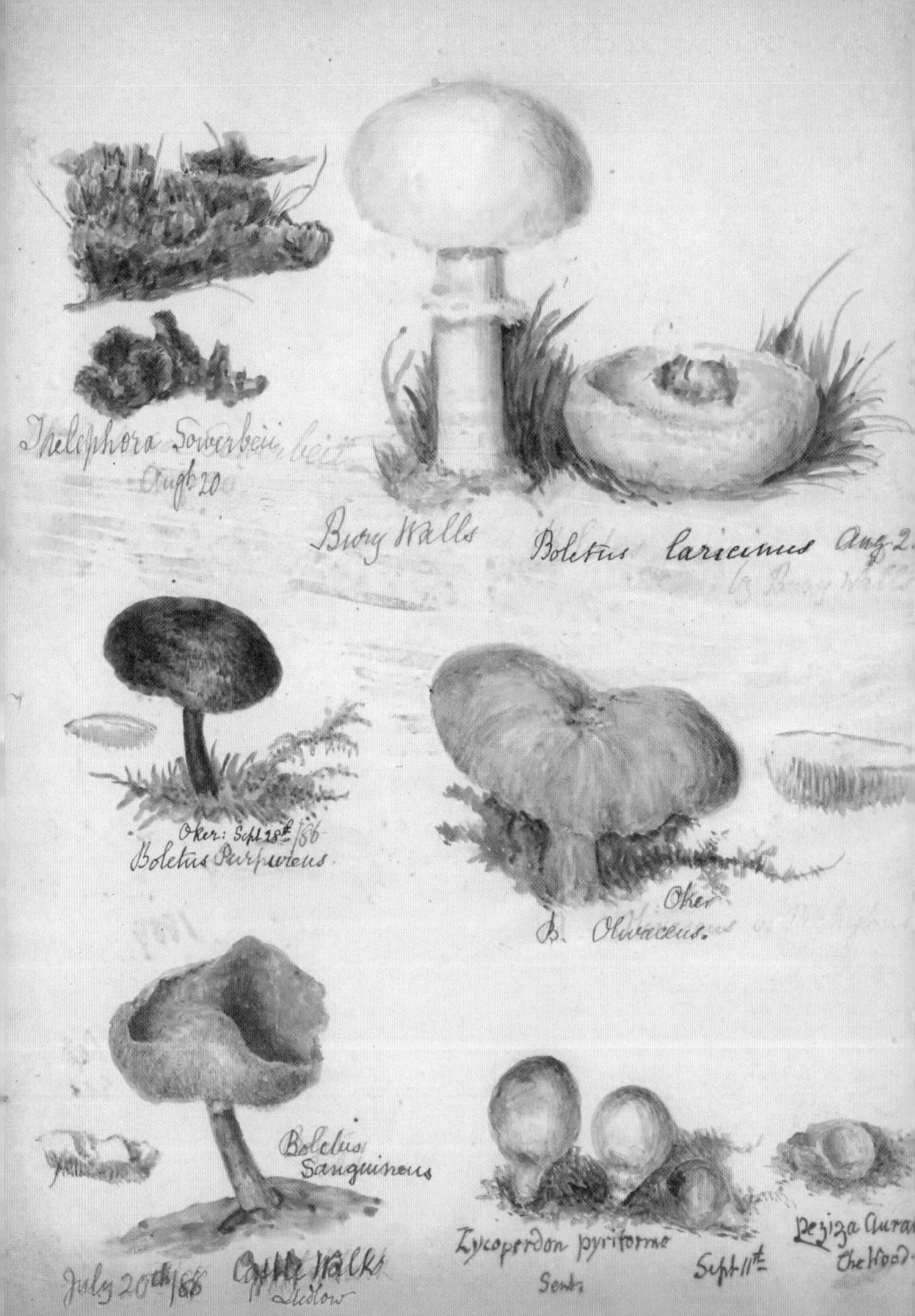

Thelephora Sowerbeii, bert
Augt 20

Brory Walls

Boletus Caricinus Aug 2.
Brory Walls

Oker: Sept 28th /86
Boletus Purpureus.

Oker
B. Olivaceus.

Boletus
Sanguineus

July 20th /88 Castle Walks
Ludlow

Lycoperdon pyriforme
Sent. Sept 11th

Peziza Auran
the Wood

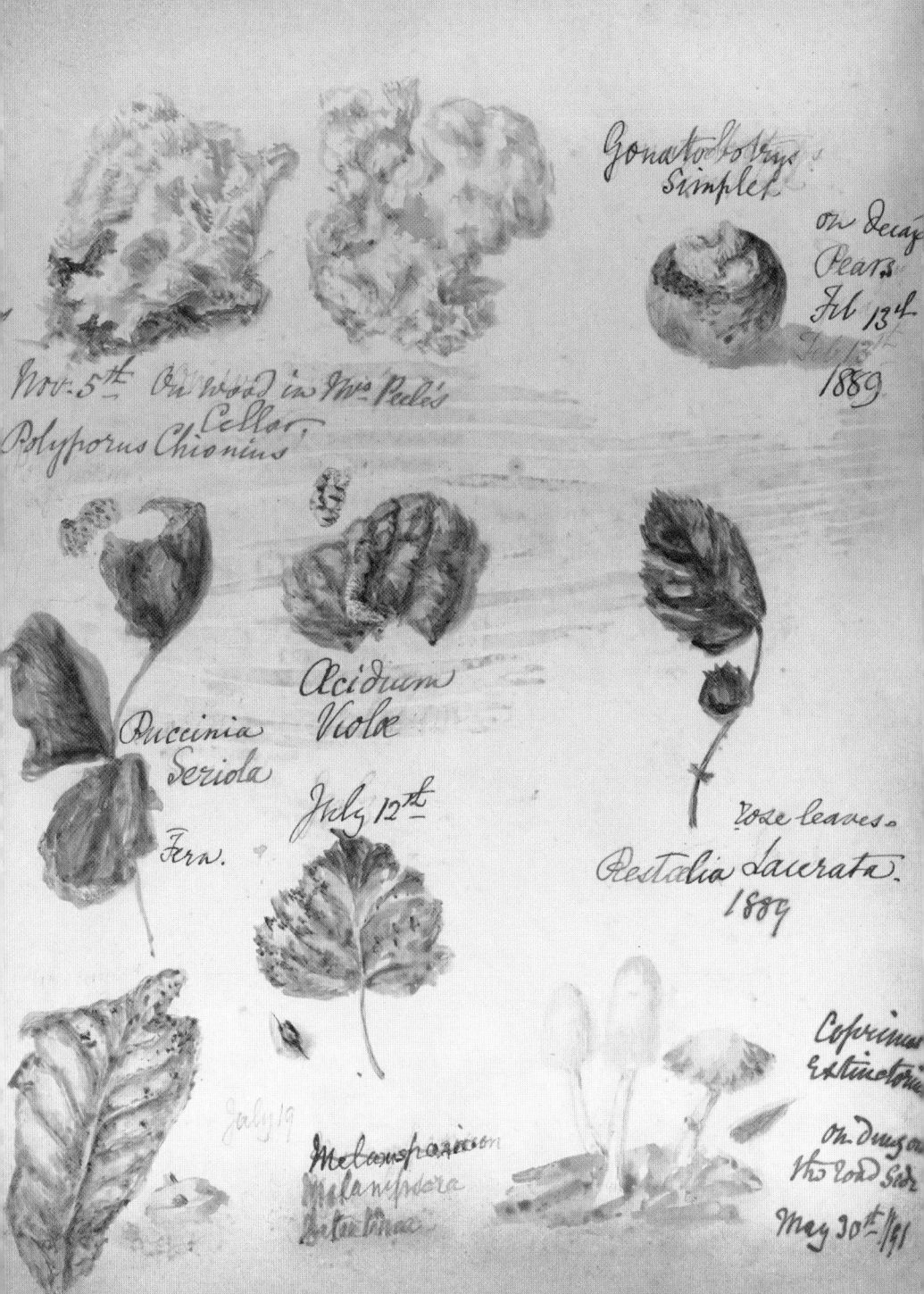

Gonatobotrys
Simplet

On Decay
Pears
Feb 13th
1889

Nov 5th On Wood in Mr Peck's
Cellar,
Polyporus Chionius

Acidium
Violæ

July 12th

Puccinia
Seriola

Fern.

rose leaves.
Restalia Laurata
1889

July 19

Melampsonieron
Melampsora
Interlineæ

Coprinus
Extinctorius

On Dung on
the Road Side

May 30th /91

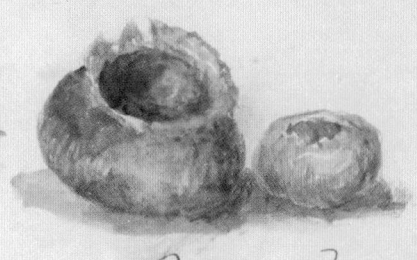

Agaricus Nudus
Nov 23ᵈ /89.
(Mʳˢ Salwey)

Peziza Succosa
Nov 21ˢᵗ 1889 Mʳ Orgills Gard

Polyporus
sutilans sp
Mʳ Marstons Garden.

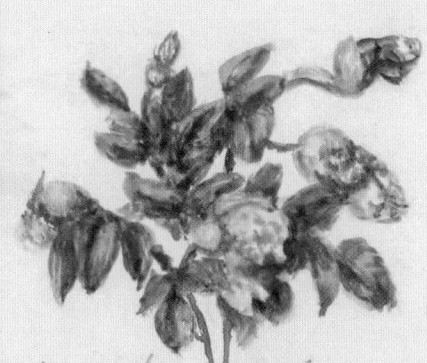
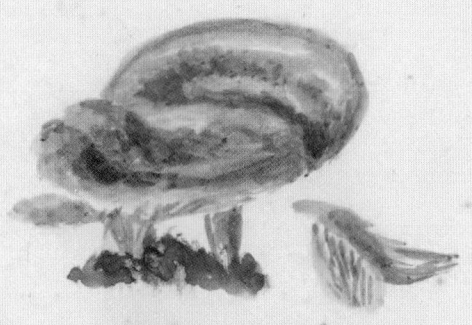

Polyporus Sulfureus.
June 24th Wet Moor.
1890

June 27th 1894 Batchcott

Coleosporium.
Pingue

Ag: humilis
Castle Garden Aug 25th
1897

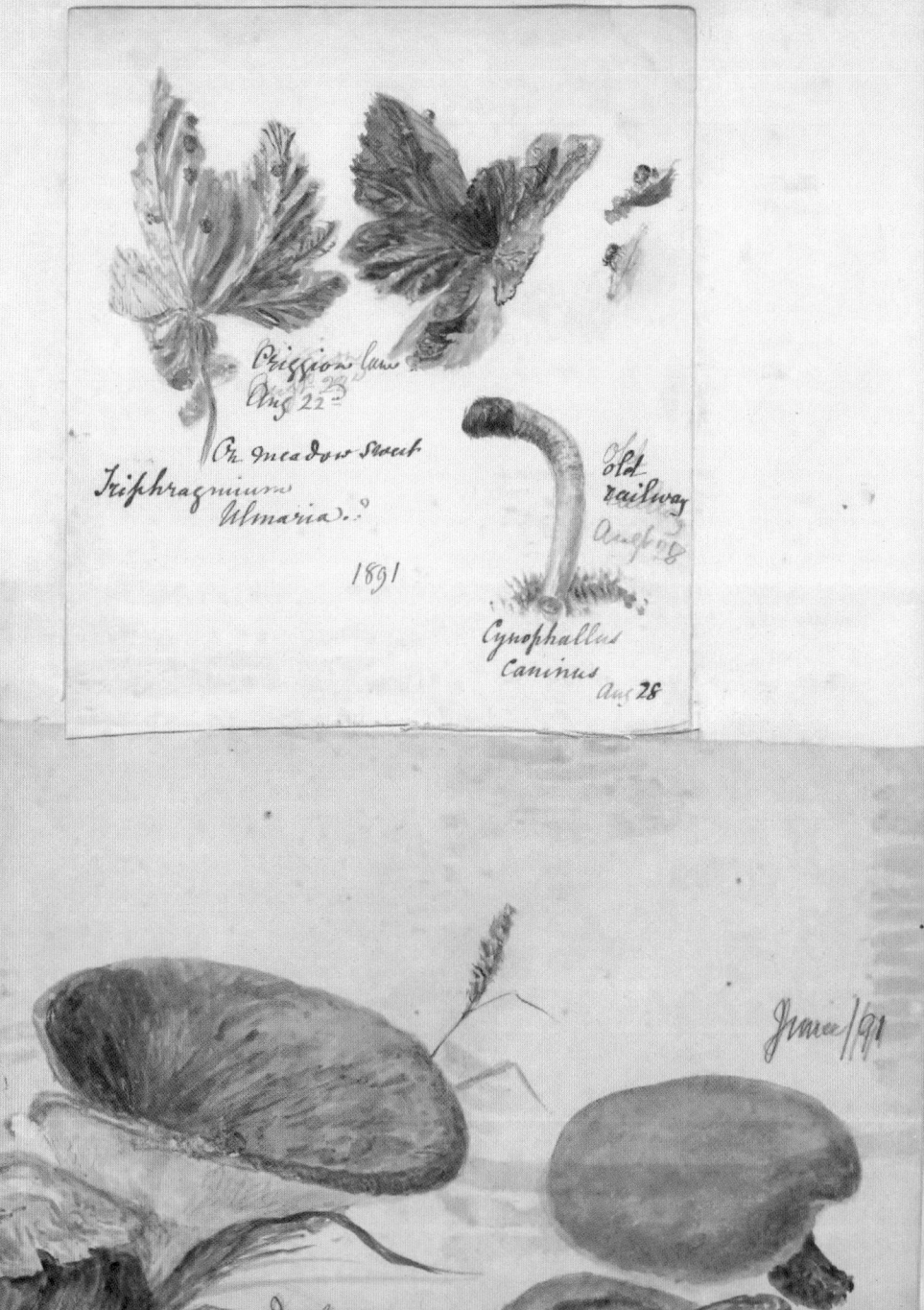

Pidgion Lane
Aug 22

On meadow sweet
Triphragnium
Ulmaria..?

1891

old
railway
Aug 28

Cynophallus
Caninus
Aug 28

June/91

June
/91 Clandrinio

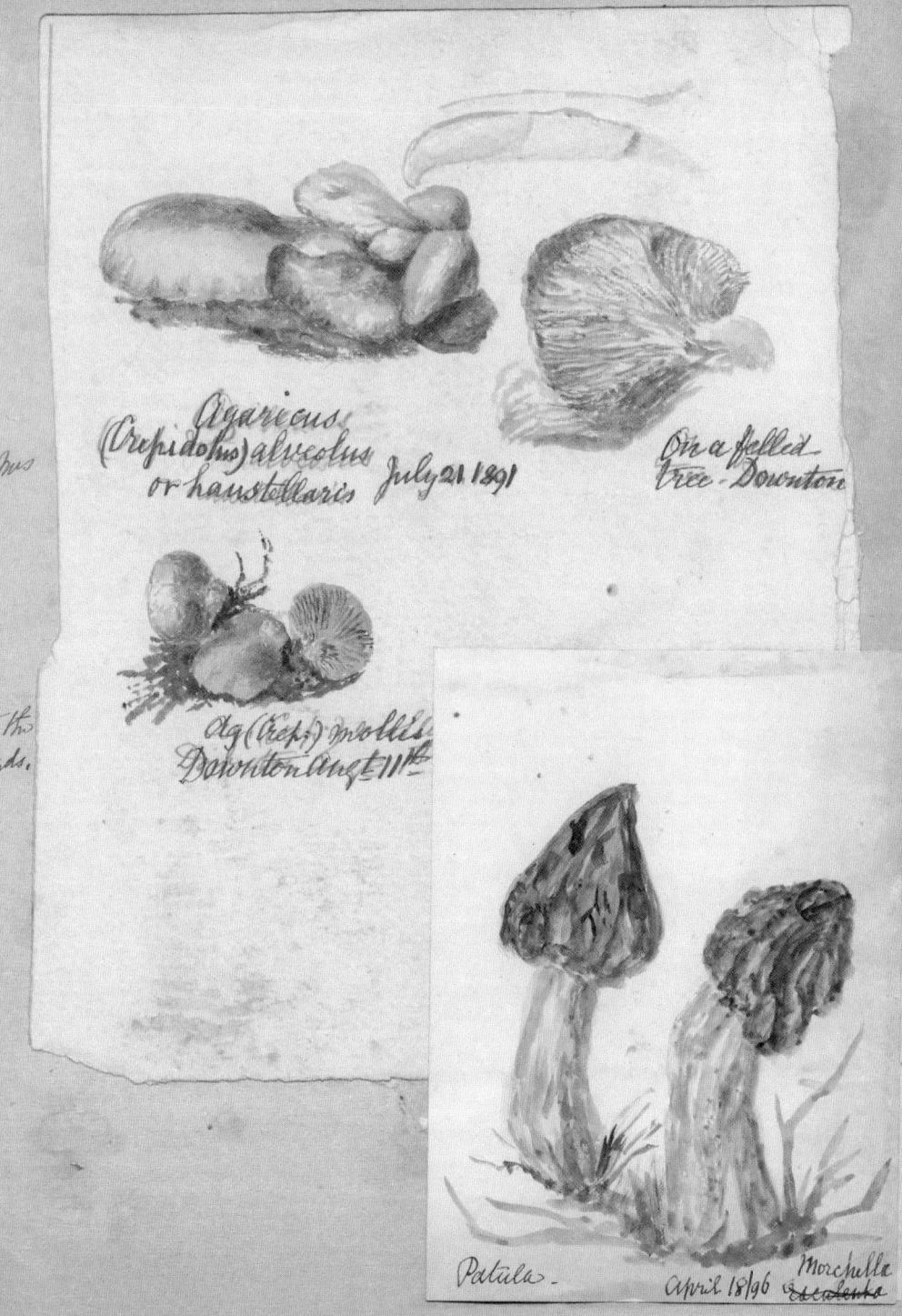

Agaricus
(Crepidotus) alveolus
or haustellaris July 21. 1891

On a felled
Tree - Downton

Ag (Crep.) mollis
Downton Aug 11th

Patula. April 18/96 Morchella
esculenta

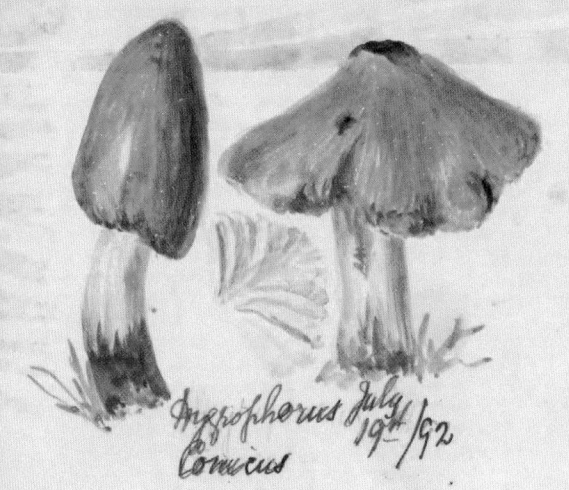

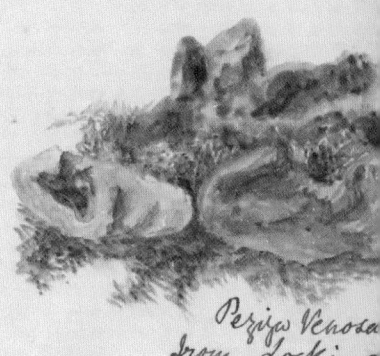

Nyctophorus July
19th/92
Comicus

Peziza Venosa
from Lockins
May 3rd

Boletus
Strincepus
Augt 8th/96

Agaricus
clypeatus

1896

Downton Aug.t .

Marasmius / alliaceus

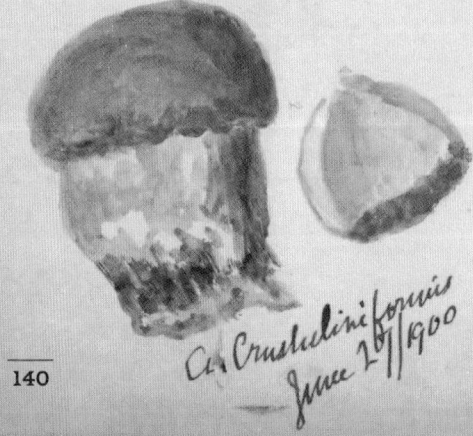

Chlora Splenicmum
Urginosus

from Ireland.

Sunny Gutter.
Oct 2 — 1897

Peziza Viridaria Feby 17th 1898.
On the gravelly ground

Ag Crustuliniformis
June 2 // 1900

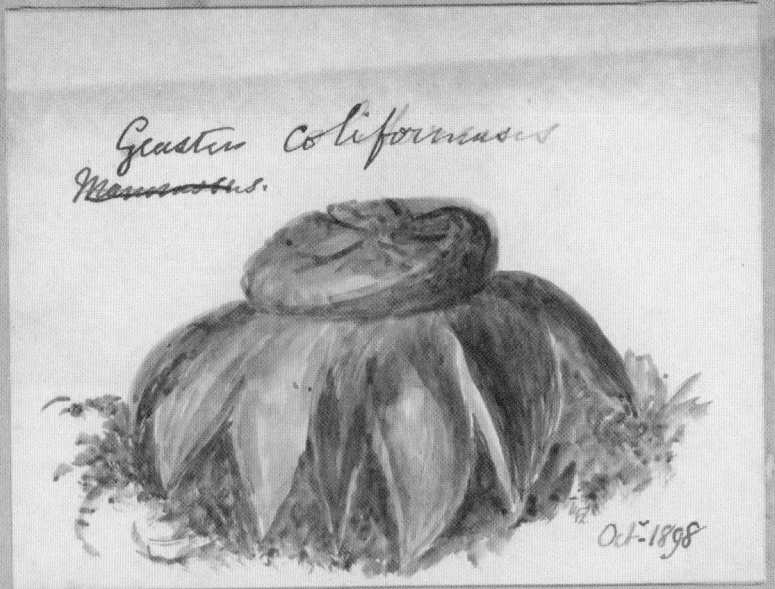

Geaster californicus
Massulus.

Oct 1898

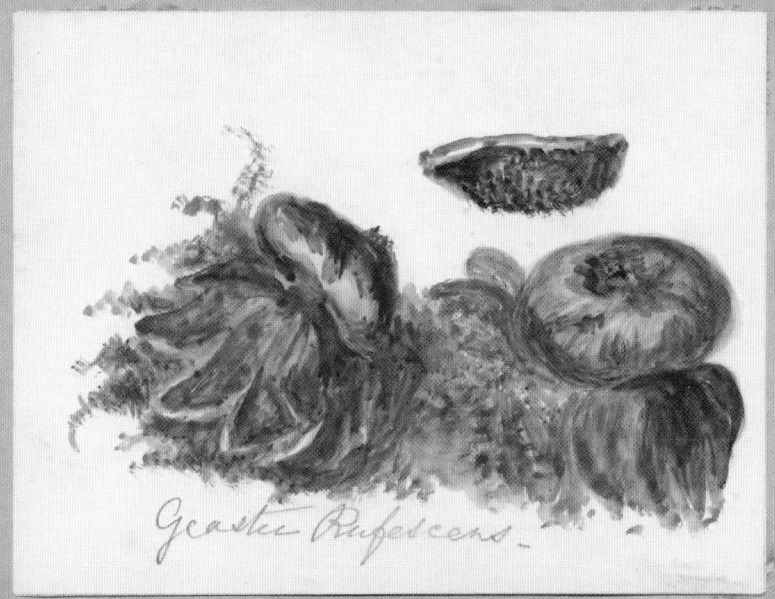

Geaster Rufescens.

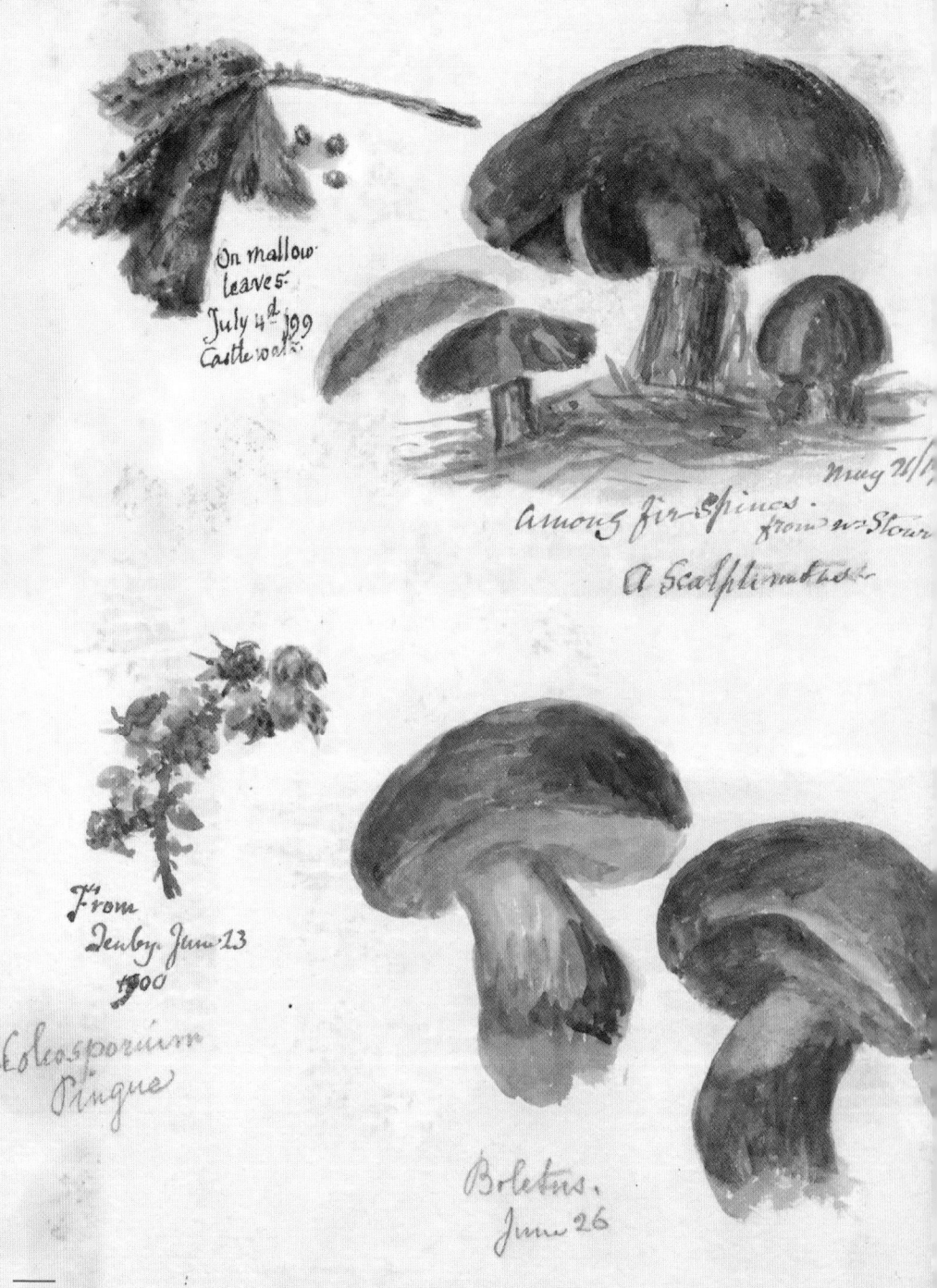

On mallow
leaves.
July 4th 1899
Castlewood.

May 21/

among fir-spines.
from w. Stour

A Scalpliniother

From
Denby Jun. 13
1900

Coleosporium
Pingue

Boletus.
June 26

1899

on lime tree
leaves.

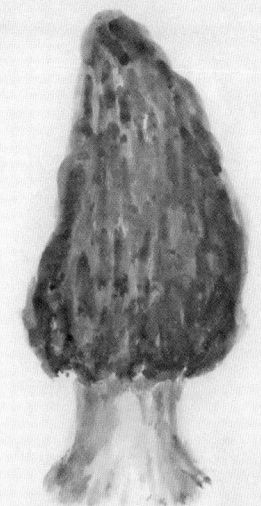

Morchella Esculenta
March 20 1902

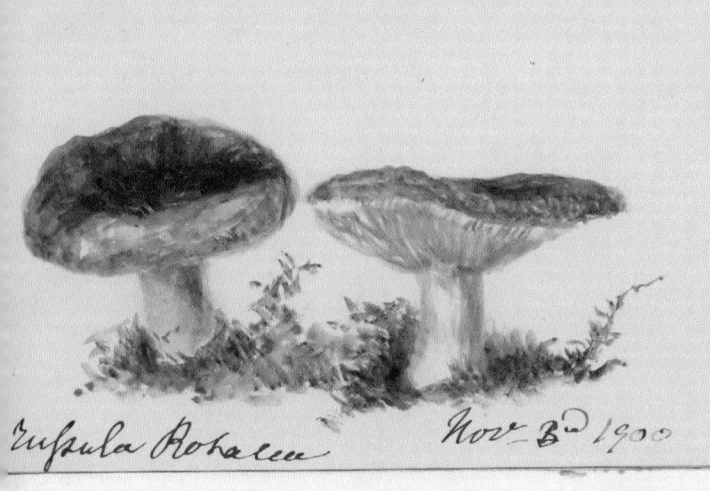

Russula Rosacea Nov 3rd 1900

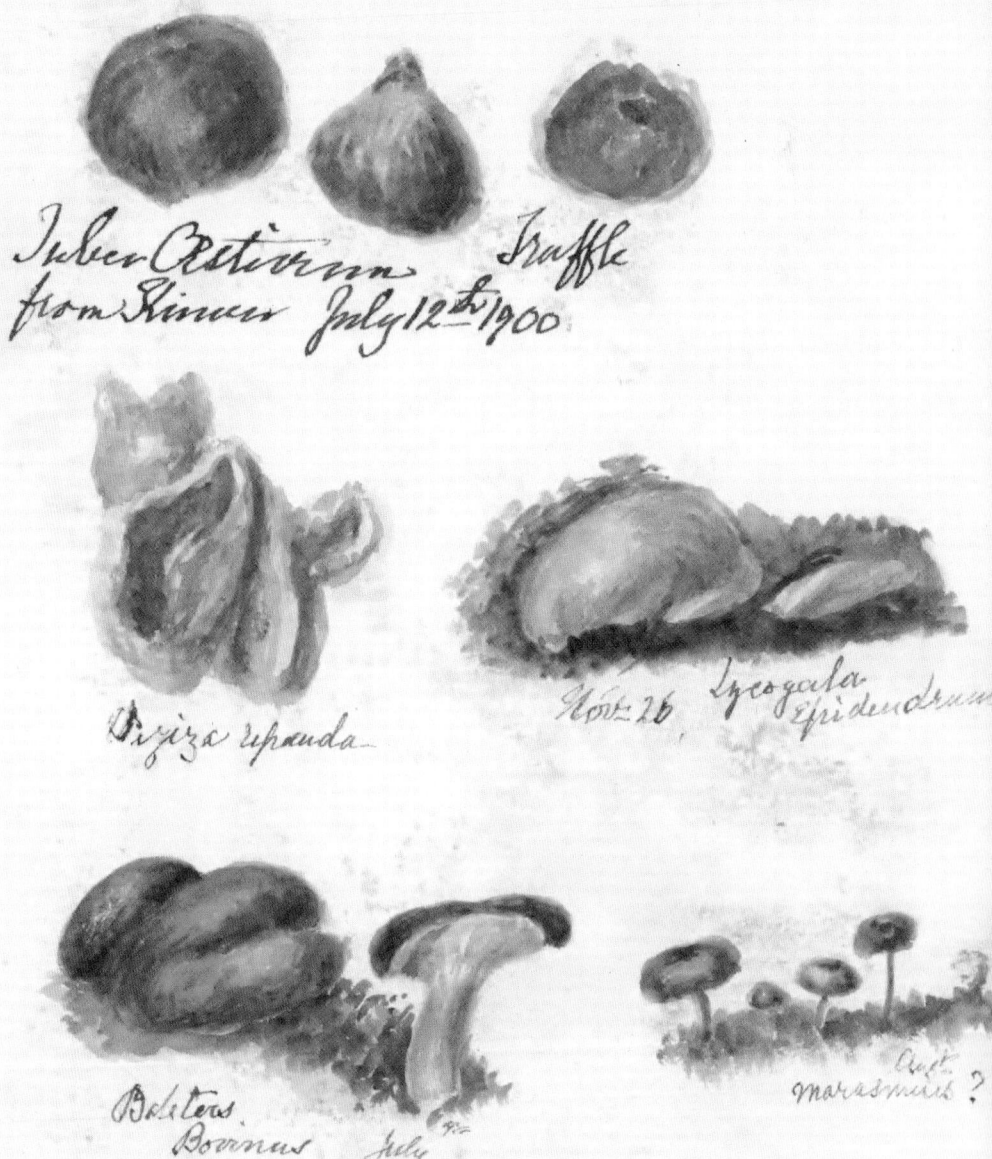

Tuber Œstivum Truffle
from Skinner July 12ᵗʰ 1900

Peziza repanda.

Nov. 26. Lycogala
 Epidendrum

Boletus.
Bovinus July

Aut.
marasmius ?

Sphærotheca
Parinosa.

Onich
July 31st

Augt
18

Aug 23

Boletus
Subtomentosus

Onich Sept 2d

Onich

On a birch or
alder stump

1893

Anthena
Flammea
Bury Walls
Sept 18th

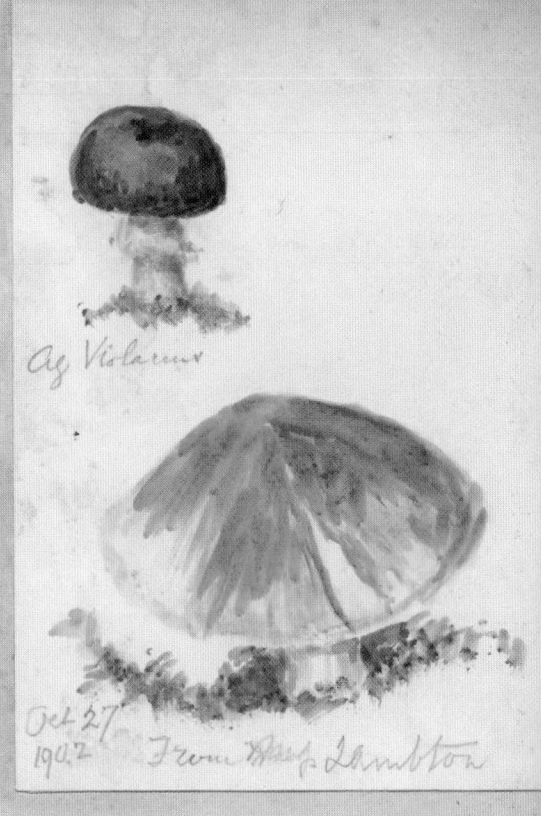

Ag Violaceus

Oct 27
1902 From Miss Lambton

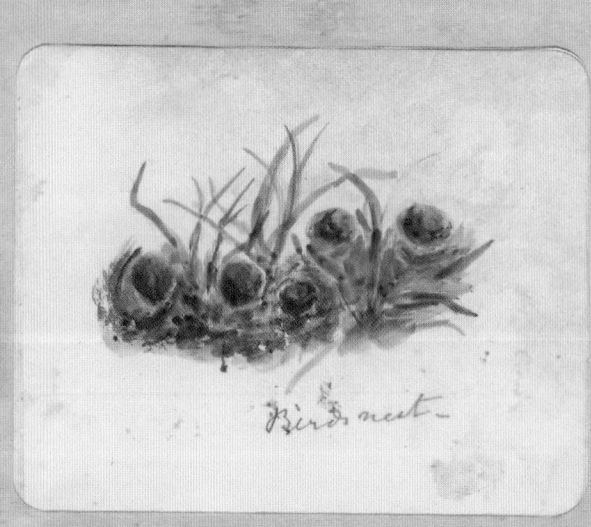

Birds nest

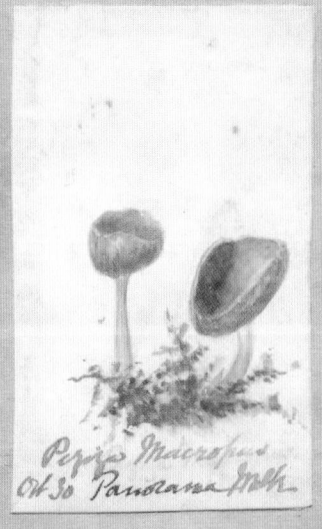

Pezia Macropus
Oct 30 Pandora Meth.

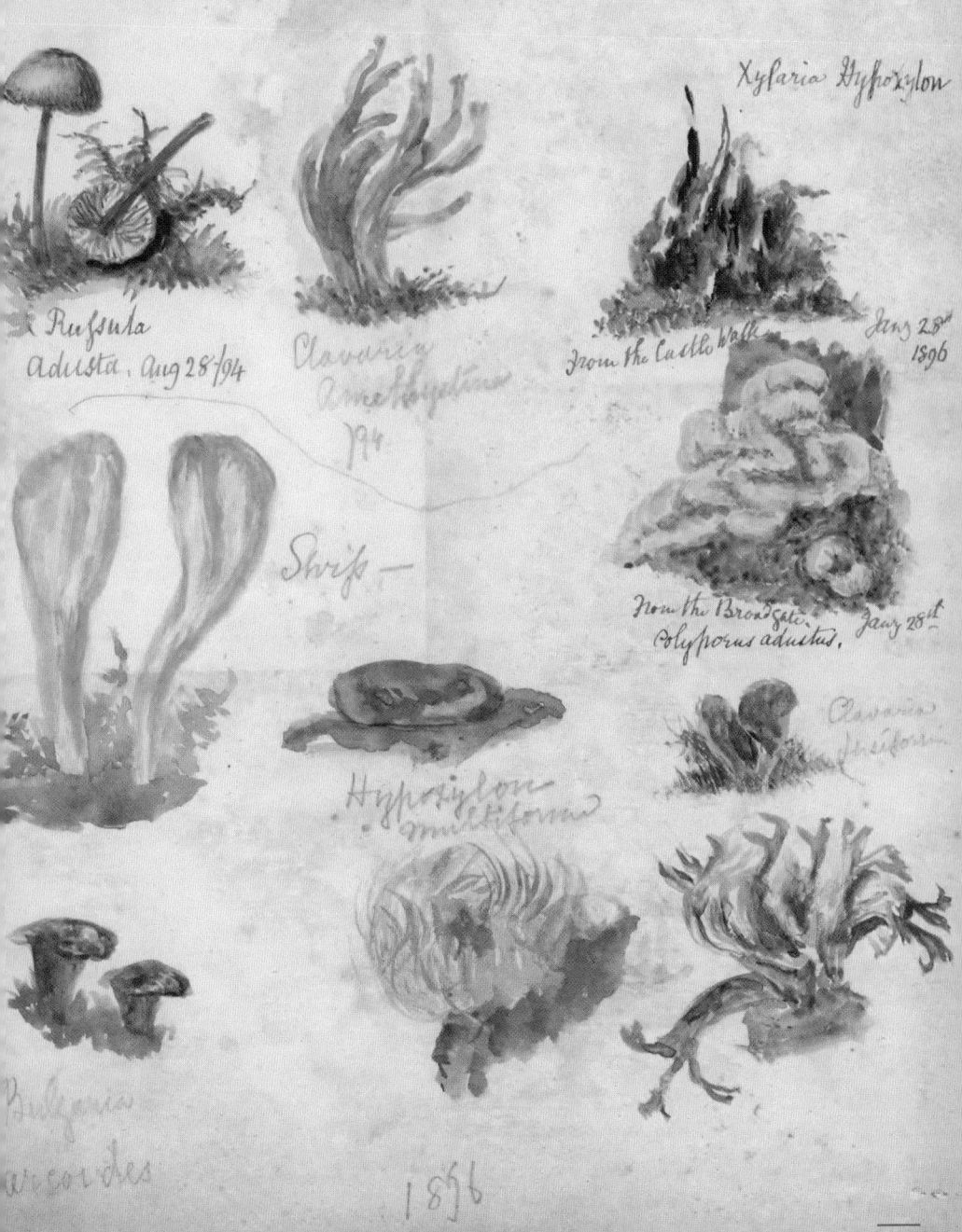

Russula
Adusta. Aug 28/94

Clavaria
Amethystina
/94

Strip —

Xylaria Hypoxylon

from the Castle Walk

Jan 28th
1896

from the Broadgate.
Polyporus adustus.

Jan 28th

Hypoxylon
multiforme

Clavaria
fusiformis

Bulgaria
inquinans

1896

147

NOTES

When Cornell University Library acquired M. F. Lewis's
three volumes of illustrations, the following pages of notes
had been appended. There is no information on who
compiled them or when, but we present them here for
two reasons: first, to help readers who want to identify the
mushrooms in the illustrations; second, to highlight the
mostly anonymous people who preserved Lewis's work
for us to enjoy today.

Quality mediocre but apparently faithful as far as they go, with gill attachment shown no microscopical data and no notes of smell, taste or habitat. Title page reads:

"Fungi collected in Shropshire and other neighbourhoods" and has crude border of foliage Date 1886 in lower left corner.

No name.Sunny Gutter on ash stump July 6 1873 — *Crepidotus mollis*

Coprinus radians? Butter Cross Ludlow. Trowscoed July 12 1873 (conical, pendant from wood) — *Coprinus*

Boletus satanas Croft Sept. 9, 1873 ✓

Polyporus fragilis Aug. 28 1873 — ?

Ptychogaster albus on old alder stump Shawbury Heath Sept.4,1873 — ? *P. albus is on conifers*

Triphragmium ulmariae Sept.3.1873 on the Crickhill ✓

Trichobasis suaveolens Stanton Lacey 19 June 1875 — *Puccinia punctiformis (=P. obtegens)*

Agaricus durus Shrewsbury (Cutley)Chhyd) Sept.4 1873 — *Stropharia coronilla*

Agaricus giganteus Sept. & Oct. ✓

Agaricus pallidus Krombholz (by a different hand) AMH — *Lactarius ?vietus*

Cortinarius violaceus (Hussey) — **A poor copy of Mrs Hussey's Plate 12**

Lactarius rufus (Hussey) under pine trees " " " " " " 15

No name Bringwood July 27 1875 — *Clitopilus prunulus*

Peziza humosa Jan.11.1873 — ?

Puccinia fabae July 26 1875. Huck's barn — *Uromyces viciae-fabe*

Uncinula bicornis? on mountain Ash leaves Sept.6.1875 — ?

Puccinia gacilis Sept.6.1875 — ?

Podisoma juniperi-sabinae Apr.22,1876 from Miss Hall ✓ (= *Gymnosporangium fuseum*)

Cordyceps militaris Festiniog Oct.25,1875 & Guilsfield /79 ✓

Geoglossum glutinosum Oct.29 Barmouth — *Probably* ✓

No name, Barmouth Oct.29 /79 — ?

Peziza coccinea white variety Mary Knowle gathered by A.L. Feb. 19, 1876 ✓

Peziza macropus Panorama Oct.30 & Miller's dale /78 ✓

P. rapulum Caynham March 24 1876 — *Probably Sclerotinia tuberosa*

Acidium euphorbiae Mary Knowle June 13, 1876 ✓ *Endophyllum euphorbiae-silvaticae*

Uromyces appendicularia? Bitterley June 14 /76 — *No. ?aphis injury*

AEcidium TUSSIlaginis Buildwas June /76 ✓ (= *Puccinia poarum*)

Ustilage typhoides Buildwas — ?

Peziza succosa from Mrs Mannder's garden Oct. 18 /76 — *Probably P. vesiculosa*

Æcidium urticae 1877 ✓ (= *Puccinia caricina*)

Roestelia lacerata 1877 ✓ (= *Gymnosporangium clavariae*)

Peziza humosa on a pot of bulbs in Mrs B.Lloyd's greenhouse March 27 /78 — ?

Clavaria crispula Sunny Gutter July 15 1878 from Mr. Walver — ?

Boletus Whixall moss Aug. 1878 — *Boletus sp parasitised by moulds*

Peziza badia Sept."28 1878 — *No!*

Peziza leporina (P.cochleata?) ✓ = *Otidea sp*

Cortinarius sanguineus Sept. 28 1878 ✓

Thelephora anthocephala — ?

Cantharellus tubaeformis ~~infundibuliformis~~ (No date or place but page is headed 1878) ✓

Hygrophorus murinaceus (rare) from ViewEdge Oct.2,1878 named at Downton by the gentlemen of the *H. ovinus* Woolhope club Oct 4th

Hygrophorus matrapodius (rare) 2 " " " " " (ie "metapodius") *Hygrophorus ovinus*

Clavaria amethystina Oct.4 1878 Downton and Hothouse grown Jan.8./83 { Oct. = C. amethystina Jan. = Ramariopsis pulchella

Hygro. adusta Downton Oct.4 ("Russula" was intended!) *Russula densifolia or R. acrifolia*

Marasmius archyropus Downton 1878 *Hygrophorus nemoreus*

Hy. unguinosus " " ? *Calocybe ionides*
No name

Daedalea rosacea or latissimae ?

Pleurotus salignus Downton Oct. 4 1878 *"Pluteus salicinus" must be meant. Not this but Pluteus sp.*

Clitocybe inversus " " " " *No! Probably Clitocybe hydrogramma*

Cortinarius saginus " " " " ?

Tricholoma cor..... " " " " *Mycena pura*

Tricholoma sulphureum " " " " *Old Armillaria mellea*

Sepedonium chrysospermum " " " " *Possibly, or perhaps Fuligo septica*

Physarum aureum bulbiforme from Water'smeet, Lynmouth Oct.7 ?

Lactarius deliciosus Mary Knowle Oct. 13 (in pencil:Lactarius volemus) *Lactarius volemus*

Thelephora ? *Cotylidia pannosa*

Marasmius oreades with cell-like fungus on the pileus Oldfield Oct.11

Geoglossum viride *microglossum viride*

No name Oct. 15,/76 ? *Clitocybe hydrogramma*

Uredo utirigo Caer fawr June 30, 1879 ?

Puff balls Cressweed July 17 /77 *Trichia sp.*

Gyromitra esculenta Apr. 30 rare from Moulsworth Oxfordshire ? Not G. esculenta

Peziza bufonia? sent Apr. 29th 1880 ? Perhaps sterile base of old Calvatia sp.!

C. ingratus Shawbury Aug. 1880 *Amanita fulva*

A. longipes Sept. 6 *Amanita vaginata*

No name Mary Knowle Sept. 6 ?

Uromyces intrusa on Lady's mantle May 28 /80 ✓ (= *Trachyspora intrusa*)

(several fungi from Grisons Sept.1880 & Salzberg 1887, including Guspinia helvelloides) ✓

Lentinus cochleatus on an oak stump Sept.22 1880 ✓

Craterellus palida rare Trescoed wood Guildfield October 1880 *Craterellus cornucopioides*

No name *Russula nigricans*

Entoloma placenta Shawbury Aug.31,1881 ? *melanoleuca sp*

Mar. eryth Whixall Sept. 5, 1881 *Omphalina ericetorum*

Tremella. Corticium incarnatum? on alder Shawbury Heath Sept.3,1881 *Plasmodia of Lycogala epidendrum*

Lactarius serifluus Aug. 23 1882 ? *Lactarius volemus*

No name *Russula nigricans*

Gomphidius glutinosus Grinshill Oct.3 1882 *Stropharia sp*

Panus torulosus Whixall Moss Oct.9,/82 (may be sp.) ?

Marasmius insititius WM

Clavaria argillacea? WM ✓ ? *Ramariopsis pulchella*

In Calver's hot house Jan.9,1883 ✓ ⚥

Xylaria bulbosa from a pot of fern in Mrs Peele's hot house Feb.5,1885 ?

Crucibulum vernicosus Stubble fields Sept. 26,1885 ✓ = *Cyathus olla*

Russula rosacea Shawbury Heath Oct. 6, 1884 *Russula ? sanguinea*

Unnamed Bolete Oker woods Oct. 12, 1885 *Boletus chrysentaron*

151

Polyporus sulfureus on an oak stump June 10, 1886 ✓

Thelephora sowerbeii Aug. 20 Bury Walls *No.* *Thelephora terrestris*

Beletus laricinus by Bury Walls Aug. 20, /86 *No!* *Surely Agaricus sp.!*

Beletus purpureus Oker Sept. 28, /86 *No!*

B. olivaceus Oker (or pachypus) *Boletus chrysenteron*

Beletus sanguineus Castle walks, Ludlow July 20 1888 *= Boletus rubellus*

Lycoperdon pyriforme sent Sept. 11 ✓

Peziza aurantia The Wood Sept. 11 ✓

Polyporus chicneus Nov. 5 1888 on wood in Mrs. Peele's cellar *?*

Genatobotrys simplex on decayd Pears Feb. 13, 1889 *?*

Puccinia seriola Fern *?*

Æcidium violae July 12 *Possibly, or Urocystis violae ?* *No !*

Restelia lacerata Rose leaves 1889 *?*

Melampsora betulina July 19 *?*

Uremyces spiculata July 19

Coprinus extinctorius on dung on the roadside May 30 /91 *Bolbitius vitellinus*

Agaricus nudus Nov. 23 /89 Mrs. Salwey ✓ *(= Lepista nuda)*

Peziza succosa Mrs. Orgill's garden Nov. 21, 1889 *No!* *? Peziza vesiculosa*

Polyporus rutilans spumeus Mrs. Marston's garden *Polyporus squamosus*

Polyporus sulfureus June 24 1890 Wet meor

Coleesporeum pingue Batchcott June 27 1894 *? Phragmidium mucronatum on Rosa*

Ag. humilis Castle garden Aug. 25, 1897 *melanoleuca sp.*

Triphragmium ulmaria? on meadow sweet Criggion lane Aug. 22 *1891 (actually depicts leaf galls)*

Cynophallus caninus Old railway Aug 28 1891

No name Llandrinio June /91 *Paxillus atrotomentosus*

Agaricus (Crepidotus) alveolus or haustellaris on felled tree, Downton July 21,1891 *Cr. moll*

Ag. (Crep.) mollis Downton Aug. 11 with the Kingsfords ✓

Morchella esculenta patula April 18, /96 *Morchella semilibera*

Hygrophorus cenicus July 19 /92 ✓

Peziza venosa from Locking May 3 /95 *perhaps Disciotis venosa* ✓ *?*

Boletus striaepus Aug. 8, /96 (Mrs.Munn)

Agaricus clypeatus Downton Aug. 1896 *probably Pluteus cervinus*

Marasmius alliaceus Downton Aug. 1896 *No!* *? Marasmius androsaceus*

Chlorosplenium aeruginosus from Ireland ✓

Peziza viridaria on the gravelly ground Feb. 17 1898 *?*

A. crustuliniformis June 27 1900 *? young Boletus sp.*

Geaster coliformis Oct. 1898

Geaster rufescens

On mallow leaves Castle walk July 4 /99 *Puccinia malvacearum*

A. scalpturatus among fir spines nr. Stourbridge May 23,1900 *No!*

Boletus June 26 *?*

Coleesporium pingue from Tenby June 23, 1900 *? Phragmidium mucronatum*

Morchella esculenta March 20, 1902

Russula rosacea Nov. 3, 1900 *Russula atropurpurea*

Tuber aestivum Truffle from Kinver (last 3 letters doubtful) July 12 1900 *Elaphomyces granulatus*

Peziza repanda

Lycogala epidendrum Nov. 26 *Reticularia lycoperdon probably*

Boletus bovinus July *No!*

Marasmius? Aug" *No!*

Sphaerotheca pannosa Onich July 31

Boletus subtomentosus Onich Sept. 2 *Boletus versipellis*

Aug. 18 *Russula lutea*

Lycogala epidendrum on a birch or alder stump Onich *Reticularia more likely*

no name Onich 1893 *Probably Laccaria laccata*

Anthina flammea Bury Walls Sept. 18 (1893 seems implied) *Myxomycete plasmodium*

Russula adusta Aug. 28, /94 *No! Leptonia sp*

Clavaria amethystina /94

Xylaria hypoxylon from the Castle walk Jan. 28, 1896

Polyporus adustus from the Broadgate Jan. 28, 1896 *?*

Swiss *Clavaria pistillaris*

Clavaria fusiformis 1896 *? Guepinia helvelloides from Switzerland.*

Hypoxylon multiforme 1896 *?*

Bulgaria sarcoides 1896 *? Coryne cylichnium*

Earlier volume has title page merely "Fungi", apparently signed MFL

Spathularia flavida Buttington July 23 1862

P. luteonitens? (in pencil "Leucoloma") *?* *on the charcoal or at least marble P. echinospora*

Peziza venosa on charcoal in fir wood and in the spines Buttington July 23 1862 *No!*

Scleroderma geaster in asparagus bed July 27 1862 *No!*

P. vesiculosa July 28 1862 dunghill, Nelly Andrew's ~~garden~~ Green near Welshpool

A. velutipes Nr. Chester Aug. 13, 1862

Craterellus crispus (cornucopioides in pencil) Ludlow Oct. 23 1862 *Craterellus cornucopioides*

P. trachycarpa on charcoal Whitecliff Oct. 23 1862 (Cooke's name) *either this or P. leiocarpa*

Pez. succosa Oct. 29 *Possibly*

No name *Lepista sordida*

Coprinus atramentarius 1862

no name Oct. 29 *Mycena epipterygia*

Coprinus comatus on bark

Agaricus arvensis Sept 24 Buttington *No! ? Agaricus vaporarius*

Cantharellus aurantiacus Sept. 31 1862

no name Oct. 1 *Lacrymaria (Psathyrella) velutina*

A. plumosus Oct. 1 1862 Whitecliff *Inocybe calamistrata*

Lycoperdon gemmatum Long mountain July 25, 1862 *No. Calvatia utriformis (= C. coelatum)*

Phallus impudicus , egg June 27 1862 Buttington; expanded July 26

no name Beacon Ring July 29 1862 *Omphalina ericetorum*

A. cepaestipes hot house on bark, Chester Aug. 31, 1862 *No. Perhaps lepiota microspholis*

A. conicus Beacon Ring July 29, 1862 *in part*

Thelephora laciniata Oct. 29 *Cotylidia pannosa*

H. conicus Oct. 29 1862 *Inocybe sp.*

153

Typed entry	Handwritten annotation
Thelephora coerulea Nov. to April	← Corticium coeruleum
Peziza tuberosa April & May	← Sclerotinia tuberosa
no name Park Wells, Builth Sep. 27 1861	Inocybe sp
Hygrophorus ovinus " "	Hygrophorus lacmus
Hirneola auricula Judaea on an elder trees Jany. 10, 1861	
Peziza aurantia Welshpool Sep. 8 /62; Ludlow /63 - 4	✓
Peziza badia? on heap of road scrapings Mary Knowle Sep. & Nov. 8 1862	Probably NOT
no name	?
no name Nr. Chester Aug. 18 /62	?
Polyporus giganteus Whitcliff, Ludlow Aug. 5 1861 also nr. Builth Aug. 22	✓
Russula depallens Aug. /68	Possibly Russula vesca
Cantharellus umbonatus rare Builth Aug. 13	
no name Builth	Stropharia semiglobata
Russula " " "	?
Peziza repanda Ludlow, April 9	No. Disciotis venosa
A. radiceus Builth	Stropharia semiglobata.
no name "	Inocybe cookei
A. pratensis variety of campestris arvensis	Agaricus sp NOT A. campestris
A. cepaestypes on a tan bed in hot house July 22 1862 Ludlow Mr. Lightbody's hot house	
Russula Saltmore July 22	Russula emetica
Boletus subtomentosus Ludlow 1862	
Boletus variegatus " July 22 1862	Old Boletus chrysenteron
A. cristata " July 24 1862, Oct. 1st.	✓ Lepiota cristata
A. tenerrimus " Aug. 12	No. Marasmius rotula
Agaricus tener "	✓ Conocybe tener or allied spec
Bovista nigrescens plumbea Ashford July 23 1861	B. nigrescens
Scl. verrucosum very young Mary Knowle July 28 1861	?
Lycoperdon gemmatum young Whitcliffe Aug. 8	?
Lycoperdon caelatum Llanelwydd rocks, Builth Aug. 20; Whitcliff, Ludlow	
Scleroderma vulgare Park Wells, Builth " "	✓ (= S. citrinum)
L. gemmatum older Whitcliff Nov. 3	L. perlatum or L. lividum
L. gemmatum bursting Bitterley Lane Nov. 3	L. pyriforme
Bovista plumbea	✓
L. saccatum Whitcliff Oct.	(= L. excipuliforme)
pyriforme Bringwood Chase Nov. 13	✓
Scleroderma verrucosum Church Stretton Oct. 7 1862 nearly burst	Lycoperdon foetidum
Helotium citrina Peziza cyathoides	Phiala cyathoidea
Peziza cerea from a tan bed in Mr. Hodge's garden April 25th	?
Geaster mammosus Onibury May 1 1861	
H. psittacinus Mary Knowle & Whitcliff July 8	
A. campanulatus May 23rd	Panaeolus (Annellaria) semi-ovata
P. sulfureus May 28 1861 Buttington	✓
P. squamosus June Buttington	✓
A. semiglobatus (on ash)	Panaeolus sp
no name on poplar May 28th	Reticularia lycoperdon ?

A. conopilus Buttington June 22 1861 No.
no name " June 20 1861 Tricholoma psammopum ?
Nematogonum aurantiacum " June 26 1861 Plasmodium
Boletus elegans " " " " ?
no name " " ?
no name " " ?
Ag foenescoii " July 26 ?
Peziza stercorea " " " on cow dung ?
no name " " 29 Panaeolus papilionaceus
Hy. ceraceus Beacon Ring No. Hygrophorus langei
Agaricus infundibuliformis Whitcliff July 29 1861 Clitocybe infundibuliformis
P. aurantia Downton woods Oct. 5, 1861
A. granulosus Sept. Cystoderma amianthina
Merulius lacrimans from Mrs. Hodgson's pew seat Oct. 8
A. emeticus No !! ? Tricholoma (Dermoloma) cuneifolium
A. odorus Agaricus aeruginosus A. odorus has no ring Stropharia aeruginosa
no name ? mycena pelianthina
A. muscarius In Bringwood Chase very common
Hy. coccineus Hygrophorus puniceus H. puniceus
Hy. niveus Whitcliff Oct. 25th
Lactarius ~~piperatus~~ vellereus very poisonous 1861 Lactarius piperatus
Lactarius torminosus "
A. rubescens young unexpanded "
no name Sept. 27 /61 Stropharia coronilla
Russula virescens (in pencil "heterophylla") edible No. ? Russula cyanoxantha
no name Aug. 5 1861 ?
Polyporus hispidus on an apple tree July /61 (in pencil "Polyporus dryadeus. P. hispidus does
 not exude drops of moisture) Polyporus hispidus
Cordyceps capitata Aug. 7 1861 No. Cordyceps ophioglossoides
no name mycena luteo-alba
Ag. sanguinolentus mycena sanguinolenta
Cop. ephemerus No. ? mycena sp
Cantharellus cibarius Ludlow Aug. 7th; Builth 15th Aug. 1861
Boletus luridus poisonous. Bitterley 1861 No. Boletus erythropus
Cortinarius turbinatus Aug. 8 1861 a close hairy web spreads across inside Cortinarius sp
no name Builth Sep. 25 1861 Psilocybe semilanceata + mycena sp
Geoglossum olivaceum Whitcliff Oct. 9 1861
Clavaria fusiformis " " " " No. Clavaria inaequalis
P. macropus Peziza cupularis Onibury Pustularia cupularis
A. squarrosus under a fir tree Onibury Pholiota squarrosa
C. ceranoides Whitcliff Oct, 9, 1861 Clavaria inaequalis
no name Oct. 15 Psathyrella disseminata
Xylaria hypoxylon Oct. 15
Cl. coralloides Whitcliff Oct. 18 1861 Clavaria cristata ?
no name " " 19 ?

Vol. II. Decorated title page is labelled "Fungusea M.F.L2 and signed at base "Del. M.F.Lew
March 27 1866"

A. aureus Whitcliff woods, Ludlow Nov. 1860 No! Old Armillaria mellea
Agaricus fascicularis Nov. Whitcliff woods Nov. 1860 No! ? Flammula lenta
Stereum hirsutum " " " " "
Panus stypticus " " " " "
A. micaceus Ludlow Oct. 1860 ✓ = Coprinus micaceus
A. piperatus " " " No!
A. humilis " " " No! Cantharellula cyathiformis
A. galericulatus " " " ✓ mycena galericulata
Tremella vesicaria Withering " " " Nostoc ?
Hygrophorus coccineus "
No name " probably Nolanea staurospora
no name " Nov. /60 Tricholoma ustale ?
Reticularia maxima " Spring /61 = R. lycoperdon
AEthalium septicum " May /61 = Fuligo septica ✓
Peziza phlebophora Caynham Spring /61 Disciotis venosa
Coprinus micaceus Ludlow Summer /61
no name Bitterby June 12 1862 Psathyrella candolleana
Agaricus nudus Ludlow wood 1861 ✓ Lepista nuda
Hygrophorus virgineus (in pencil"odorus?) No! Clitocybe fragrans
no name Clitocybe sp
no name ? Flammulina velutipes or Collybia erythropus
no name Mycena alkalina ?
no name Tubaria furfuracea
no name Builth Sept. 1861 Leptonia serrulata
Stereum rugosum No! Coriolus versicolor
conicus No! Hygrophorus coccineus
Hydnum repandum Nov. 1860 ✓
Marasmius oreades ✓
A. humilis melanoleuca sp
Hygrophorus pratensis No! Inocybe patouillardii probably
A. fascicularis more like Hypholoma sublateritium
Lycoperdon pyriforme
Clavaria Clavaria corniculata
no name Nov. 5, 1861 Tricholoma saponaceum
granulosus Oct. 20 1861 Cystoderme amianthinum
Marasmius erythropus Ludlow 1860 ✓
Geoglossum difforme ?
G. hirsutum Whitcliff possibly ✓
Hy. virgineus ?
A. foenisecii ✓ Panaeolina foenisecii
P. aurantia ✓
no name ?

Cl. inequalis Whitcliff *No.* *Clavaria fusiformis*
El. fusiformis " *No.* *Clavaria inequalis*
Coprinus fimitarius tan bed by railway Oct. 9 *No.* *Coprinus comatus*
A. nidorosus Oct. 19 /61 *No.* *? Tricholoma saponaceum*
no name Mary Knowle Oct. 19 *Cystoderma carcharias*
P. alligatus Whitcliff Oct. 14 /61 *Hexagonus Giennis*
no name Bibberley Oct. 18 *Amanita citrina*
no name Whitcliff Oct. 19 *?*
Tremella foliacea v. ferruginea Bitterley Oct. 22 1861 ✓ *Tremella foliacea*
Clavaria umbrina Miss Hodgson Oct. 23 *Clavaria umbrinella*
C. cristata Bitterley Oct. 22 *Clavaria Kunzei*
A. psittacinus Oct. 25 ✓ *Hygrophorus psittacinus*
Hy. ovinus Bitterley Oct. 25 Whitcliff *Hygrophorus laetus*
Hy. coccineus Oct. 25 (in pencil "Hygrophorus puniceus) ✓ *Hy. puniceus*
Tremella albida Nov. 1st *Exidea nucleata*
Hygrophorus calyptraeformis on beech leaves, Bitterley Nov. 1st. *No!* *mycena pura*
Hygrophorus distans (in pencil "virgineus") ✓ *Hygrophorus virgineus*
Ag fumosus under an ash tree Nov. 1st. ✓ = *Lyophyllum decastes*
Peziza nivea Nov. 1st. *No*
Trichia fallax Bitterley Oct. 30/31 1861 *?*
A. ~~squarrosus~~-A.-~~flavobrunnea~~ A. heteroclitus Bitterley Oct. 30/31 1861 ✓ = *Pholiota destruens*
Arthina brunnea " *sterile mycelium*
Clavaria crispula " *?*
Calocera cornea on oak " ✓
cristata " *Clavaria cinerea*
A. variabilis Beech wood " ✓ = *Crepidotus variabilis*
Crepidotus alveolus? mollis " ✓ = " *mollis*
Ag. foliaceus " Nov. 1st. *Cantharellus cyathiformis.*
Lactarius turpis poisonous, under beech trees " *No!* *Lactarius fuliginosus*
Clavaria rugosa "
Arcyria punicea " *Comely .*
Craterium minutum " "
P. reticulata ~~firma~~ ✓ (= *Rutstroemia firma*) " Nov. 11/13 1861 *No!* *?*
Bulgaria inquinans (named by M.J.Berkeley(" " " *Pleurotellus Sp*
Cantharellus retirugis (Broome) A hypnephilus in pencil " " " " *No!*
Thelephora laxa Bitterley " " *No!*
Helotium fructigenum on acorn " "
Hypoxylon fuscum
A. sulfureus (in pencil "A. sublateritius, & sulfureus has white gills) Nov. 12 *Hypholoma sublat.*
no name Nov. 9 Bitterley 1861 *Lacrymaria pyrotriche*
Mycena lacteus " " *? mycena sp*
Russula delica " " *No!* cf. *Clitopilus prunulus?*
no name " " *?*
no name " " *?*
Stereum purpureum " " ✓

A. cyathiformis	Bitterley	Nov. 11/13 1861	✓
Lenzites betulina	"	" " "	✓
L. zonarius	"	" 1st & 2nd 1861	*Nb!* Lactarius blennius
Ag murineus under horse chestnut	"	" " " "	Volvariella murinella
Helvella crispa under beech trees	"	" " " "	?
Cortinarius	"	" " " "	Psathyrella spadicea ?
no name	"	" " " "	Not a Cortinarius !
Cortinarius radicata (C. cinnamomeus in pencil)	"	" " " "	*Nb!* Mycena polygramma
androsaceus on beech leaves	Bitterley	" " " "	Mycena sp
no name Henley lane Nov 2nd			
A. laccatus v. amethysteus	"	"	" on beech leaves ✓
Peziza humaria Bringwood Chase			Possibly melastiza chateri
A. galericulatus on oak trees	"		" = mycena galericulata ✓
no name under fir trees Whitcliff	Nov. 6		Tricholoma squarrulosum
no name Nov. 6			Mycena inclinata ✓
Cyathus striatus Ludlow woods			
Cr. mollis	" "		✓
P. cupularis	" "	Nov. 19	Possibly
Helvella lacunosa	" "	" "	
Russula rosacea (alutacea) Ludlow woods			*Nb!* Russula atropurpurea
P. brunnea?			Humaria (Lachnea") hemispherica
Cantharellus infundibuliformis	" "		*Nb!* Hygrophoropsis aurantiaca
Polyporus fumosus	" "		?
Bulgaria sarcoides	" "		Ascocoryne cylichnium more like
no name (on a stick)	" "		?
Hydnum farinaceum	" "	Nov. 23	*Nb.* Possibly Mycoleptodon ochraceus
A. epipterygius	" "		✓ = Mycena epipterygia
Naematelia nucleata	" "		*Nb!* Naematelia encephala
Leotia lubrica	" "	Nov. 20	
P. nidulans	Bitterley Nov. 20		? Possibly Ischnoderma resinosum
tear like lacrymans	" " "		?
R. alutacea	July 22 1861		*Nb!* Russula pectinata or allied
A. mappa			✓ = A. citrina
no name	July 22		Psathyrella candolleana
A. rubescens			✓ Amanita rubescens
Lactarius hyginus poisonous Aug. 1st.			? Not recognisable
Russula heterophylla Onibury Aug. 9 1861			*Nb.* ? R. vesca
Boletus luteus Aug. 12			*Nb.* Boletus subtomentosus
Clavaria fragilis Builth Aug. 12; Ludlow Sept.			✓ = Clavaria vermicularis
C. argillacea Aug. 13			*Nb.* Clavaria fumosa
Clavaria helveola Park Well Aug. 18			Clavaria fusiformis
Cantharellus orcella Builth Aug. 13 (in pencil "Hygrophorus virgineus)			✓ = Clitopilus prunulus
no name			? Clitocybe tabescens

Page headed "Boletus" bears at foot "Augt. 14th 1861 Builth"

Boletus pachypus ½ size No. Boletus luridus ✓

scaber ✓

B. flavus chrysenteron bovinus No. Boletus subtomentosus

B. sanguineus (in pencil "luridus") ✓ = Boletus rubellus
 ?
?elegans
 Boletus badius
badius

A. phalloides Augt. 17 1861 Glan Wye; 1867 Ludlow

Lactarius chrysorheus Augt. 17th Llanelwydd (in pencil "Russula nigricans?) ✓ (Lactarius)

A. ramenticole No. Pleurotus dryinus

hypnorum (Mycena) Augt. 20 No. Mycena (Gerronema) fibula
 Mycena sp.
no name Sep. 24

Agaricus radicatus Park Wells Aug. 19; Ludlow 67 Amanita vaginata ?

Agaricus capillaris Park Wells Augt. 20 (Annotation "Marasmius rotula") Marasmius rotula

Cantharellus orcella Wellfield Aug. 22nd = Clitopilus prunulus

Hebeloma dulcamarus? Wellfield Inocybe sp. or ? Collybia peronata
 Amanita excelsa
A. asper Park Wells Aug. 19; Ludlow /68

Polyporus varius Polyporus lentus Buttington Feby. 2 1862 ✓ P. varius

cyathiformis Whitcliff May 29 1862 No!

no name May 18 Coprinus micaceus + ? Tricholoma carneum

Lycogala epidendrum Wood Ludlow May 21 1862
 ?
A. stylobates? Bringwood Chase May 21 /62

no name June 11th 1862 Psathyrella disseminata

Boletus piperatus No!

Blewits No! Cortinarius (myx.) pseudosalor

Lactarius subdocis A. laccatus No. Lactarius camphoratus

radicatus Mycena sp. cf. M. polianthona

Polyporus perennis Charcoal rings Augt. 1 Paxillus involutus

Russ. sardonia Augt. 1st No!! Conocybe lactea

Bolbitus tener Mr. Lightbody's Garden Augt. 3rd. Mycena pura

no name ✓ Lactarius rufus

A. laccatus Lactarius rufus Hygrophorus ceraceus

no name Mycena avenacea ?

no name No

A. vulgaris ✓ = Psilocybe semilanceata

Ag. semilanceatus

 Sheet headed Boletus 1861

laricinus Builth Sept. 3; Ludlow 67 No. perhaps Porphyrellus pseudoscaber

scaber Builth Sept. 7

chrysenteron Oct. 18 No. perhaps Porphyrellus pseudoscaber

pachypus Glan Wye castaneus rare Sept. 12th ✓ = Gyroporus castaneus

B. laricinus Whitcliff Oct. 18th

chrysenteron Bitterley Nov. 1st ? B. pseudoscaber

granulatus Builth Sept. 14th 1861 impolitus scaber yellow-grey variety — ¾ nat size
 ? B. subtomentosus
B. striaepes? Bringwood Nov. 12 B. subtomentosus

no name Abbotsfield Augt. 23 *B. elegans*

subtomentosus Ludlow Sept. 20

bovinus Ludlow Sept. 20 No! *B. luteus*

versipellis No! *B. elegans*

edulis Sept. 20 (annotated in pencil "B. edulis has no ring it is B. luteus)✓ *B. luteus*

stapes (in pencil"B. impolitus) ?

Dacrymyces deliquescens on fir tree ✓

Auricularia mesenterica Bitterley Spring 1862 ✓

Cantharellus umbonatus ✓

Tremella mesenterica Feby. ✓

A. vernus Ludlow poisonous Augt. 1861 ✓

N emetica No.

Marasmius The Wood *Marasmius calopus*

Crucibulum vulgare Mary Knowle wood Nov. 16 ✓

A. galopus ~~no name Nov. 16~~ ✓

no name Nov. 16 ?

no name Nov. 8th ? *melanoleuca sp*

no name Bitterley ?

no name Bitterley *Mycena galericulata*

no name Bitterley *Inocybe sp*

Polyporus igniarius of With. on an apple tree Diddlebury Nov. No! *Polyporus hispidus*

Tremella foliacea brunneus Witches butter ✓ *Tremella foliacea*

P. adustus ✓

P. versicolor ✓

P. spumeus June 7 1862 ?

polyporus vulgaris June 7th 1862 *Poria versipora*

P. squamosus No!

P. spumeus ?

P. fraxineus ?

Exidia glandulosa Oct. 30th /62 ✓

Podisoma foliicolum

nudus Nov. 1861 ✓ = *Lepista nuda*

A. personatus Blewitts edi. Good to eat ✓

Lactarius volemum No! *Clitocybe invara ?*

Xylaria polymorpha Augt. 1861 No! *X. hypoxylon*

A. prunulus May 31st 1862 Whitcliff woods No! *Entoloma clypeatum*

. erythropus satanas May 31st 1862 Whitcliff ✓ B. erythropus
~~oneocegnava-surea~~ Spunaria alba May 29 1862 mucilago spongiosa? or Fuligo?
A. purus June 4 upon fir spines Duttington ✓ = Mycena pura
Marasmius erythropus Whitcliff June 15th old Marasmius dryophila
Polyporus frondosus mice smelling polypore nr. Ludlow June 17 ✓
A. flavobrunneus June 20th Buttington (in pencil "lacrimabundus") ✓ (Lacrymaria velutina)
Lactarius subdulcis June 24 No! ? Tricholoma vaccinum
no name on dung Coprinus niveus
A. crustuliniformis under larch Buttington June 23rd ✓ = Hebeloma crustuliniformis orally
no name June 23rd Mycena sp
P. acetabulum May 3rd 1862; June 1864 ✓ Paxina (Helvella) acetabulum
Marasmius graminum
Naematelia encephala Stoke St. Milbro' No. Exidia thuretiana is likely
no name Stoke St. Milbro' (Rubus stem with caeomata) Phragmidium violaceum or P. bulbosum
P. leporina (deleted "macropus", added "Helvella elastica") Helvella sp
Clavaria bovista (Copied) but found later (in pencil "Clavaria botrytis) ✓ C. botrytis
Agaricus adnata Bitterley June 12th (in pencil "Ag. cervinus") ✓ Pluteus cervinus
no name mycena (Germena) fibula
Russula heterophylla edib. Jun. 8th R. cyanoxantha more likely.
Ag carnosus (Bolton) obesus var (Withg) Bitterley June 23rd Panus torulosus ✓ P torulosus

Tubercularia vulgaris on hazel	✓ Lachnellula (Trichoscyphella) hahniana
Peziza calycina on larch	?
Merulius on ash	?
Diatrype verrucaeformis on ash bark	?
Nectria aquifolia on holly	?
Xylaria hypoxylon	✓
Coprinus picaceus	Coprinus atramentarius
Ag. spadiceo-griseus	Psathyrella sp
Agaricus(Mycena)setosus	No
Nectria peziza on deal	?
Tremella sarcoides on beech	✓ (Ascocoryne sarcoides)
Agaricus viridis Ag. odorus Whitcliff Nov. 1860	✓ Clitocybe odora
Cordiceps militaris " " "	
Clavaria fragilis " " "	✓ = Clavaria vermicularis
Nectria peziza on scarlet japonica	?
A. dryophilus Whitcliff 1860	Tricholoma fulvum
A. coprinarius on dung " Feb. 1861	? Stropharia sp.
Hygrophorus ceraceus "	old Hygrophorus coccineus
Tubercularia vulgaris on currant Feb. 28 1861	?
Polyporus C. W's garden	Inocybe sp
A. laccrus	Laccaria laccata
A. lactatus Llanelwydd rocks Aug. 25 1861	Fomes pomaceus
Polyporus igniarius Onibury May /61	
Agaricus micaceus Nr. Ludlow	✓ Coprinus micaceus
no name " "	?
no name " "	?
no name " "	?
no name " "	?
no name " "	?
A. hebeloma " "	✓ Hypholoma sublateritium
sublateritius Nov. "	?
Peziza atra/Peziza saniosa of Berkeley Withering Nov.	NB! old Russula sp
Agaricus flexuosus Nr. Ludlow	?
no name Glynfredr nr. Crickhowell Nov. 1860	NB! Tricholoma terreum
A. dryophilus " " 1860	Mycena pura
no name " " Dec. 17 1860	NB! Panaeolus sp ?
A. semiglobatus Builth Sept. 27 1861	?
no name " " "	
Ag lenticularis grammopodia the largest was 9½ inches diameter Glynfredr Dec. 18 1860	Clitocybe nebula
Peziza coccinea Jany.11.1861 snow on the ground	✓ Sarcoscypha coccinea
Peziza scutellina Buttington June 22 & 24 1861	✓ Scutellinia sp

P. varius Bitterley Nov. 14 1863 ✓ ? + Oxyporus populinus

Polyporus contiguus Nov. 14 1863 Mycena acicula

Ag. rosellus also Urtica stem with Leptosphaeria acuta

Helotium calyculus Nov. 17 1863

M. hudsoni

Stemonitis fusca, Cribraria intermedia & Stemonitis obtusata unrecognisable! No!

A. pterigenus Nov. 17 1863 ✓ Mycena pterigena

Cyatus vernicosus Bitterley Nov. 21 1863 ✓ = C. olla

Peziza coccinea orange variety Dec. 22 1863 ? Femsjonia luteoalba

Auricularia? Castle wlak, Ludlow on an old lime tree Jany. 20 1864 Exidia glandulosa

Clavaria cinerea The Vinals nr. Ludlow Sept. 5 1865 ✓

Corticium quercinum No.

Merulius candidium Guiltfield July 1, 1864 No! Probably Sphaerotheca pannosa on Rosa

Morchella esculenta May 1864 April 6 71 (later endorsed "gigas") M. esculenta ✓

no name Guilsfield Oct. 27 1864 Lepiota friesii

Merulius cerium Weston S. Mare Jany. 19, 1865 No! Merulius tremellosus

Morchella esculenta May 1900

Aecidium urticae Guilsfield vicarage garden June 8, 1865 ✓ (= Puccinia caricina)

A.procerus Ludlow wood Aug. 18, 1865 ✓ Lepiota procera

Clavaria fastigiata Aug. 16 1865 Clavaria (Ramaria) suecica

no name Garfa lane June 12, /65 ? Tricholomopsis platyphylla

Peziza viridaria Aug. 16 1865 ?

Peziza hemispherica Aug. 16, 1865

P. ferruginosus Ludlow Aug. 1o, 1865 ? or ? Fomes pomaceus. ? host!

Cortinarius aimatochelis Garvagh Lane Aug. 6, 1865 ✓ = Cortinarius armillatus

Ag.(Tricholoma) flavobrunneus Aug. 15, 1865 No! ? Collybia peronata

Polyporus leptocephalus? Lenta. Mary Knowle Aug. 18 1865 Polyporus nummularius

Polyporus intybaceus Aug. 21st 1865 Probably cover for spp drawing. Love surely P. giganteus

Agaricus rachodes under a yew tree in Ludlow Park [Ludford Park] Aug. 26 1865 ✓ Lepiota rachodes

Daedalea quercina on oak trees Aug. 22 1865 ✓

Hydnum repandum Ludlow Aug. 30, 1865 ✓ (var. rufescens)

Cl. botrytis very young The Wood, Ludlow Aug. 30, 1865 ✓

Clavaria "muscoides" Aug. 31, 1865 No! Clavaria formosa

Poly. alligatus Aug. 25, 1865 ?

Agaricus melleus Aug. 29 1865 ✓ Armillaria mellea

A. sublateritius Aug. 29 1865 ✓ Hypholoma sublateritium

Lactarius serifluus Sept. 5 1865 No! Lactarius tabidus

Helvella elastica (rare) Sept. 8, 1865 The Vinals ✓

Hydnum compactum The Wood, Ludlow Sept. 9, 1865 Hydnum nigrum

Polyporus salignus The Vinals Sept. 5, 1865 ?

Strobilomyces strobilaceus Oak woods Aug., Sept. & Oct.

Xylaria digitata Downton woods Sept. 22 Xylaria polymorpha

Cyphella capulus on nettle stems nr. Starvebrow Oct. 17 1865 Leptoglossum muscigenum

Cantharellus retirugis Bentley Wood Sent Sept. 22, 1865

Hydnum udum? Weston S.Mare Nov. 20. 1865 No! P. radiatus ?

A. lacrymabundus 1862 ✓ (ie *lacrymaria velutina*)

no name Llanymynech 1862 ?

no name "Pool" aug. 21. *Agrocybe ? praecox* *Hygrophorus sp*

Hy. ceraceus

Hy. coccineus No! cf. *Hy. miniatus*

Hy. virgineus ✓

no name Sept. 10 1862 ?

Ag. puniceus Church Stretton 1862 *Laccaria laccata*

Cortinarius Trilobite dingle Sept. 12, 1862 *Cortinarius sp* cf. *C. hinnuleus ?*
no name *Psathyrella Candolleana*
Pax llus involutus near Welshpool and Ludlow 1863

Coprinus plicatilis BlkPool Sep. 15 *doubtful.* more like *C. lagopus*

no name Black Pool *Leptonia sericella* & ? *Tricholomopsis rutilans*

no name Trilobite dingle Sept. 15 *Probably Macrocystidia cucumis*

no name Criggien Sept. 17 *Entyloma porphyrophaceum*

no name Criggien *Inocybe geophylla*
 ?

A. haustellaris

Ag. carcharias Church Stretton Hills Oct. 7 1862 ✓

Cortinarius Oct. 14, 1862 *Cortinarius sp.*

A. nivalis 1862 No! *Amanita citrina*, white form

A. ulmarius 1862 No! *Pleurotus dryinus*

(Clavaria) fastigiata 1862 No! *clavaria rosea*

C. acuta ?

no name ?

no name ? *Cantharellus infundibuliformes*

no name Oct. 30 1862 *Hygrophorus hypothejus*

Cantharellus tubaeformis Oct. 30 1862

Boletus subtomentosus Guilsfield Aug. 20 1863 ✓

A. squarrosus Stanton Lacy Nov. 1862 ✓ *?Pholiota squarrosa*

Agaricus cinnamomeus? (in pencil "clavus") Stanton Lacy Dec. 20 No! ?

Agaricus velutipes on an ash nr. Tru... Dec. 10 ✓ *Flammulina velutipes*

Ag muscarius ✓

A. pterigenus Dec. 10 ✓ *mycena pterigena*

A. corticola Dec. 10 No.

Thelephora Oct. 29 *Ptychogaster albus*

Agaricus rutilans on Whitcliff Oct. 25 and Shawbury Heath. Much larger at Shawbury ✓

Cop. atramentarius Sept. 29, 1863

Thelephora melissima Sept. 29 1863 *Thelephora terrestris*

T. sebacea Sept. 29 ?

T. terrestris Sept. 29 ?

Cortinarius sublanatus Oct. 3 ?

Cortinarius varius Oct. 3 No. One of the *C. anomalus* series? or *C. alboviolaceus* ?

no name Nov. 5 ?

Russula Sept. 27 1863 Cl ? *Tricholoma* ~~argillee~~ *argyraceum*

Cl. *Clavaria corniculata*

P. sulphureus Ludford Park ✓

Jew's Ear Castle walk, Ludlow ✓

Helvella sulcata (in pencil "nana" "elastica")　　Helvella (Leptopodia) elastica

Peziza cochleata Sept. & Oct. Bitteley & Moor Park　　Probably Otidea onotica (porcelans)

Geaster rufescens Whitcliff Oct. 13 1862

Cyathus vernicosus Nov. 5 1862　　✓ = C. olla

Hyd. zonatum Mary Knowle wood Sept & Oct. 1862　　Hydnum melaleucum

Helotium pallescens Nov. 1862　　Helotium calyculus

Tremella albida　　Exidia thuretiana probably

Corticium quercinum　　No! ?

no name Sept. 30 1863　　Armillaria mellea

Agaricus rachodes Sept. 30 1863　　Lepiota rhachodes

Bovista nigrescens Sept. 20 1862

Cynophallus caninus Llanychydol plantations Sept. 6 1863　　✓

Hypoxylon concentricum from Moor end near Cheltenham Aug. 1. 1863　　✓ (=Daldinia)

Merulius corium and Corticium quercinum Garvaur wood Aug. 14, 1863　　Poria versipora + ?

Merulius palus　Guilsfield　Aug. 10.　　Merulius corium

Mucor tenerrimus? Trilobite dingle Aug. 18 1863　　Trichoderma viride

Peziza repanda Glasswell June 20 1863("cupularis" in pencil)　　Neither !

Fistulina hepatica Garva wood Aug. 15, 1863. Sept. & Oct.

Thelephora multizonata near the Dorwen Aug. 18 1863　　Possibly. if not Heteroporus biennis!

Boletus bovinus: turns green　　Boletus albidus

Coprinus comatus Sept. 30 1863　　✓

Ag. mollis Guilsfield Aug. 25　　Crepidotus mollis ✓

Merulius rufus Guilsfield Aug. 26　　Phlebia merismoides

B. edulis Guilsfield Aug. 16　　Boletus erythropus

A. petasatus on thatch Guilsfield Aug. 25　　✓ (Pluteus petasatus)

A. campestris var vaporarius Trilydyn. Field very good eating　　✓ Ag. vaporarius

Boletus pachypus nr. Trilydyn Aug. 1863　　? Boletus scaber

Agaricus bifrons　　Aug-Sept. 1863　　Psathyrella sp

Lactarius pyrogalus under laurels Sept. 1, 1863　　No! Russula grisea or alliedspp.

Boletus subtomentosus Ditch Sept. 1863　　Boletus pruinatus

Lactarius rufus under laurels &c Sept. 1863　　No! Gomphidius rutilus

Fistulina hepatica Sept. 1863　　✓

A. procerus Trelydyn lane Sept. 19, 1863　　✓

Sphaerobolum stellatus Mary Knowle Oct. 12, /63

Naematelia virescens Oct. 4 1864　　?? Lectia sp.

Lenzites flaccida Oct. 16　　Lenzites betulina

P. leiocarpa Oct. 8 Pez. brunnea Oct. 20 on turf on Whitcliff (appear same but name queried)?

Clavaria ardenia Mary Knowle Oct. 12, 1863　　✓ (= Clavaria fistulosa)

Clavaria striata Stanton Lacy Oct. 20 1863

Clavaria juncea Oct. 15 1863　　✓ (sclerotial form = Typhula phacorrhiza)

A. rubi on ash twig nr. Stanton Lacy Oct. 20 1863　　No! Marasmiellus ramealis

Ag. roridus hyaline stem Oct. 20

Cantharellus? on sawdust in a cellar Oct. 16, 1863　　? sterile deformed Hypholoma fasciculare

Russula vitellina Oak woods Sept. 1868 *Russula lutea*

Double mushroom Mr. Lightbody's Tan bed Dec. 8 1863 *Ag. vaporarius*

Hydnum auriscalpium on the camp Weston S. Mare Jany. 3 1866 ✓

Polyporus annosus on hazel roots Weston S. Mare Jany. 5 1866 ✓

Arcyria umbrina on an ash stump Guilsfield June 24 1866 *stemonitis sp*

Helvella ephippium Oct. 13 1866 Bringwood Chase (det M.J.Berkeley) *Helvella atra*

Ag. spadiceo-griseus Guilsfield June 26 on ash wood *Bolbitius vitellinus*

Agaricus geotropus Weston S. Mare Dec. 1, 1865 *with Ag mitis* *Old Clitocybe nebularis with Crepidotus variabilis*

Agaricus stylobates " " " Jany. 29 1866 *Marasmius sp*

Stereum spadiceum " " " Feb. 26 1866 *Merulius tremellosus*

Marasmius androsaceus Cresswood wood on leaf of oak Sept. 5 1866 ✓

Polyporus hispidus soft and velvety on a plum tree July 21 1867 ✓

Clavaria juncea Oct. 29 1867

Calocera tuberosa Oct. 29 1867 *Calocera cornea (or C. glossoides?)*

Agaricus acerosus (rare) Stanton Lacy woods Nov. 21 1867 *Pleurotellus acerosus or P. tremulus*

Daedalea latissima Oct. 29 1867 ?

Stereum rugosum Stanton Lacy 1867 *M!* *Hymenochaete rubiginosa*

Spathularia flavida Oct. 27 1867 from Clun

Clavaria ceranoides Clun Oct. 25 1867 *Clavaria fusiformis*

Aregma bulbosum Nov. 2 1867 (bramble leaf) — *Phragmidium bulbosum or P. violaceum*

Corticium laeve Stanton Lacy Nov. 24 1867 ?

Morchella semilibera April 9 1865 Camham ✓

Peziza reticulata of Greville Ludlow April 9 1868 ✓ *(= Disciotis venosa)*

Cordyceps entomorhiza Hay Park May 13, 1868 *Ancr ang!! ✓* *= Cordyceps gracilis*

Sporodina dichotoma growing on Peziza reticulata Apr. 17 1868 *M!*

Corticium calveum Apr. 17, 1868 *? Peniophora quercina*

Mucor ramosus on the above Ludlow ?

no name Hay Park May 13, 1868 ?

Polyporus picipes velvety on a ~~beech~~ apple Mrs. B.V's garden July *Polyporus hispidus*

Polyporus dryadeus on an oak stump July 20 1868 ✓

P. heteroclitus July 22 1868 W.L. *Polyporus sulphureus*

Clavaria pistillaris Oct. 16, 1868 Oct. 31 1874 ✓

A. applicatus Jany. 2 1869 ✓ *(Resupinatus applicatus)*

Ustilago July 7 1870 *Presumably Ustilago tritici (? orTilletia)*

A. vaginatus Sept. 1869 — *Amanita vaginata*

Cortinarius aureus Aug. 9 /69 *M!*

A. placenta Ludlow *Melanoleuca melaleuca*

A. niderosus Ludlow *M! ? Hebeloma sp*

A. pantherinus Oct. 1869 Ludlow *prob Amanita pantherina*

Craterellus cornucopioides Nac. /69 Ludlow ✓

Auricularia lobata Feby. 15 1871 Ludlow ✓ *= A. mesenterica*

Cordyceps ophioglossoides Guilsfield Nov. /69 No! Geoglossum sp.

A. variabilis Nov. /69 Crepidotus mollis (? var calolepis)

Anthina flammea Nov. sterile mycelium

Calocera tuberosa? Clavaria fusiformis

Cortinarius evernius Ludlow Oct. /69 No! Cortinarius pseudosalor

Russula vitellina rare Oct. /69 = Russula lutea

Dasyscypha calycina March 3 1871 No!

Xylaria carpophila Weston S. Mare March 11; Cainham 73

Cantharellus lobatus March 11 Leptoglossum muscigenum

Cyphella musoigena March 11 1871 Mniopetalum sp?

Roestelia lacerata Ashford July 1871 yes (= Gymnosporangium clavariiforme)

Calocera viscosa Shawbury Heath Oct. 17, /71 No!

Cantharellus aurantiacus white variety Mycena pura

A. sericelsus Haughmond Oct. 13 Hygrophorus calyptraeformis

Hyg. psittacinus lilac variety Haughmond Oct. 15 Lactarius deliciosus

Lactarius acris under fir trees Shawbury heath

Lactarius controversus? Caynham Camp Nov. 7 /71 probably Lacrymaria (Psathyrella) velutina

Cortinarius callochorus Caynham Camp Hygrophorus hypothejus

A. odorus No! ? young Amanita vaginata

Russula decolor No! Russula nigricans

Russula adusta Shawbury Heath = L. turpis

Lactarius plumbeus Hawkes on Oct. 20 rare Oudemansiella radicata

A. longipes Caynham Camp Nov. 7 /71 Hebeloma sp

A. auricomus

Ag. fusipes pale form

A. rimosus No! Tricholoma sculpturatum Not Russula. probably old Armillaria mellea

Russula aurata Shawbury Heath (Oudemansiella radicata)

A. radicatus Haughmond Abbey (" mucida)

A. mucidus on beech Haughmond

Puccinia anemones Poughnill wood March 19 1872 ; Cainham Camp (= Tranzschelia)

Melampsora populina? on willow Cainham melampsora sp

Uredo filicum on Cystopteris fragilis Hyalopsora polypodii

Russula ochroleuca Fir woods Shawbury Heath No? Russula sp

Lactarius deliciosus Fir woods Shawbury Heath ?

Thelephora fastidiosa Sept. 13 1872 smells like a fox ?

Russula sardonia No! Russula puellaris

Geaster bryantii under yew trees Clun churchyard June 2 1886

Geaster hygrometricus Oct.9, 1872 Diddlebury rare named by Mr. Broome No! Geastrum triplex

no name Sept. 14. Oldfield ? Lyophyllum immundum

Localities of M.F.Lewis' collections 1860-1902

(B)= Breconshire (H)= Herefordshire (M)= Montgomeryshire (S)= Shropshire

Ashford 2½ miles S. of Ludlow(S)

Barmouth Merionethshire

Batchcott 4 miles SW of Ludlow (S)

Beacon Ring 3 miles E of Welshpool (M)

Bitterley 3½ miles NE of Ludlow (S)

Bringewood Chase 4 miles W of Ludlow (H)

Buildwas (S)

Builth Wells (B)

Bury Walls 4 miles ESE of Wem (S)

Buttington 3 miles NE of Welshpool (M)

Cainham, Caynham 3 miles SE of Ludlow (S)

Chester, Cheshire

Church Stretton (S)

Clun (S)

Crickhill Chester

Crickhowell (B)

Criggion 7 miles NE of Welshpool (M)

Crosswood 1 mile W of Guilsfield (M)

Diddlebury 6½ miles N of Ludlow (S)

Downton 5½ miles SW of Ludlow (H)

Festiniog, Merionethshire

Gaer Fawr, ?also Garvaur,1 mile N of Guilsfield (M)

Glen Wye, Glan Gwy 3 miles NW of Builth Wells (B)

Grinshill 3½ miles S of Wem (S)

Guilsfield 3 miles NW of Welshpool (M)

Hay Park 1½ miles SW of Ludlow (H)

Haughmond 3 miles ENE of Shrewsbury (S)

Hucks Barn 1 mile S of Ludlow (S)

Kinver 3½ miles SW of Stourbridge, Staffs.

Llandrinio 9 miles S of Oswestry (M)

Llanelwydd 1 mile NE of Builth Wells (R)

Llanychidel, Llanerchydel 1 mile W of Welshpool (M)

Llanymynech 6 miles SSw of Oswestry (S)

Locking, Somerset

Long Mountain 3 miles E of Welshpool (M)

Ludlow (S) Ludford Park is in Ludlow

Lynmouth, north Devon

Mary Knowl(e) 2 miles wsw of Ludlow (H)

Millers Dale, Derbyshire?

Moor Park 2 miles SS" of Ludlow (S)

Oker woods, Derbyshire?

Oldfield 4 miles SW of Ludlow (H)

Onibury 5 miles NW of Ludlow (S)

Onich, Invernessshire

Panorama, apparently nr. Barmouth

Park Wells, 1 mile W of Builth Wells (

Poole ?Pool quay (M)

Poughmill ?Poughill, Devon

Shawbury Heath 7 miles NE of Shrewsbur

Stanton Lacy 3 miles NW of Ludlow (S)

Stourbridge, Worcestershire

Sunny Gutter ?

Tenby, Pembrokeshire

Trilobite Dingle ?

Trowscoed, Troscoed,1 mile NW Guilsfie

Vinals, The:5 miles SW of Ludlow (H)

Wel(l)field 2 miles N of Builth Wells

Welshpool (M)

Weston S(uper) Mare, Somerset

Whitcliff 1 mile W of Ludlow (S)

Whitcliff wood, W of Whitcliff, along
 Herefordshire border (S)

Whixall Moss 4-5 miles N of Wemm (S)

"Castle walks" etc- refs to Ludlow

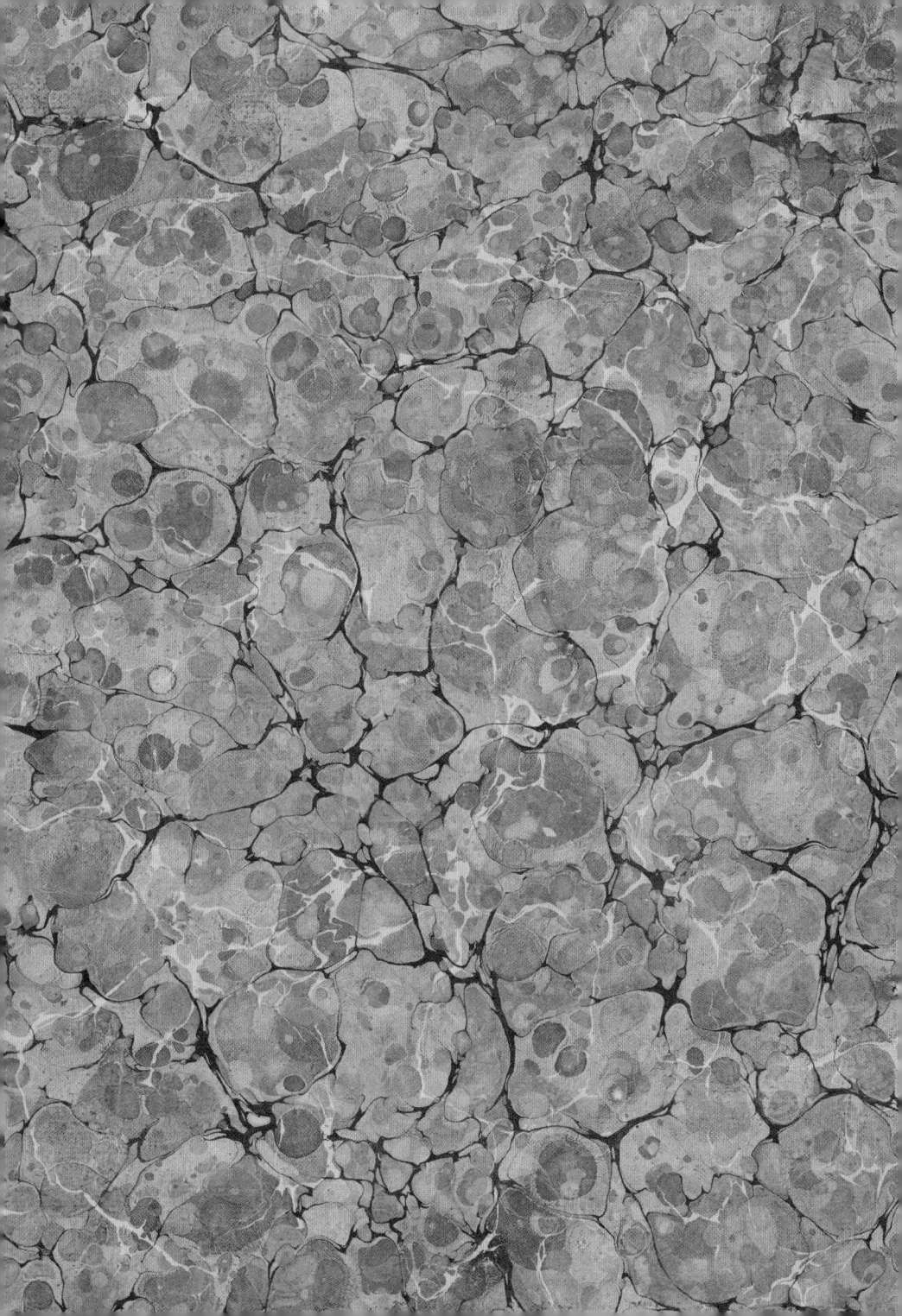

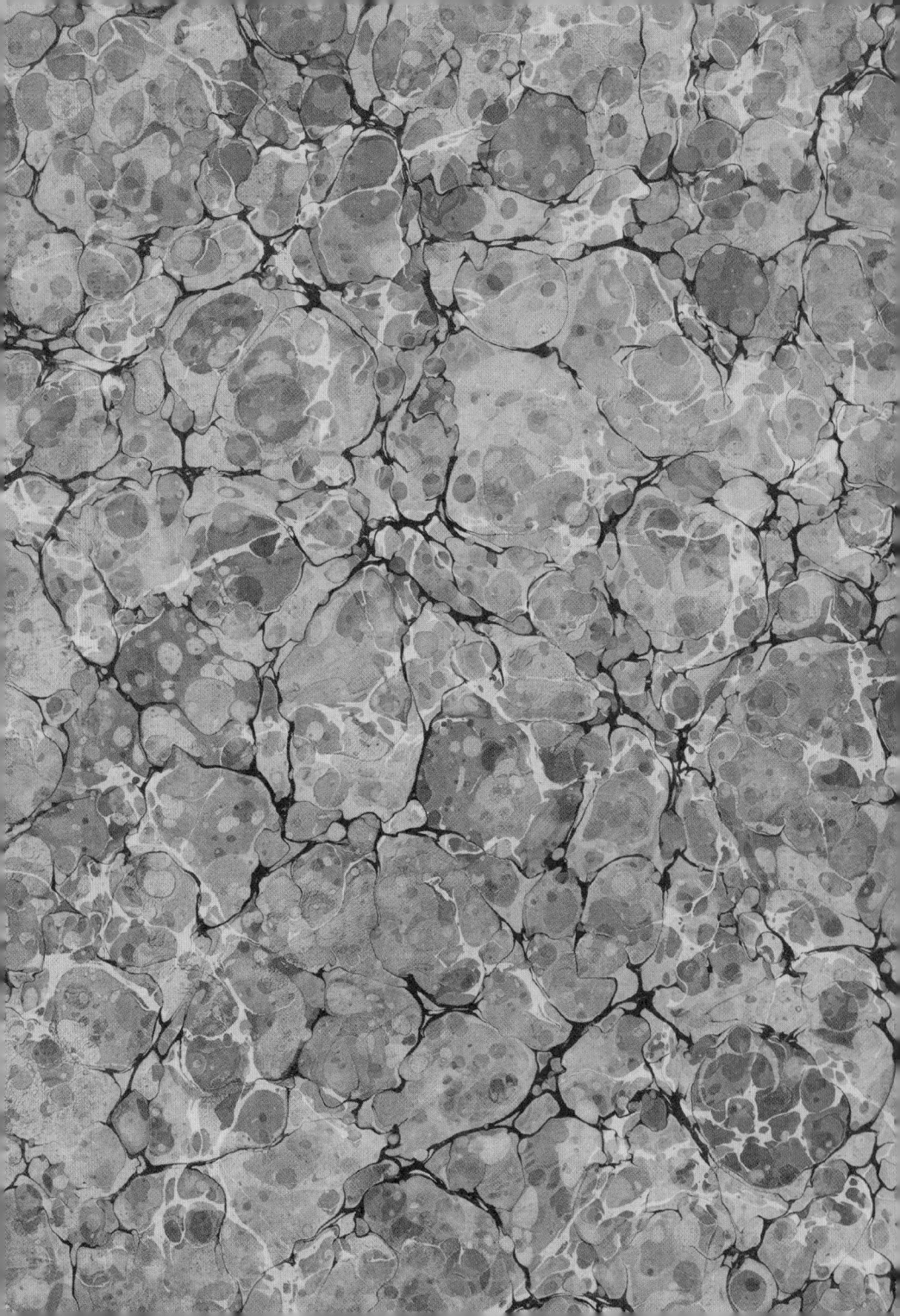